LAKELAND
LANDSCAPES

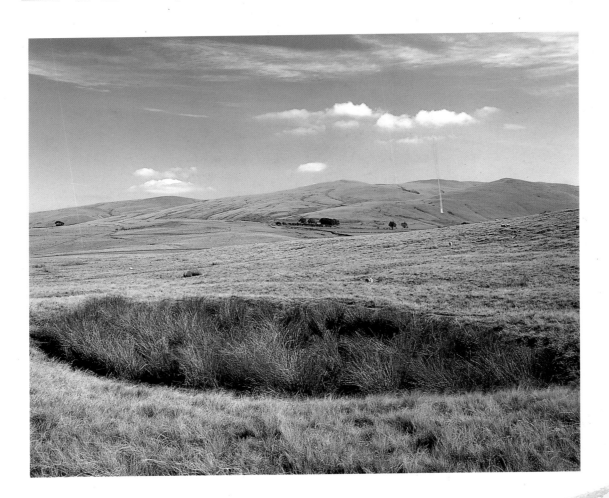

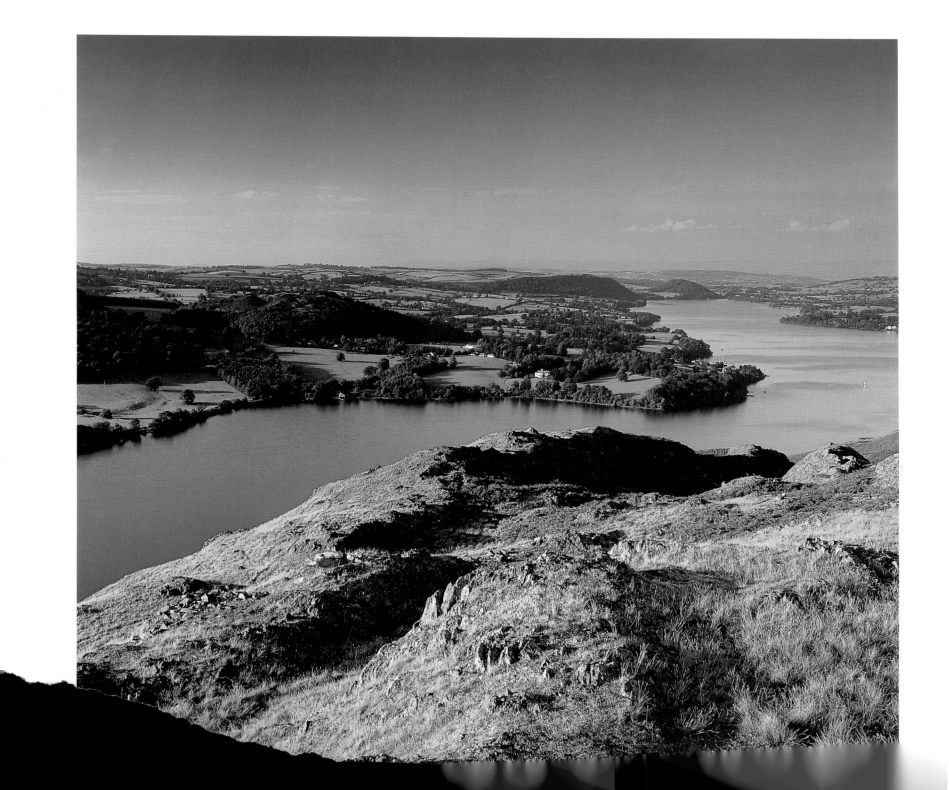

LAKELAND LANDSCAPES

PHOTOGRAPHY BY ROB TALBOT

TEXT BY ROBIN WHITEMAN

PHOENIX ILLUSTRATED

First published in 1997 by
George Weidenfeld & Nicolson Ltd

This paperback edition first published in 1999 by
Phoenix Illustrated
Orion Publishing Group, Orion House
5, Upper St. Martin's Lane
London WC2H 9EA

British Library Cataloguing-in-Publication Data
A catalogue record for this book is available from the British Library
ISBN 0-75380-511-1

Designed by Harry Green

Litho origination by Newsele Litho Spa
Printed and bound in Italy

Half-title. The landscape around Uldale – on the northern fringe of the National Park – features in Hugh Walpole's *Herries Chronicle* (the history of a Lakeland family from 1730 to 1932). In 1785 Judith Herries (later Paris) was eleven. For her, Uldale was 'by far too tame'. She 'preferred so infinitely the life at Stone Ends [near Caldbeck], where Uncle Gauntry drank, hunted, beat her, loved her, taught her to ride, to hunt, to prepare the birds for cock-fighting and to learn everything there was to learn about men and women'. Like the fictional Gauntry, John Peel (born in 1777) liked to drink and hunt; so much so that it is said he neglected his farm, his wife and his children. He died in the family's home at Ruthwaite, less than a mile west of Uldale.

Title page. During the late eighteenth century, cannons were deliberately discharged from a vessel on Ullswater to create echoes. The effect of a series of discharges, spaced apart by a few seconds, was described by Gilpin: 'The effect of the first is not over, when the echoes of the second, the third, or perhaps the fourth, begin. Such a variety of awful sounds, mixing, and commixing, and at the same moment heard from all sides, have a wonderful effect on the mind; as if the very foundations of every rock on the lake were giving way; and the whole scene, from some strange convulsion, were falling into general ruin.' He also suggested the introduction of a few French horns and clarinets 'to form a thousand symphonies, playing together from every part'.

Other books by Talbot & Whiteman
THE COTSWOLDS
THE ENGLISH LAKES
SHAKESPEARE'S AVON
CADFAEL COUNTRY
THE YORKSHIRE MOORS & DALES
THE HEART OF ENGLAND
THE WEST COUNTRY
WESSEX
THE GARDEN OF ENGLAND
ENGLISH LANDSCAPES
EAST ANGLIA & THE FENS
BROTHER CADFAEL'S HERB GARDEN
THE PEAK DISTRICT

Photographs by Talbot
SHAKESPEARE COUNTRY
THE LAKELAND POETS
COTSWOLD VILLAGES

Text by Whiteman
THE CADFAEL COMPANION

ACKNOWLEDGEMENTS
Robin Whiteman and Rob Talbot would particularly like to acknowledge the generous co-operation of English Heritage (Historic Properties North) and the National Trust (North-West Region) for allowing them to take photographs of their properties and sites featured in this book. Additional thanks go to Diana Lanham, Manager of the National Trust Photographic Library. They are also extremely grateful to: Lord and Lady Inglewood, Hutton in the Forest; John Spedding, Mirehouse; Lowther Estate Trust, Yanwath Hall; The Trustees of Rydal Mount; Lord and Lady Cavendish, Holker Hall; Mr and Mrs C. H. Bagot, Levens Hall; Fred Rogerson of The Bob Graham 24 Hour Club for information regarding current holders of the Bob Graham Round and the 24 Hour Fell Running Record. John Poucher for permission to use quotes from W. A. Poucher's *Lakeland Through the Lens* and *Lakeland Holiday*. Dr and Mrs R. Clark for permission to photograph Parcey House, Hartsop. Special thanks go to Ron Hill, of Hills the Wholesalers at Workington, for all his help and enthusiasm over many years. Appreciation also extends to all those individuals and organizations too numerous to mention by name who nevertheless have made such a valuable contribution.

CONTENTS

INTRODUCTION

Lakeland, siutated in the north-west of England, is one of the most beautiful and unspoilt areas in Britain. Covering only thirty-five square miles, the diversity of the Lakeland landscape is remarkable: high peaks, wild fells, spectacular waterfalls, lush pastures, secluded valleys, enchanting lakes, ancient sites, historic buildings, isolated farmsteads, remote villages and bustling towns. Also added to the allure of the region are the history, traditions and literary connections, which attract visitors from all over the world.

One of the earliest visitors to the region was the sixteenth-century antiquarian, John Leland, who recorded material for a great work on the history and antiquities of England and Wales, to be entitled *Antiquate Britannica* or *Civilis Historia*. It was never finished. William Camden followed, drawn by a thirst for 'making Excursions into one quarter or another, in quest of Antiquities'. In his *Britannia*, first published in 1586, he wrote of Cumberland: 'The Country, tho' the Northern situation renders it cold, and the Mountains, rough and uneven, has yet a variety which yields a prospect very agreeable. And giveth contentment to as many as travel it.'

Celia Fiennes took her *Great Journey to Newcastle and to Cornwall* in 1698, riding side-saddle through Kendal, Windermere, over Kirkstone Pass into Patterdale, and on to Penrith. Her impressions of the scenery were simple and direct, with no preconceived notions about what to expect.

❛ As I walked down at this place I was walled on both sides by those inaccessible high rocky barren hills which hangs over one's head in some places and appear very terrible; and from them springs

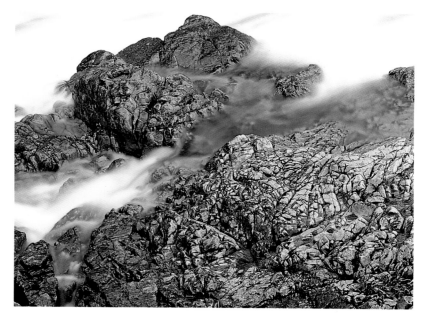

Stonethwaite Beck, Borrowdale

In his Yorkshire history of Dent, entitled *A Memorial by the Trustees of Cowgill Chapel* (1868), Adam Sedgwick explains why Borrowdale suffers from abnormally heavy rainfall: 'The bottom of Wasdale is open to the warm west winds that come from the sea. These winds after being driven up the valley of Wasdale are forced over the high pass of Styhead; and there they become rolled up with the cold air that hangs about the summits of Scafell and Great Gable. This mixture ... produces continual showers of heavy rain, which are blown onwards and fall into the head of Borrowdale. The consequence is, that there is a rainfall, in one or two spots near Borrowdale Head, of full a hundred and fifty inches in the year.' One spot, Seathwaite, is the wettest inhabited place in England.

*Derwentwater & Keswick,
from Brandelhow*

Standing on the banks of the River Greta, beneath the shadow of the Skiddaw range, Keswick grew from a small wool-market town to a prosperous centre of the Elizabethan mining industry. In the mid-sixteenth century mining engineers were imported from Germany to look for minerals, mainly copper. It is said that because of the initial hostility of the locals, they took refuge on Derwent Island (centre of photograph). The world's first pencil works were established at Keswick in 1566, using 'wad' (black lead or plumbago) from the mines at Borrowdale. The factory still makes pencils, but the lead is now imported. Keswick's prosperity, which suffered a dramatic decline, was revived when tourists began to discover the Lakes in the early nineteenth century.

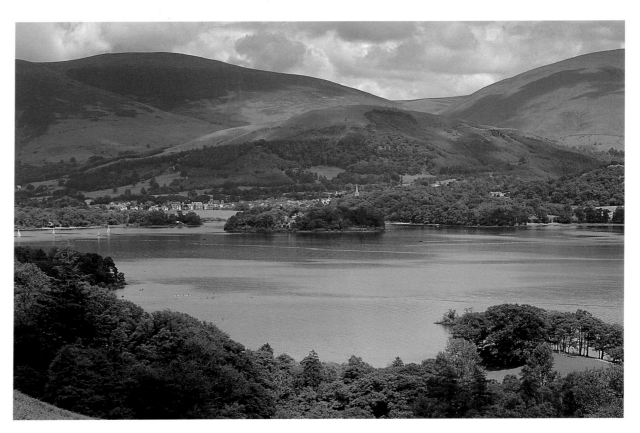

many little currents of water from the sides and clefts which trickle down to some lower part where it runs swiftly over the stones and shelves in the way, which makes a pleasant rush and murmuring noise and like a snowball is increased by each spring trickling down on either side of those hills, and so descends into the bottoms which are a moorish ground in which in many places the waters stand, and so form some of those Lakes as it did here. '

Twenty-six years later, Daniel Defoe published the first of his three-volume *A Tour Thro' the Whole Island of Great Britain*. After commenting on the dainty, potted char of 'Winander Meer' (Windermere), he wrote:

' Here we entered Westmorland, a country eminent only for being the wildest, most barren and frightful of any that I have passed over in England, or even in Wales itself; the west side, which borders on Cumberland, is indeed bounded by a chain of almost unpassable mountains, which, in the language of the country, are called fells. '

In the third quarter of the eighteenth century, travellers began to popularize the wild and terrifying scenery. Dr John Brown's letter to Lord Lyttelton, 'describing the Vale and Lake of Keswick', is clearly influenced by classical scenes and romantic sensibilities. The rocks and cliffs are:

' … of stupendous height, hanging broken over the lake in horrible grandeur, some of them a thousand feet high, the woods climbing up their steep and shaggy sides, where mortal foot never yet approached. On these dreadful heights the eagles build their nests; a variety of waterfalls are seen pouring from their summits, and tumbling in vast sheets from rock to rock in rude and terrible magnificence: while on all sides of this immense amphitheatre the lofty mountains rise round, piercing the clouds in shapes as spiry and fantastic … '

And to underline the correlation with the classical landscape tradition of seventeenth-century Rome, Brown added that:

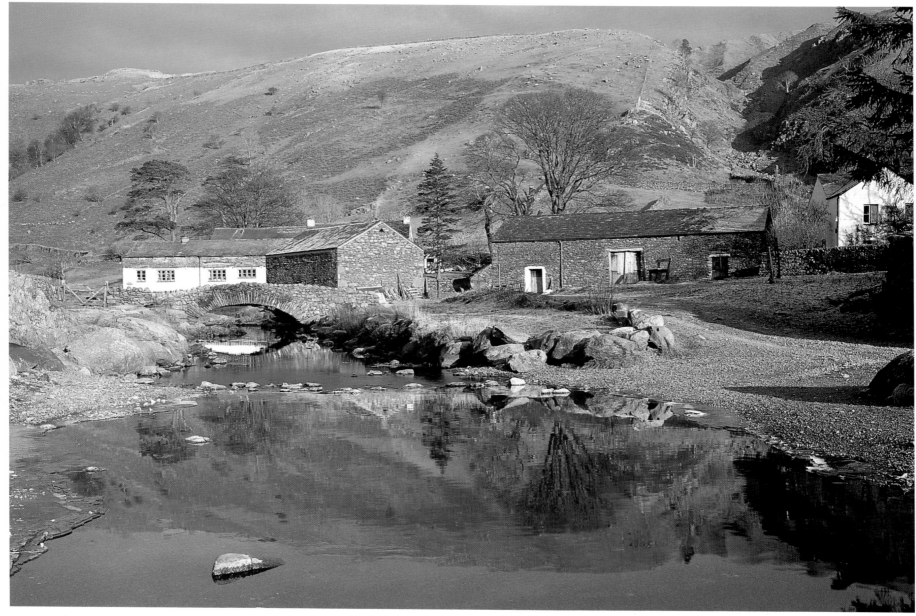

Watendlath

Remotely isolated in a hidden valley, high above Borrowdale, the hamlet of Watendlath consists of a small cluster of slate cottages and farm buildings mainly dating from the late seventeenth and eighteenth centuries. A plaque on Fold Head Farm, once called John Green House Farm, says that it was the 'home of Judith Paris', the fictional heroine of Walpole's second *Herries Chronicle*. Although the house stands on a site that may have been used by the Norse settlers who gave the hamlet its name, the oldest parts are no earlier than late sixteenth century. Walpole called it 'a queer little place indeed, crouched into the soil as though it feared a blow'.

' … the full perfection of Keswick, consists of three circumstances, beauty, horror, and immensity united … to give you a complete idea of these three perfections, as they are joined in Keswick, would require the united powers of Claude [Lorrain], Salvator [Rosa], and [Gaspard] Poussin. '

The beauty, horror and immensity of the region were further promoted by Dr John Dalton in his descriptive poem 'Enumerating the Beauties of the Lake of Keswick'. Thomas Gray (1716–71), author of the *Elegy*, visited the Lakes in 1769. His *Journal*, taking the form of a series of letters to Dr Wharton (who had been prevented from accompanying the poet through illness) was first published in 1775. Venturing into Borrowdale from Keswick, he was terrified that the 'immense mass of rock' overhanging the road would tumble down on him:

' The road on both sides is strewed with piles of the fragments strangely thrown across each other, and of a dreadful bulk; the place reminds me of those passes in the Alps, where the guides tell you to move on with speed, and say nothing, lest the agitation of the air should

loosen the snows above, and bring down a mass that would overwhelm a caravan. I took their counsel here and hastened on in silence. '

Nevertheless, as the steep, wooded fellsides closed in around him, Gray decided not to go any further than the tiny hamlet of Grange, convinced that 'all farther access is here barred to prying mortals'.

The first to produce a Lakeland guide book was Father Thomas West, whose *A Guide to the Lakes* was published in 1778. The revised and greatly enlarged second edition of 1780 also had the bonus of an 'addenda' containing Brown's description of the 'Vale and Lake of Keswick', an extract from Dalton's poem 'Enumerating the Beauties of the Lake of Keswick', and Gray's *Journal*. In his introduction to 'the curious of all ranks', West wrote:

' The design of the following sheets, is to encourage the taste of visiting the lakes, by furnishing the traveller with a Guide; and for that purpose, the writer has here collected and laid before him, all the select stations and points of view, noticed by those authors who have last made the tour of the lakes, verified by his own repeated observations. He has also added remarks on the principal objects as they appear viewed from different stations; and such other incidental information as he judged would greatly facilitate and heighten the pleasure of the tour. '

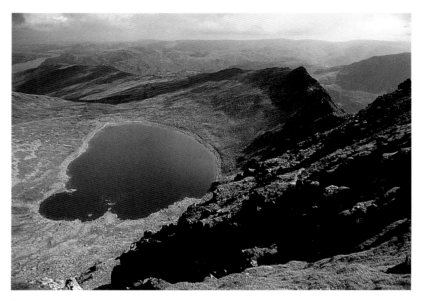

Red Tarn & Striding Edge, from Helvellyn

On the summit of Helvellyn, near the start of the steep and dramatic descent to Striding Edge, stands a monument to Charles Gough and his faithful dog, erected in 1890 by Canon Hardwicke Rawnsley and Miss Frances Power Cobbe. Part of it reads: 'Beneath this spot were found in 1805 the remains of Charles Gough, killed by a fall from the rocks. His dog was still guarding the skeleton.' The tragic incident was immortalized in poetry by both Wordsworth and Scott, the latter opening with the celebrated line: 'I climb'd the dark brow of the mighty Helvellyn.' Red Tarn, lying at an altitude of over 2,350 feet, was once dammed to supply water to the lead mines of Glenridding. Dixon's Cross, on Striding Edge, commemorates a huntsman's fatal fall from the ridge in 1858.

In terms of introducing the concept of the 'picturesque' to the general public, however, the most influential books of the time were by the Reverend William Gilpin: *Observations on the River Wye, and Several Parts of South*

Wales, &c. relative chiefly to Picturesque Beauty, made in the Summer of the Year 1770 (1782); *Observations, relative chiefly to Picturesque Beauty, made in the year 1772, on several parts of England; particularly the Mountains, and Lakes of Cumberland and Westmorland* (1786); and *Three Essays on Picturesque Beauty; on Picturesque Travel; and on Sketching Landscape* (1792).

Following the publication of books like Gilpin's and West's (the former explaining how to see, the latter what to visit), it became fashionable for the wealthy to tour Lakeland in horse-drawn carriages or on horseback – especially since travel in Europe was made difficult by the French revolutionary wars of 1793–1802, and the Napoleonic wars of 1803–15. These early tourists, or 'Lakers' as they came to be known, were obsessed with a passion for lakes, peaks, echoes (artificially produced by cannons) and vapours (the Romantic name for mists and clouds). In their guides, both West and Gilpin advised 'Lakers' to locate the best viewing spots or 'stations', which, preferably, were to be admired

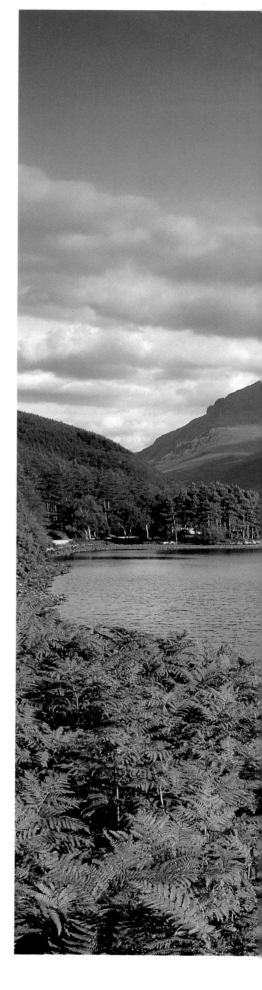

through a Claude-glass – a small 'plano-convex mirror', plain or tinted, which framed and simplified the landscape, thereby reducing it to a manageable and less terrifying size. Although the glass helped artists find 'picturesque' scenes, it was also used to view the landscape as a work of art in itself.

After recommending the use of a telescope 'for viewing the fronts and summits of inaccessible rocks, and the distant country, from the tops of the high mountains', West suggested that:

❝ The landscape mirror will also furnish much amusement … Where the objects are great and near, it removes them to a due distance, and shows them in the soft colours of nature, and in the most regular perspective the eye can perceive, or science demonstrate. The mirror is of the greatest use in sunshine; and the person using it ought always to turn his back to the object that he views. It should be suspended by the upper part of the case, and the landscape will then be seen in the glass, by holding it a little to the right or left (as the position of the parts to be viewed require) and the face screened from the sun. A glass of four inches or four inches and a half diameter is a proper size. ❞

Ennerdale & Pillar, from Bowness

The fells on the southern side of Ennerdale – one of the remotest and least-visited valleys in Lakeland – culminate in the rugged mass of Pillar (2,927 feet). While visiting the valley in 1799, Wordsworth heard the story of a shepherd who had fallen asleep on the top of Pillar and plunged to his death, leaving his staff midway on the rock. Inspired, he wrote about the incident in a poem entitled 'The Brothers'. Leonard, the elder by eighteen months, returned after a twelve-year absence to find his brother dead. The priest pointed to the place where he died: 'You see yon precipice; it wears the shape / Of a vast building made of many crags; / And in the midst is one particular rock / That rises like a column from the vale, / Whence by our shepherds it is called THE PILLAR.'

The 'picturesque', popularized by Gilpin, meant, quite literally, that the landscape was viewed as if it were a picture. The intention was to stimulate the imagination to admiration or reverie. It also gave travellers a reason to travel. For those who went in search of the 'picturesque', Gilpin tried to define its qualities: 'Roughness forms the most essential point of difference between the beautiful, and the picturesque; as it seems to be that particular quality, which makes objects chiefly pleasing in painting.'

Although he set out precise rules for looking at the landscape in terms of the 'picturesque', Gilpin also admitted that they very often did not conform with nature: 'I am so attached to my picturesque rules, that if nature goes wrong I cannot help putting her right.' Instead of looking at the true character of a landscape (and taking account of the real life of those who lived in it), his sole concern was with its visual aspect. For him, a genuine ruin (not one fabricated in the mock-Gothic fashion of the time) was much preferred to an occupied building.

❝ A piece of Palladian architecture may be elegant in the last degree. The proportion of its parts – the propriety of its ornaments – and the symmetry of the whole may be highly pleasing. But if we introduce it in a picture, it immediately becomes a formal object, and ceases to please. Should we wish to give it picturesque beauty, we must use the mallet, instead of the chisel: we must beat down one half of it, deface the other, and throw the mutilated members around in heaps. In short, from a smooth building we must turn it into a rough ruin. ❞

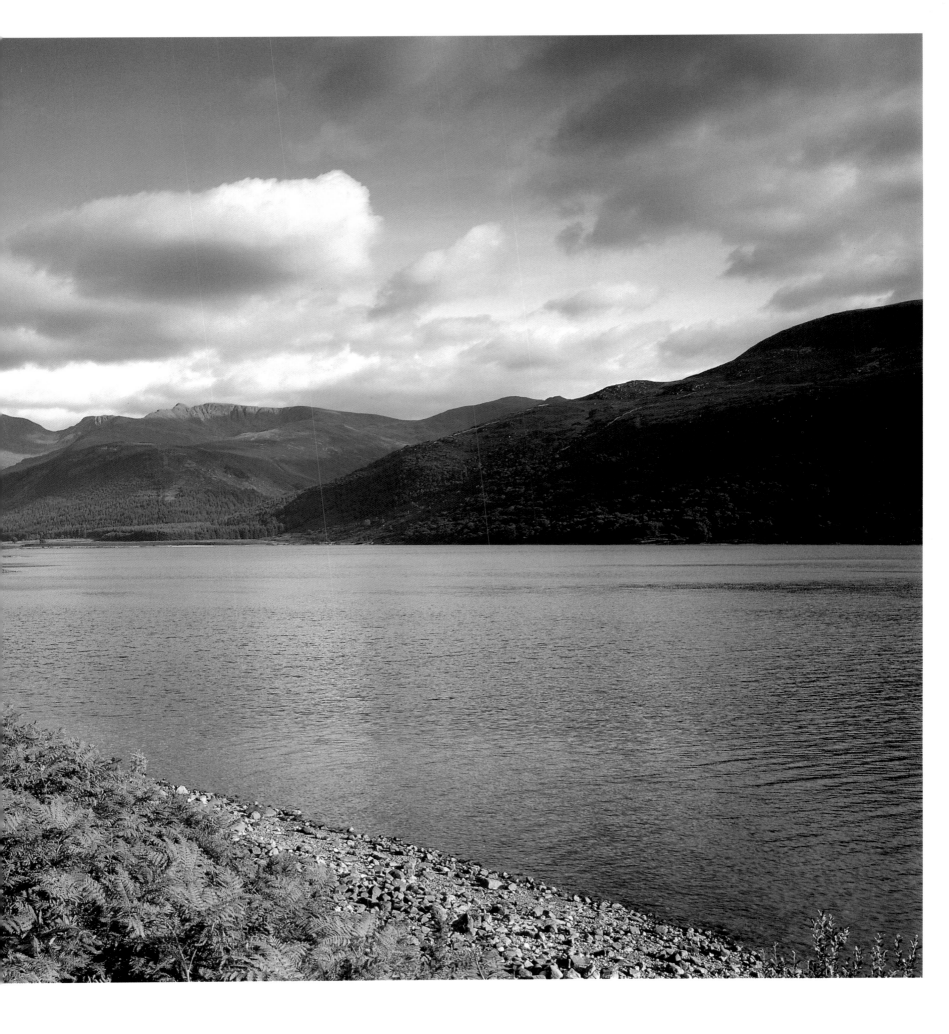

Dove Cottage, Grasmere

From December 1799 until May 1813 (when he moved to Rydal), Wordsworth lived at Grasmere; first at Dove Cottage, then at Allan Bank, and finally at the Old Rectory. Dove Cottage, standing at the foot of the 'little nook of mountain ground' which rises steeply behind it, was the Wordsworths' home for some eight years, until it became too small for the growing family. Today, the property is owned by the Wordsworth Trust, who have kept it much as it was during the poet's residency.

The cult of the 'picturesque' as a social acquirement was satirized by Jane Austen in *Northanger Abbey* (1818):

> He talked of foregrounds, distances and second distances; side screens and perspectives; lights and shades; and Catherine was so hopeful a scholar, that when they gained the top of Beechen Cliff, she voluntarily rejected the whole city of Bath, as unworthy to make part of a landscape.

If Gilpin's 'picturesque' writings reduced the scenery to the size of a sketch pad for the privileged few, West's *Guide* opened up the Lakeland landscape to members of a crowd. Indeed, the year 1778, the date of its first publication, can be said to mark the beginning of the mass popularity of the Lakes among tourists and, indeed, holiday-makers. Nevertheless,

Upper Eskdale, from Border End

Among the swelling, mountainous sea of high fells that dominate Upper Eskdale are the Scafell Pikes, Esk Pike and Bowfell, all attaining over 2,900 feet. It was down from the crowning height of Scafell Pike (3,210 feet) that Coleridge made his perilous descent into Upper Eskdale in August 1802. So violent were his exertions that 'great red heat-bumps' appeared across the whole of his breast, from neck to navel. After being forced to seek an 'imperfect Shelter from a Thunder-shower' at the 'Toes of Sca' Fell' (the 'Head of Eskdale'), he wrote: 'such Echoes! Oh God! what thoughts were mine! O how I wished for Health & Strength that I might wander about for a Month together, in the stormiest month of the year, among these Places, so lonely & savage & full of sounds!'

despite the improvement of roads into the region, it was not until the arrival of the railway in the mid-nineteenth century that working- and lower-middle-class day-trippers invaded Lakeland en masse.

In November 1799 Wordsworth, accompanied by Samuel Taylor Coleridge and others, went on what was jokingly called a 'Pikteresk Toor' of the Lakes, and by the end of the year he and his sister, Dorothy, had moved into Dove Cottage at Town End, Grasmere. It was to be Wordsworth's home for eight of the happiest and most productive years of his life. Here, in 1802, he brought his new wife, Mary Hutchinson, and here their three eldest children were born. Although Gilpin's writings on the 'picturesque' had a lasting effect on Wordsworth, in 'The Brothers' (one of the first poems he composed after moving to Dove Cottage) the poet highlighted the triviality of the concept (as compared to the reality of 'Man, Nature and Human Life'), and especially the idleness it encouraged. Sitting on a stone seat beneath the eaves of his cottage, the priest of Ennerdale says to his wife:

> These Tourists, Heaven preserve us! needs must live
>
> A profitable life: some glance along,
>
> Rapid and gay, as if the earth were air,
>
> And they were butterflies to wheel about
>
> Long as their summer lasted: some, as wise,
>
> Perched on the forehead of a jutting crag,
>
> Pencil in hand and book upon the knee,
>
> Will look and scribble, scribble on and look,
>
> Until a man might travel twelve stout miles,
>
> Or reap an acre of his neighbour's corn.

Through his poetry, Wordsworth broke down the notion of Gilpin's picture frame, seeing the landscape not by means of some mechanical device or from some predetermined 'station', but freshly, inwardly, through

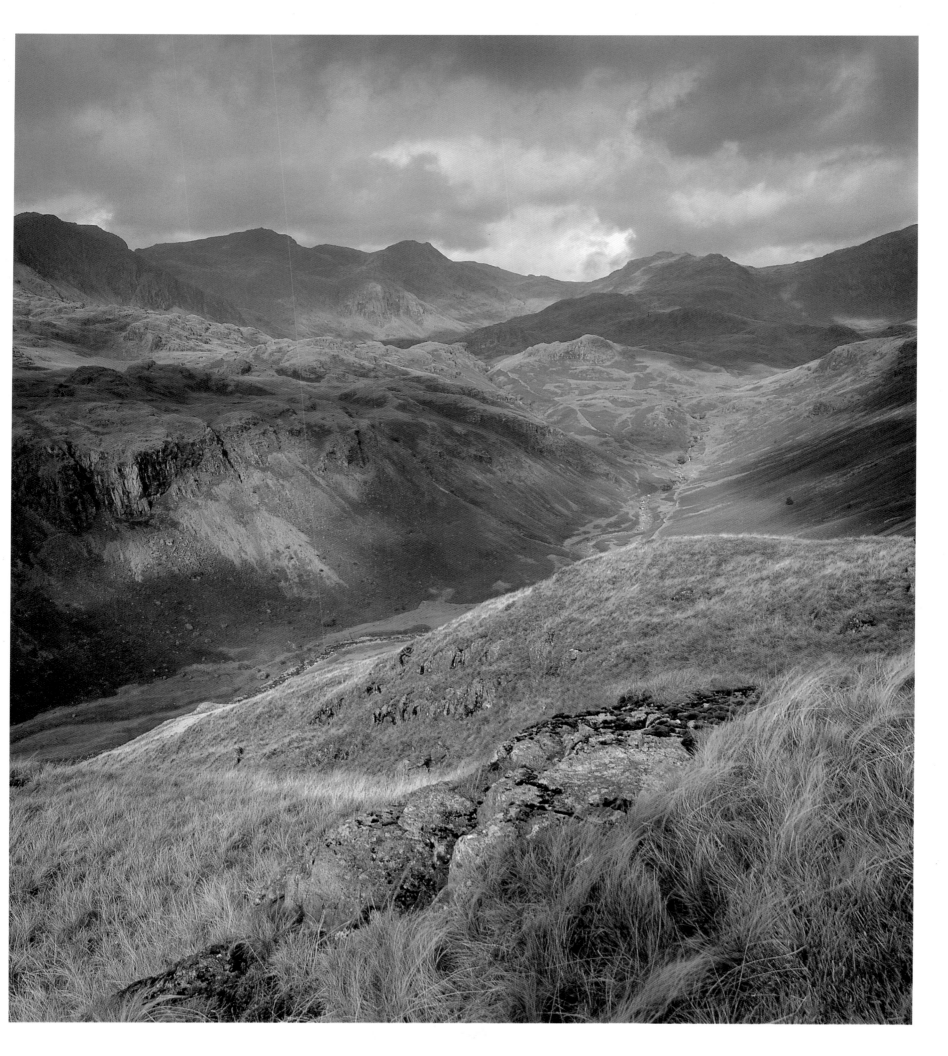

no one's eyes but his own. Not only did he write about what he saw, he also expressed what he felt and experienced with a passion so intense that he revolutionized people's perception of the Lakes.

While they were at Dove Cottage the Wordsworths attracted some of the great literary figures of the time to the Lakes to visit or to live. These included Robert Southey and Samuel Taylor Coleridge, who, with Wordsworth, came to be known as the Lake Poets. (Sometimes Thomas De Quincey, who took over the tenancy of Dove Cottage after the Wordsworths left, is included among them.) Wordsworth's *Guide to the Lakes*, first published in 1810 (which proved to be more popular than his poems), did much to encourage tourists to the region. In a letter to Lady Beaumont, dated 10 May 1821, he explained that his *Guide* was intended: 'to give a model of the manner in which topographical descriptions ought to be executed, in order to their being either useful or intelligible, by evolving truly and distinctly one appearance from another.' In the fifth edition of 1835, entitled *A Guide through the District of the Lakes in the North of England*, Wordsworth wrote under 'Directions and Information for the Tourist':

Wastwater Screes

Along the eastern side of Wastwater (which is used as a reservoir by British Nuclear Fuels) are the renowned Wastwater Screes, rising almost 2,000 feet from the bottom of the lake to the rugged crags of Illgill Head (1,983 feet). Coleridge described the Screes or 'Shiver' in August 1802: 'consisting of fine red Streaks running in broad Stripes thro' a stone colour – slanting off from the Perpendicular, as steep as the meal newly ground from the Miller's spout ... like a pointed Decanter in shape, or an outspread Fan, or a long-waisted old maid with a fine prim Apron.' The reddish streaks in the screes are caused by iron in the rocks. This ore was used to produce ruddle, a red ochre used for 'smitting' or marking sheep. It was collected by local boys and sold to the farmers.

❛ In preparing this Manual, it was the Author's principal wish to furnish a Guide or Companion for the Minds of Persons of taste, and feeling for Landscape, who might be inclined to explore the District of the Lakes with that degree of attention to which its beauty may fairly lay claim. ❜

In his *Guide to the Lakes* Wordsworth described an excursion from Borrowdale to the top of Scafell Pike.

❛ On the summit of the Pike, which we gained after much toil, though without difficulty, there was not a breath of air to stir even the papers containing our refreshment, as they lay spread out upon a rock. The stillness seemed to be not of this world – we paused, and kept silence to listen; and no sound could be heard: the Scawfell Cataracts were voiceless to us; and there was not an insect to hum in the air. The vales which we had seen from Ash-course [Esk Hause] lay yet in view; and, side by side with Eskdale, we now saw the sister Vale of Donnerdale terminated by the Duddon Sands. But the majesty of the mountains below, and close to us, is not to be conceived. We now beheld the whole mass of Great Gavel [Great Gable] from its base, – the Den of Wastdale at our feet – a gulph immeasurable: Grasmere and the other mountains of Crummock – Ennerdale and its mountains; and the sea beyond! ❜

In complete contrast, when Rob and I clambered up Scafell Pike to celebrate the final day of photography for *The English Lakes*, the boulder-strewn summit was awash with

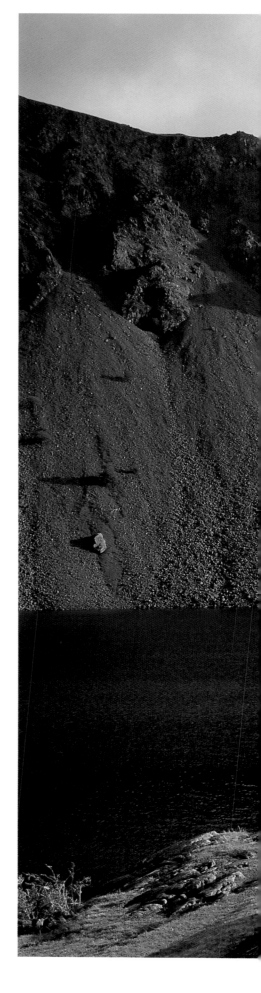

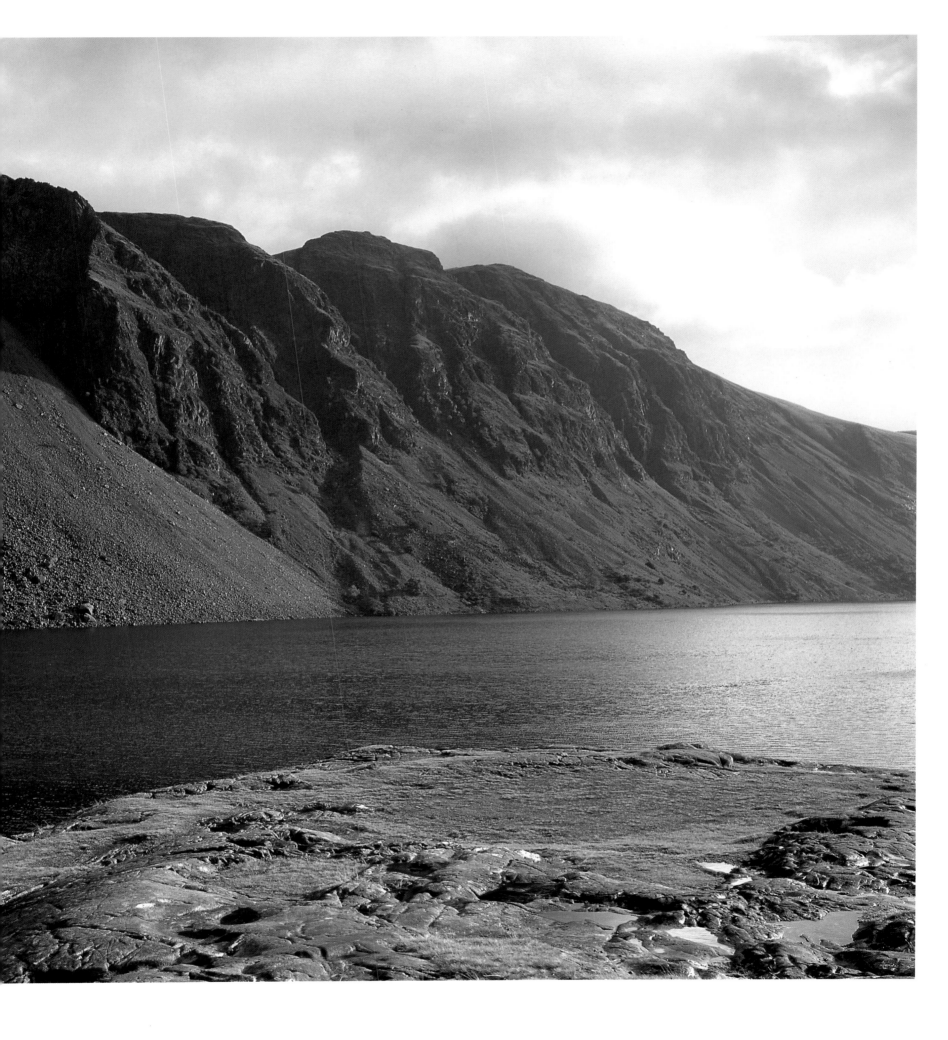

people. The commotion seemed to be not of this world – we paused, and kept silence to listen; and no silence could be heard. Instead of Claude-glasses everyone had cameras, but rather than focusing on the mountain views, they were all pointed at the massive circular stone cairn, on the top of which all and sundry wanted to pose as if they had just scaled Everest.

Coleridge, too, climbed to the top of Scafell on his solitary tour of the western Lakes, during the summer of 1802. In a letter to Sara Hutchinson, dated 6 August, he described his perilous and foolhardy descent into Eskdale (the route down is thought to have been by way of Broad Stand and the Mickledore Gap):

There is one sort of Gambling, to which I am much addicted … It is this. When I find it convenient to descend from a mountain, I am too confident and too indolent to look round about and wind about 'till I find a track or other symptom of safety; but I wander on, and where it is first possible to descend, there I go – relying upon fortune for how far down this possibility will continue. So it was yesterday afternoon … the first place I came to, that was not direct Rock, I slipped down, and went on for a while with tolerable ease – but now I came (it was midway down) to a smooth perpendicular Rock about 7 feet high – this was nothing – I put my hands on the Ledge and dropped down. In a few yards came just such another. I dropped that too. And yet another, seemed not higher – I would not stand for a trifle, so I dropped that too. But the stretching of the muscle of my hands and arms, and the jolt of the Fall on my Feet, put my whole Limbs in a Tremble, and I paused, and looking down, saw that I had little else to encounter but a succession of these little Precipices – it was in truth a Path that in a very hard Rain is, no doubt, the channel of a most splendid Waterfall. So I began to suspect that I ought not to go on; but then unfortunately tho' I could with ease drop down a smooth Rock 7 feet high, I could not climb it. So go on I must, and on I went …

Coleridge's descent of the eastern face of Scafell Pike anticipated by some eighty years the pioneering efforts of English rock climbers: men like Walter Parry Haskett Smith (the 'father of British rock climbing'), the Abraham brothers (Ashley Perry and George Dixon), John Wilson Robinson and Owen Glynne Jones, who among others made Wasdale Head the centre of the new sport. Perhaps, the most surprising climber to be found amid their ranks was Aleister Crowley, magician, Satanist, drug addict and self-styled 'Beast 666', who made a new route up Napes Needle in 1893. In his *Confessions*, Crowley revealed his loathing for Jones after climbing with him only once (the mountain was Great Gable). Accusing his fellow climber of being 'absolutely unsportsmanlike' and of endangering the party through 'personal vanity', Crowley added insult to injury by asserting that Jones's reputation was 'founded principally on climbs which he did not make at all, in the proper sense of the word. He used to go out with a couple of photographers and have himself lowered up and down a climb repeatedly until he had learnt its peculiarities, and then make the "first ascent" before a crowd of admirers'.

Today, the challenge of ascents like Pillar and Napes Needle attracts thousands of rock climbers to the region. For some, though, it is not enough to climb the peaks of Lakeland, they have to run up them. The record for the standard Bob Graham Round of forty-two peaks, covering a total distance of sixty-two miles and 26,000 feet of ascent and descent is currently held by Billy Bland, who ran the distance in thirteen hours, fifty-four minutes. In 1975 Jos Naylor, a sheep farmer from Wasdale, set an awesome record by climbing seventy-two Lakeland peaks in less than twenty-four hours. Incredibly, in 1988, this record was broken by a Cheshire

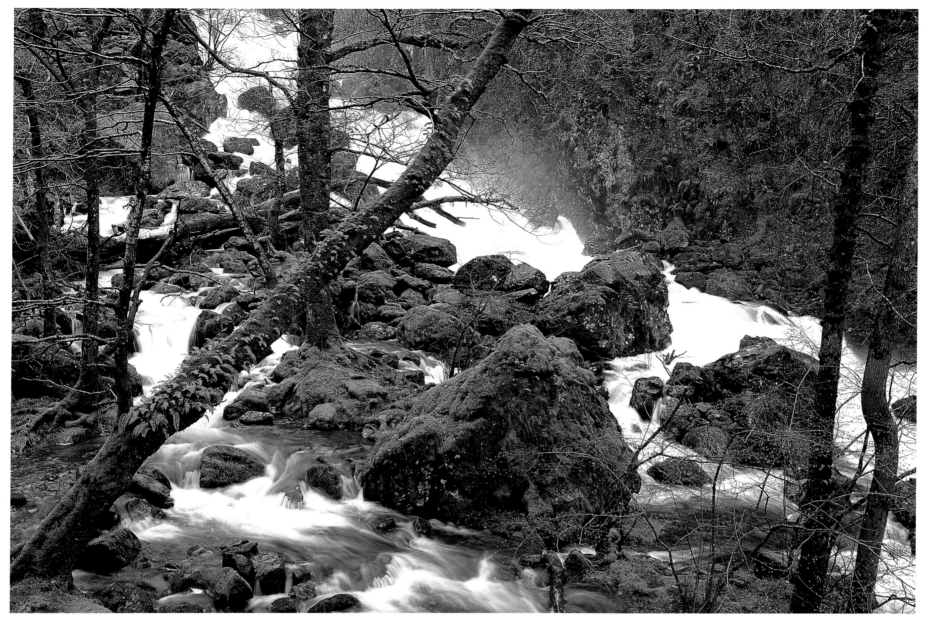

Lodore Falls

Situated behind the Lodore Hotel at the southern end of Derwentwater is one of Lakeland's most popular waterfalls. Dropping down a wooded ravine in a multitude of small cascades, it culminates in a forty-foot cataract split by huge boulders. Robert Southey wrote a famous poem about the fall in 1822, and a less-famous letter to his brother in 1809: 'Why it comes thundering and floundering, and thumping and plumping … with a dreadful uproar – and that way the water comes down Lodore.' Nevertheless, it is only after a heavy storm that the waterfall approaches anything like Southey's description. In dry weather it shrivels to almost a trickle.

computer programmer, Mark McDermott, who added a further four summits to Naylor's total, achieving an astonishing seventy-six summits within the time limit.

The arrival of the Kendal and Windermere railway in 1846–7 (to which Wordsworth and others vehemently objected) not only brought profound changes and vastly increased numbers of visitors to Lakeland, it also coincided with the invention of photography. In 1839, quite independently of each other, the Englishman, William Henry Fox Talbot, and the Frenchman, Louis Jacques Mandé Daguerre, revealed two different photographic processes for permanently fixing images. Within a few years, what Fox Talbot called 'the art of fixing a shadow' or 'photogenic drawings', had arrived in Lakeland; the first known photograph being that of a customs officer taken in 1852. Generally regarded as mysterious or magical, the optical-mechanical-chemical process produced what was often described as an image 'painted by Nature herself'.

Right from the outset, photography was deemed both an aid and a threat to artists. Yet by

documenting and freezing moments in time, it played an important part in reshaping people's perception of the world. For the first time, Lakeland landscapes could be instantaneously documented and, in consequence, travellers became collectors of images. The fact that unlimited and identical copies could be made of a scene inevitably led to the development of the tourist postcard. Before that, however, photographs were influenced by pictures found in books or hung on walls – travel illustration, architectural drawing and portraiture. It was to be many years before the photograph was accepted as a revolutionary new form of creative expression.

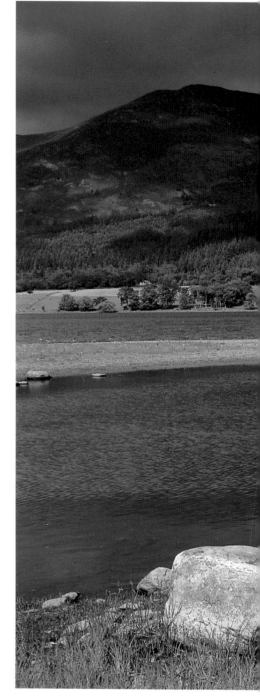

At first, because of the large amount of equipment required to produce and fix an image, photography was primarily studio based. The earliest photographic studios in Lakeland

were established in the 1850s. It was there that those tourists who could afford it posed to have their portraits taken. One enterprising photographer, Joseph Flintoft, decided to attract customers to his studio in Keswick by building a relief model of Lakeland on the scale of three inches to the mile. Taking seven years to research and assemble (without recourse to Ordnance Survey maps of the region), it was so popular that many rival studios constructed similar models.

Gradually, however, photographers ventured out into the landscape with their equipment. For instance, Roger Fenton (1819–69) – founder of The Photographic Society in 1853 (later The Royal Photographic Society) – transported his apparatus, which included a dark room, inside a horse-drawn van. Perhaps the most famous pioneering photographers of Lakeland scenes were the Abraham brothers of Keswick, who not only climbed up the mountainsides, but took with them their bulky photographic apparatus (camera, lenses, tripod and glass-plate negatives in wooden containers). The view over Wasdale Head and Wastwater from the heights of Great Gable is typical of their achievements. Furthermore, unlike modern climbers, they did not have the advantage of specialist clothing and accomplished everything wearing cumbersome outfits and thick heavy boots. After a visit to the Alps in 1898, where they saw picture postcards on sale, the Abraham brothers began to produce their own cards of Lakeland. And with their climbing photographs, taken from the highest peaks in all four seasons, they threw down a challenge that few could match, let alone better.

By the end of the nineteenth century photography had become an industry and an essential part of social life. In addition to producing souvenirs for the flourishing tourist trade, photographers recorded special events or memorable occasions, like the great freeze of 1895 when Windermere became a vast skating rink. Although the people in these early photographs are now no more, their images have been fixed and preserved for all time. The passing experience has been reduced to an instant, turned into a shadow and captured for eternity. From the moment the photographs were taken, the living – transformed into gradations of black and white – became a part of history, their images memorials to familiar and unscary ghosts.

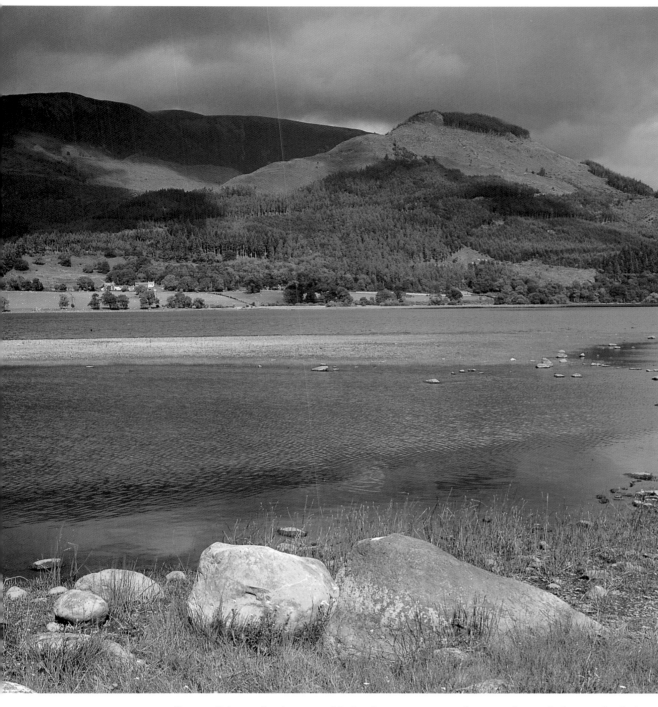

Bassenthwaite Lake, Skiddaw & Dodd

Dominating the eastern side of Bassenthwaite Lake is the isolated bulk of the Skiddaw range, mainly composed of very old and crumbly mudrocks. The lower slopes of Dodd (1,612 feet) were first planted with trees in 1790 by Thomas Storey of Mirehouse. In the 1860s the fell was the home of a Scottish vagrant named George Smith. Known as the 'Skiddaw Hermit' or the 'Dodd Man', he lived in a huge domed structure made of stones, branches, moss and bracken. One writer described it as 'a great big chitty's nest' (chitty being Cumbrian for a wren). Often drunk, he earned a little money by painting portraits or describing people's characters from the bumps on their heads. Most of his food was eaten raw; sugar and tea he mixed together and ate dry.

Some of the early photographic landscapes were made more dramatic by manipulating either the camera or the printed image. For example, tilting the camera to make fellsides appear far steeper, and painting on top of the photograph to exaggerate the height of the mountains or to introduce elements that did not actually exist. But, whatever the subject and whatever the use of artifice, almost all early Lakeland photographs have long ceased to be purely records of a particular moment in historical time. Instead, they have become nostalgic reminders of another, unattainable era; when cars and lorries did not clog the roads, when aircraft did not criss-cross the sky, and electrical wires, television aerials, burglar alarms and satellite dishes did not clutter the roofs and walls of buildings.

Although early photographs were black and white (or monochrome variations of the same), few depicted

Lakeland in bad weather, in poor visibility or in heavy rain. In fact, the sort of weather that is so characteristic of the region. I remember taking my wife to Scale Force, near Buttermere, for the first time and experiencing such an unexpected and heavy deluge of rain that we both thought we had stumbled under the waterfall by mistake.

Rob had an even worse experience. To solve the perpetual problem of reasonably priced accommodation being fully booked (or simply unwilling to accept dogs), he had purchased a camper van. It seemed the ideal solution, especially as his work pattern often involved going out before dawn and getting back well after dusk. On one particular occasion, Rob had booked onto a campsite just outside Keswick, literally right on the banks of Derwentwater. As was so often the case when he wanted to take photographs, the weather turned atrocious. Day after day it grew progressively worse, until one night he could hardly sleep for the incessant pounding of torrential rain on the camper roof. Next morning, he slid open the door of the van to find a scene of utter devastation. The lake had burst its banks and flooded the campsite. Fortunately – despite the pandemonium caused by those desperately trying to rescue their tents and portable belongings – all Rob had to contend with was the camper being entirely surrounded by water.

On the positive side, the more it rained the more spectacular were the waterfalls. From the campsite, Rob noticed that, unusually, Lodore Falls, on the far side of Derwentwater, was clearly visible through the trees. Deciding that it was worth trying to capture in a photograph, he went to investigate. Had he not known where the falls were, all that was necessary for him to do was to follow the sound. Close to, the noise was deafening. So powerful, so overwhelming was it, in fact, that even the rocks seemed to shudder under his feet, while the spray – billowing clouds of mist – coated everything for yards around with fine droplets of water, especially Rob's camera (viewfinder, lenses, filters and all).

One of the landscape (or mountain) photographers that both Rob and I admire for his commonsense approach to the medium is W. A. Poucher (1891–1988), author of almost forty photographic books published in his lifetime, ten of which were specifically about Lakeland. In his first book *Lakeland Through the Lens* (1940) – the 'complete answer' to the conception that taking successful pictures of the mountain landscape was impossible 'owing to its affinity for the moisture-laden atmosphere of the Atlantic' – Poucher recommended the use of portable lightweight equipment, and rejected the idea that owning an expensive camera was the only way to produce good photographs. What was essential, he stressed, was to have a good lens.

In *Lakeland Holiday* (1942) Poucher began his photographic vacation by boarding a train in London. After alighting at Shap station, he intended to 'ramble' into Lakeland by way of Mardale (which was then in the process of being engulfed by the rising waters of the newly-constructed reservoir at Haweswater). The year was 1941 – Britain was at war with Germany and Italy.

‘ The long train seemed to be packed with soldiers, sailors and airmen, either going on or coming from leave … I had noticed that at every station at which the train stopped, we picked up more and more passengers until the corridors were packed … Evidently, like myself, many of them were bound for Lakeland, and a period of respite from the more mundane things of life. ’

For Poucher, Lakeland was 'a very paradise for the photographer'. In *Lakeland Through the Lens* he wrote:

‘ Many visitors to this most beautiful part of Britain carry a camera and frequently take photographs in a haphazard manner, perhaps to record a scene which appeals to them or to pose a friend on some fierce looking

crag which they can subsequently exhibit to their companions' awe and amazement. Whatever be the motive, these pictures are cherished as a reminder of a pleasant holiday and years afterwards will revive happy memories of the scene. '

In 1951, nearly a decade after Poucher had called the region 'Britain's National Park', almost 900 square miles of Lakeland was officially designated as such. The formation of the Lake District National Park marked another shift in people's perception of the Lakeland landscape: a shift which stemmed from objections – by people like Wordsworth, John Ruskin and Canon Hardwicke Rawnsley (one of the founders of the National Trust) – to the commercial and industrial exploitation of the Lakeland environment. In consequence, the landscape became something special, something precious – an area to be conserved, protected and managed. Although the land inside the park remained (and still remains) in private ownership, it was now watched over by a ruling body, whose aim was to preserve and enhance the natural beauty of the area and promote its enjoyment by the public. In spite of its statutory duties, however, the Lake District Planning Board (charged with protecting the area for both farmers and visitors) found itself with limited powers. Especially when it came to stopping unsightly developments like the construction, in the 1970s, of the Keswick bypass and the dual carriageway along the shore of Bassenthwaite Lake; or preventing low-flying military jets from disturbing the calm and tranquillity of the countryside.

Rob's dog, George, in Martindale.

Unfortunately, no power on earth was able to prevent deadly radioactive fallout contaminating the region in 1986, after the Chernobyl nuclear reactor exploded 2,000 miles away in the Soviet Union – an accident that threatened the livelihood of hundreds of Cumbrian sheep farmers and contaminated the land for many years after. It is estimated that the total radioactivity released from the reactor was twenty times greater than that of the Hiroshima and Nagasaki atomic bombs combined. More perturbing (especially with the Sellafield nuclear complex on the Cumbrian coast), is the discovery that some of the radiation on the county's hills was there long before the Chernobyl disaster.

Lakeland is a favourite haunt for a rich variety of birds, especially eagles, and many of the early travellers such as Dr John Brown mention the presence of eagles in Lakeland. Today, the eagle, like all other birds of prey in Britain, is protected by law. Yet these powerful and magnificent birds are still in danger. Nests have to be guarded to stop the eggs and young from being stolen, while the adults have been poisoned: accidentally by pesticides and other pollutants accumulated in the bodies of their prey (in less severe cases this can lead to infertility); or deliberately and illegally by ruthless landowners, shepherds and gamekeepers.

Probably a greater threat than egg collectors and gamekeepers are ordinary walkers, rock climbers, bird-

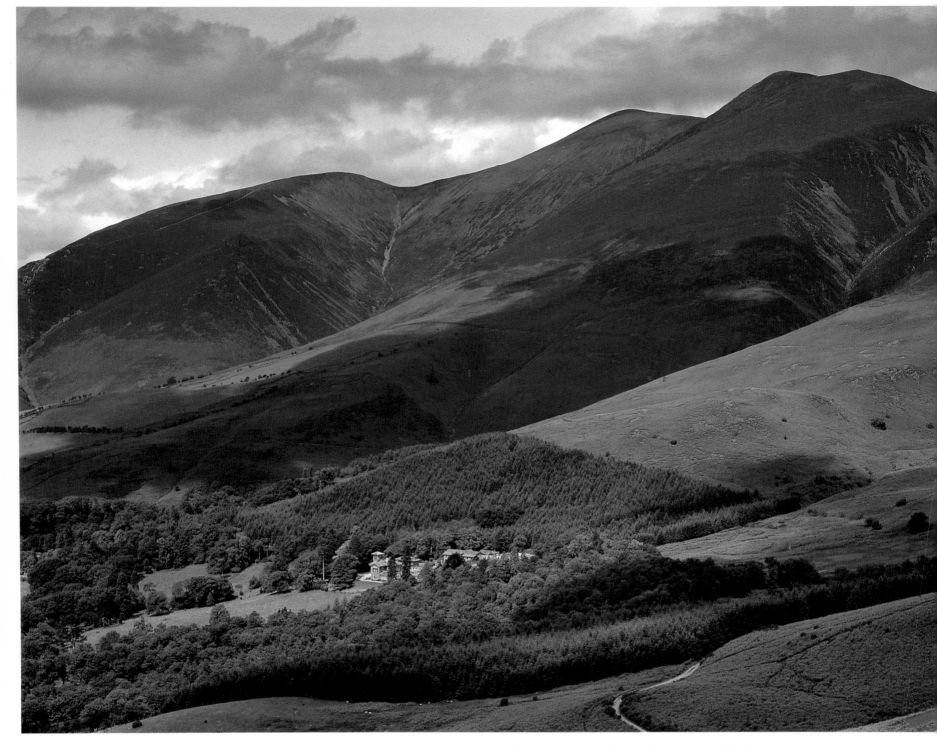

watchers and bird-photographers. In 1987, perhaps unfairly, the Royal Society for the Protection of Birds was accused of being indirectly responsible for the death of the only golden eagle to hatch in Lakeland that year. In an attempt to keep the sightseers away, the society had built a hide from where the birds could be seen without being disturbed. It seems that the presence of people in the eagle's hunting area drove the rabbits underground and, as a result, the birds were unable to find enough food to feed their offspring. Yet the birds can fly great distances in search of food.

From the eighteenth century, when the environment was considered hostile, terrifying and unruly, people's perceptions of the Lakeland landscape have changed according to the events, discoveries and fashions of the time: Gray found the mountains 'pregnant with religion and poetry'; West, sensing God's power in the rocks,

Skiddaw, from Latrigg

Although the summit of the Skiddaw range is treeless, patches of forest occur along the lower slopes of the south-western side, notably on Dodd and around the Underscar Manor Hotel (shown in the photograph). Forests of natural broadleaved trees once reached up to 2,000 feet above sea-level, almost to the top of the high fells. However, by the end of the sixteenth century, the demand for charcoal and timber had almost totally denuded the region of woodland. Centuries of close grazing, mainly by sheep, prevented its natural regeneration. Some eighteenth- and nineteenth-century landowners planted fast growing conifers for timber. But it was not until 1919, when the Forestry Commission was formed, that selected areas of Lakeland began to be afforested on a large scale.

regarded them as 'sublime and beautiful objects' leading to 'both rapture and reverence'. Gilpin viewed everything according to his rules of 'picturesque beauty'; Wordsworth saw nature as the great teacher and the 'soul of all my moral being'; Fox Talbot, with his 'sun pictures', considered that even the most transitory of scenes could 'be fixed for ever in the position which it seemed only destined for a single instant to occupy'; and rock climbers like the Abraham brothers looked on the peaks and crags as a physical challenge. Poucher, in essence, regarded the mountains as a potential collection of photographs; while Alfred Wainwright viewed them as a series of practical walking routes. Incidentally, both Poucher and Wainwright had their ashes scattered on the Lakeland fells in accordance with their individual wishes.

Obviously, a person's perception of the environment varies according to their relationship with it. The priorities of the hill farmer, for instance, whose livelihood depends on the land, will always be different to those of the visitor – be they day-trippers, rock climbers, fell walkers, geologists, botanists or boating enthusiasts. The one thing that many have in common is that, deliberately or otherwise, they interpret the landscape as pieces of reality, selective fragments of a larger whole. It is a sad reflection of the times that the attitude which seems to predominate among visitors today is 'seen it, done it, and here's a photograph or video to prove it'.

The 'father of Cumbrian painting' is generally considered to be Matthias Read (1669–1747), a Londoner who took up permanent residence at Whitehaven in about 1690. Among his admirers, and indeed pupils, were the father and grandfather of the Reverend William Gilpin. Many of Read's landscapes, which predated the cult of the 'picturesque', were painted from an elevated viewpoint. 'In these bird's eye landscapes,' wrote Mary E Burkett and David Sloss in *Read's Point of View*, 'there is a sense of detachment and natural tranquillity which is often lost in the romantic and picturesque, where "Nature" was elevated to an academic cult.'

Like Read, many famous and lesser-known artists have drawn inspiration from the Lakeland landscape. But it was not until 1977, when Richard Harris became the first sculptor-in-residence at the forest environment of Grizedale, east of Coniston Water, that the individual artist's response to the Lakeland environment shifted significantly from a visual record or impression to a living experience. Although many of the sculptures in the forest are clearly recognizable as such, others tantalizingly blur the distinction between art and nature, thereby heightening our appreciation of the environment in which they are set. Richard Long may not have worked at Grizedale, but the sentiments he has expressed about his own sculptures echo those of many artists whose work can be found in the growing-decaying forest: 'These works are made of the place, they are a rearrangement of it and in time will be absorbed by it. I hope to make work for the land not against it.'

Today, 'site-specific sculptures' are not restricted to Grizedale. They can be chanced upon throughout the

Lakeland landscape. Standing on the shores of Derwentwater, for example, is the 'Hundred Year Stone' created by Peter Randall-Page in 1995 to commemorate the centenary year of the National Trust. Intended to be a symbolic bridge between past and future, it was also the first permanent contemporary stone sculpture to be sited in the Lake District National Park.

More significantly, between 1996 and the year 2000, 100 sheepfold, washfold and pinfold sites throughout Cumbria will be turned into sculptural works by Andy Goldsworthy. Rebuilt or restored by a traditional waller, each fold will incorporate an original artwork. In a *Daily Telegraph* article by John Whitley, dated 8 June 1996, Goldsworthy explained:

' I can decide to lift a wall, turn it, do something with it, change it in a way that alters the perception and reveals something that is inherent within it. My work is really saying something about time and change and

these walls have been built in layers over time, piece by piece just as the landscape itself has been built in layers. It's that layering quality, building a new wall on an old wall, putting my work on old work, that connects it to the past and makes time part of the piece. '

In addition to first likening the topographical layout of Lakeland to an imaginary wheel, with the spokes – represented by the valleys – radiating out from the central hub of Scafell and Great Gable (in fact, Helvellyn forms a second hub), Wordsworth must also lay claim to being one of the earliest conservationists. Unable to ignore the effect the influx of tourists was having on the Lakeland environment, he appealed in his *Guide*, 'that they deem the district a sort of national property, in which every man has a right and interest who has an eye to perceive and a heart to enjoy'.

Although this book does not ignore conservation and environmental issues – issues which are of increasing relevance in Britain and the world today – it is essentially a photographic celebration of the diverse and often breathtaking landscape still to be found within Lakeland. In taking the photographs, Rob has travelled the length and breadth of the region, exploring, in all weathers and in all seasons, not only the popular locations but also those less well-known. He has avoided the hordes of tourists by visiting places out of the holiday season, or early in the morning, or when the habitual call of mealtimes has lured hungry and thirsty visitors back to hostelries and restaurants in town and village. The photographs, assembled for this book are by no means definitive. But they do capture and convey something of the mood, beauty, essence and uniqueness of the Lakeland landscape.

Wordsworth, writing in the early nineteenth century, summed up much that is still true of Lakeland today: 'I do not know any tract of country in which, within so narrow a compass, may be found an equal variety in the influences of light and shadow upon the sublime or beautiful features of the landscape.' Despite the intervening years, and the increasing pressures of industry and tourism, the region has not been ruined. The landscape and our perceptions of it have changed, certainly. But change is part of the natural order of things. Nothing is simply dead or static. Everything that exists is undergoing constant transformation or modification (even if the development occurs over long periods of time). Lakeland is no exception. Like every other place on earth, it is inextricably bound up with the relentless, ongoing process of change.

Yet, as Rob's photographs testify, there is much in this rich and varied landscape that is worth cherishing. If – and, admittedly, it is an enormous if – a sensible balance can be found between the needs of the residents and the demands of the visitors, the exploitation of the resources and the conservation of the environment (bearing in mind the necessity for some form of land-management) – and, instead of relying on the action, or non-action, of authorities, governments and industry, each individual could treat the landscape with respect, leaving all as it was found – the continued existence of this small, yet spectacularly varied region will be assured for generations to come.

Lakeland Landscapes: 'A Tour of Pleasure'

After being invited to accompany her uncle and aunt 'in a tour of pleasure' to the Lakes, Elizabeth Bennet accepted most readily and gratefully:

'My dear, dear aunt,' she rapturously cried, 'what delight! what felicity! You give me fresh life and vigour. Adieu to disappointment and spleen. What are men to rocks and mountains? Oh! what hours of transport we shall spend! And when we do return, it shall not be like other travellers, without being able to give one accurate idea of anything. We will know where we have gone – we will recollect what we have seen. Lakes, mountains, and rivers, shall not be jumbled together in our imaginations; nor, when we attempt to describe any particular scene, will we begin quarrelling about its relative situation. Let our first effusions be less insupportable than those of the generality of travellers.'

Pride and Prejudice
JANE AUSTEN

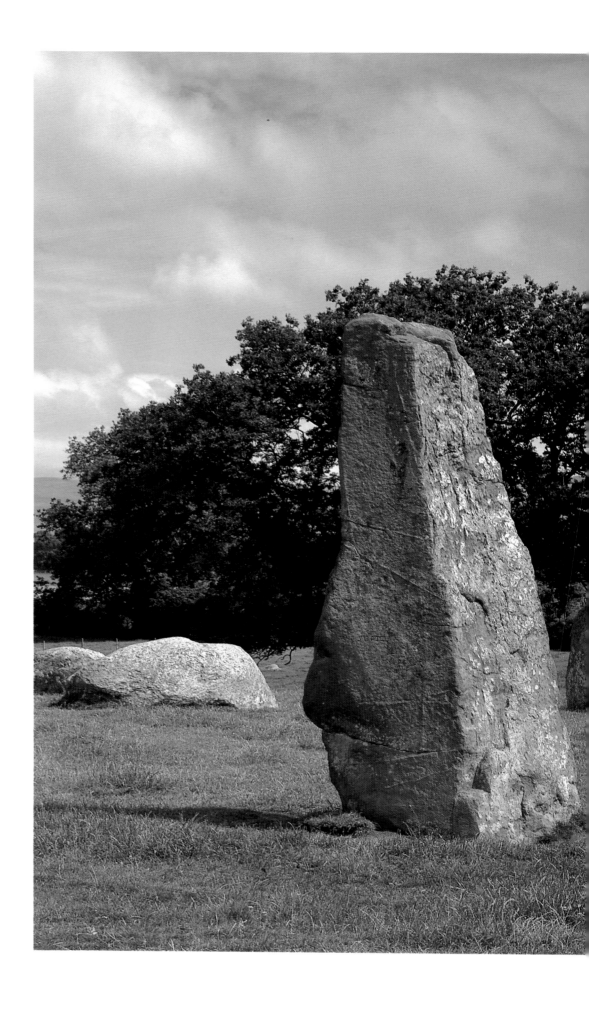

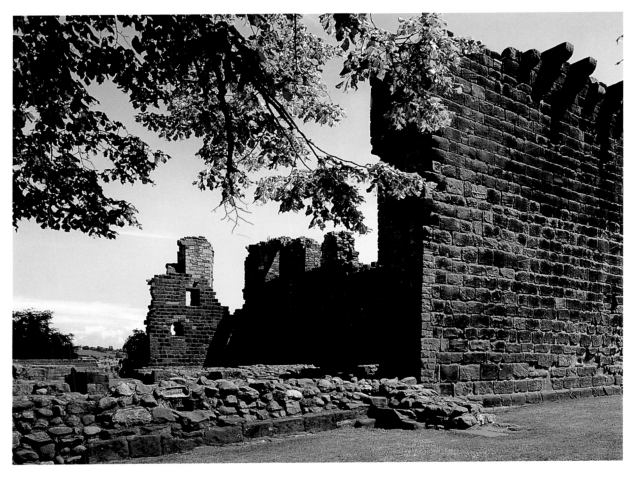

Long Meg, near Little Salkeld

Occupying a sloping sandstone terrace above the River Eden, Long Meg (a tall monolith) and her Daughters (a large stone circle) are part of an extensive ceremonial complex dating from the late Neolithic/Early Bronze Age. Long Meg, standing some sixty feet south-west of the circle, is made of local red sandstone, while her children are boulders of volcanic porphyrite. Local legend maintains that Meg was a witch who was turned to stone with her followers for dancing on the Sabbath. The origin of her name may derive from the word 'magus', meaning 'magician'. It is not known whether the circular designs on Long Meg's side were carved before or after the stone's erection. Her position in relation to the circle suggests an alignment on the mid-winter sunset.

Penrith Castle

Occupying a hilltop site overlooking the ancient market town of Penrith, the red sandstone castle originated as a pele tower, built to provide protection against raiders from Scotland. From *c.*1399 William Strickland (later Bishop of Carlisle) added further fortifications, and in the early 1470s it became a royal fortress under Richard, Duke of Gloucester, 'Guardian of the West March towards Scotland' and later King Richard III. During the Civil War the castle remains were largely dismantled by the Parliamentarians. Further demolition took place in the nineteenth century, with the construction of the Lancaster to Carlisle railway line. The ruins, standing in a public park close to Penrith Station, are now in the guardianship of English Heritage.

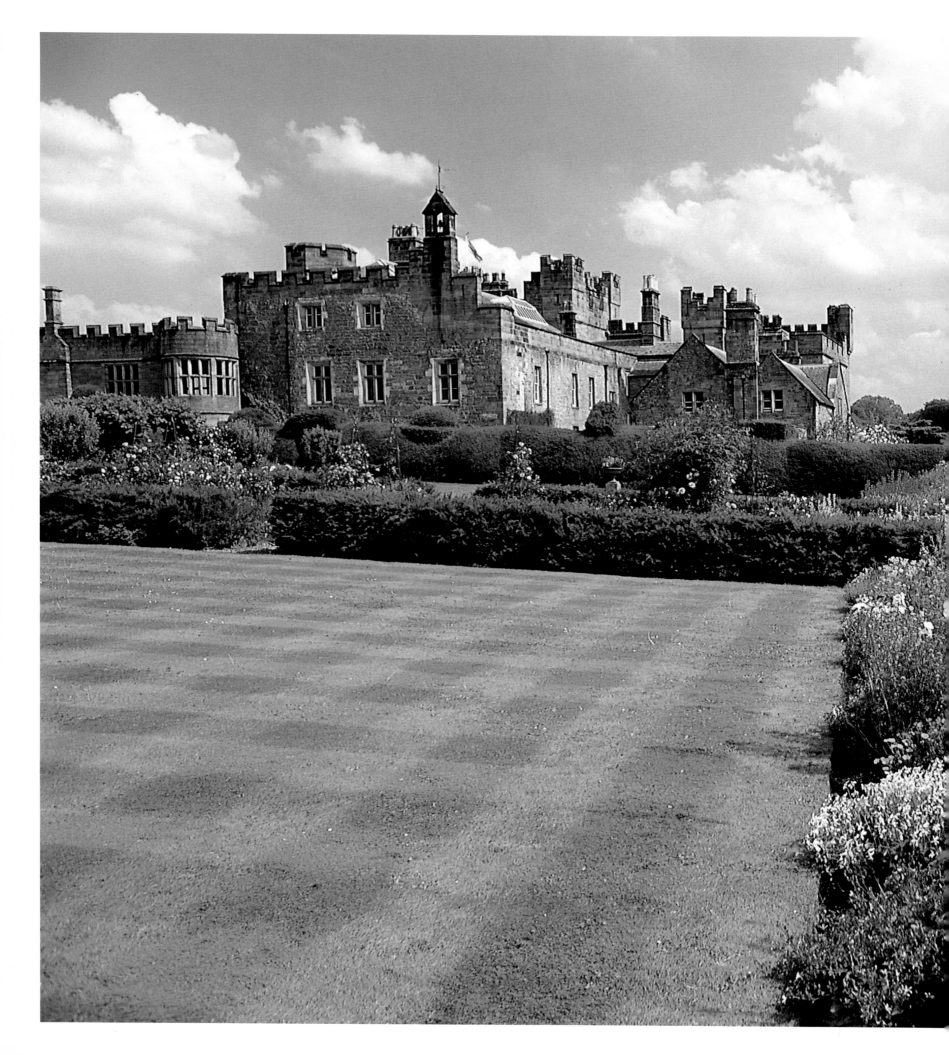

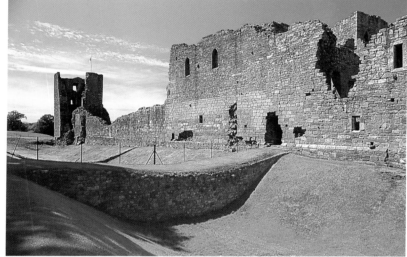

Hutton-in-the-Forest

Built around a medieval pele tower, the historic house of Hutton-in-the-Forest stands in the former Royal Forest of Inglewood, seven miles north-west of Penrith. Owned by Lord Inglewood's family since the early seventeenth century, the house was altered and enlarged by succeeding generations. Consequently, the building, inside and out, displays a wide range of architectural and decorative styles, including: the barrel-vaulted Stone Hall, built in the late thirteenth century; the long gallery, dating from the 1630s (a rarity in the North of England); the mid-eighteenth-century Cupid Room, with its delicate plaster ceiling; and Lady Darlington's Room, decorated in the Arts and Crafts style. The house and gardens are open to the public.

Brougham Castle

After the Roman invasion of Britain in AD 43, the conquerors built the fort of Brocavum (Brougham) to guard the river crossing, south-east of Penrith. In the early thirteenth century, during an interval of declared peace between England and Scotland, the Normans erected the keep of Brougham Castle adjacent to the Roman site. Further fortifications, living accommodation and a chapel were added over subsequent centuries, culminating in rebuilding carried out by Lady Anne Clifford in the seventeenth century. Fifteen years after her death in 1676, the castle was partly demolished for building materials. The ruins (including a small display of tombstones from the Roman cemetery) are now in the guardianship of English Heritage.

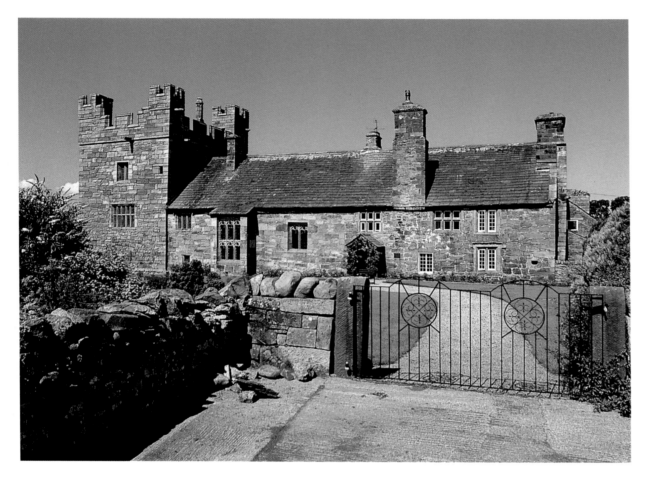

Mayburgh Earthwork, Eamont Bridge

Between the rivers Eamont and Lowther, south of Penrith, are two prehistoric circular earthworks (or henges) dating from *c.* 2500–1700 BC. Mayburgh consists of a single standing stone encircled by a bank, up to fifteen feet high, built with over five million cobble-sized stones. In the seventeenth century Dugdale recorded four massive stones in the centre of the one-and-a-half-acre site, with a further two by the entrance to the east. The second henge, King Arthur's Round Table, was badly mutilated in the nineteenth century. Originally there were two entrances through the outer bank and ditch into the central area, but only the one to the south-east remains. Both sites may have been used for ceremonial purposes and are now in the care of English Heritage.

Yanwath Hall

After the great Scottish victory over the English at Bannockburn in 1314, the raids from across the Border became so frequent and so ferocious that the wealthier landowners were forced to build strong defensive structures, known as 'pele towers'. In more peaceful times, a hall was added to the tower, followed by further modifications and extensions over the centuries. Yanwath Hall – on the southern side of the River Eamont, south of Penrith – is an excellent example of this type of building. Its battlemented tower (with Elizabethan five-light mullion-and-transom windows on the first floor) dates from the early fourteenth century, while the hall range is fifteenth century. The house, forming three sides of a courtyard, is not open to the public.

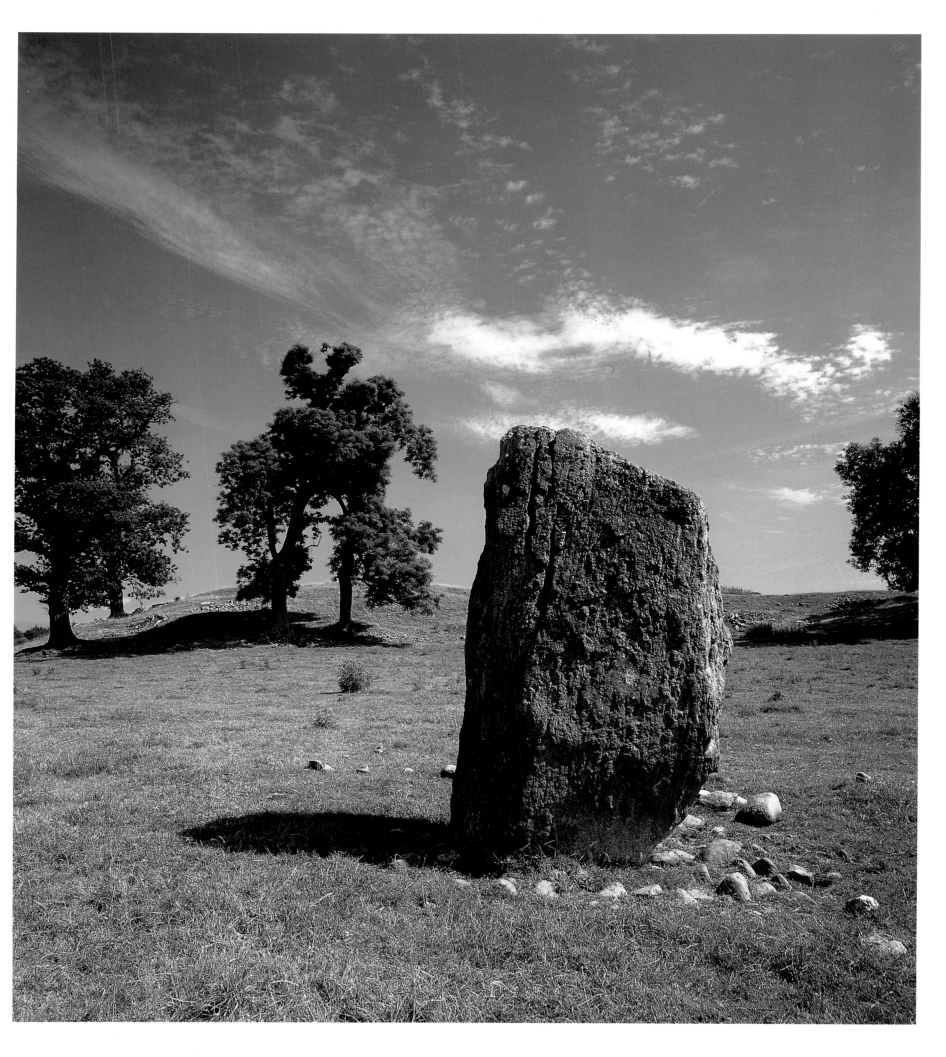

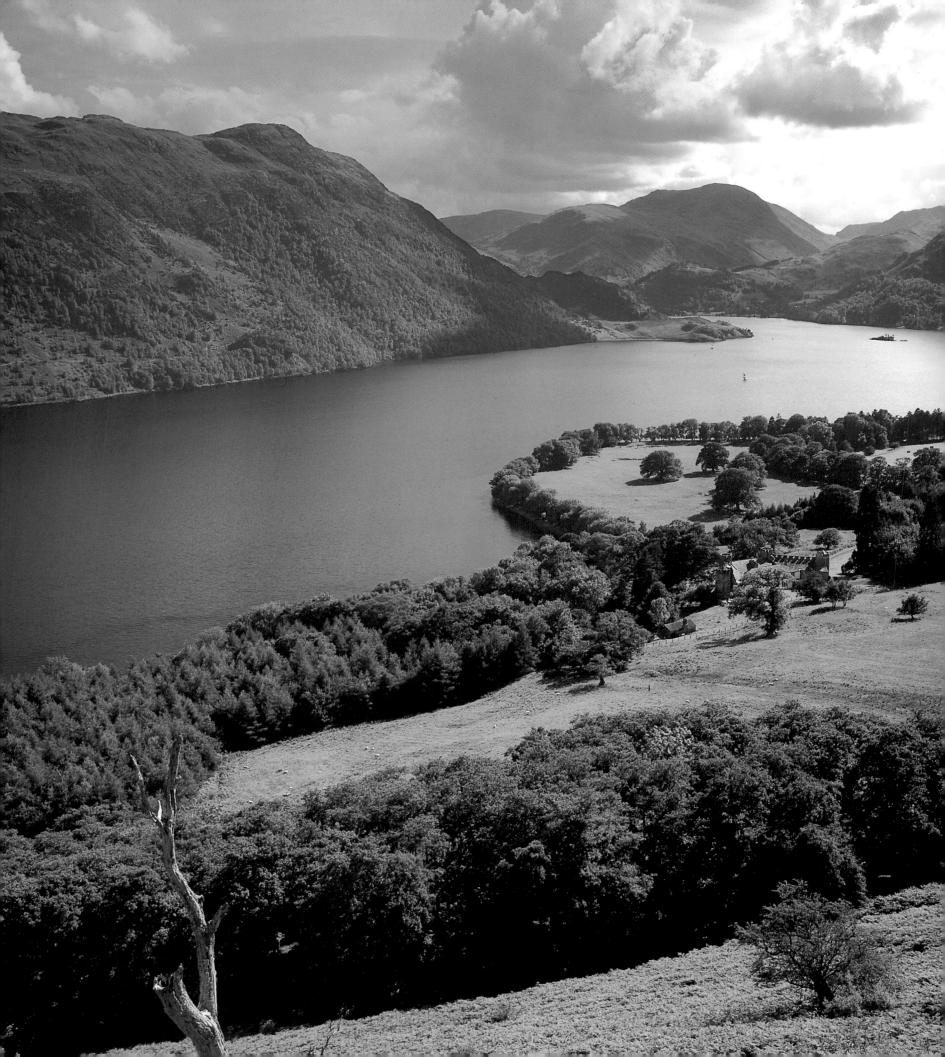

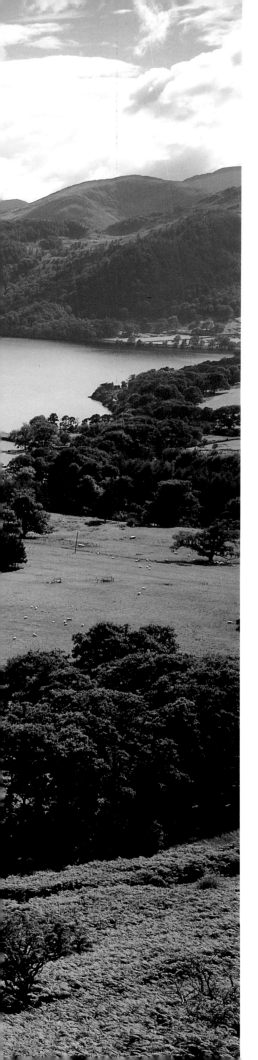

Ullswater, from Gowbarrow Park

Second largest of the sixteen lakes, Ullswater is seven-and-a-half miles long, about three quarters of a mile wide and over 200 feet deep. Gowbarrow Park, on its northern side, takes its name from the Old Norse word for 'windy hill'. It was once a medieval deer park and, near the shore of the lake, is a castellated structure known as Lyulph's Tower, built in 1780 by Charles Howard of Greystoke (later became the 11th Duke of Norfolk). Ullswater is derived from an Old Norse personal name and means 'L'Ulf's lake'. Like Haweswater and Red Tarn, the lake is inhabited by a rare, silvery fish known as a schelly. Despite fears that it was extinct in Ullswater, poisoned by pollution from the lead mines above the village of Glenridding, the fish still survives.

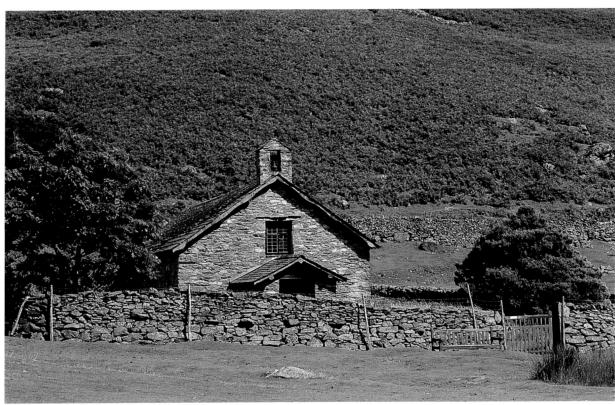

St Martin's Church, Martindale

Standing on the site of an earlier foundation, the small church of St Martin – near Christy Bridge in Martindale – dates from the early seventeenth century. Inside the simple barn-like building is a stone font, thought to have been used as a wayside shrine on the Roman road across High Street. Before being placed in the church, the stone was used for sharpening metal tools, hence the deep grooves on the sides. In about 1880 the church had fallen into such a bad state of disrepair that the new church of St Peter was erected at the top of The Hause. On the day it was consecrated – 6 January 1882 – a great storm tore the roof off the old church. Fortunately, the damage was made good. St Martin's is now used for occasional services during the summer months.

Martindale & Boardale

From Pooley Bridge the road running along the eastern banks of Ullswater climbs up from Howtown, over The Hause on Hallin Fell, to descend into Martindale and the remote glacial valleys of Boardale and Bannerdale. Wordsworth, together with Dorothy, visited the area in November 1805, and wrote in his guide: 'Towards its head, this valley splits into two parts; and in one of these (that to the left) there is no house, nor any building to be seen but a cattle shed on the side of a hill, which is sprinkled over with trees, evidently the remains of an extensive forest.' The photograph was taken from Hallin Fell. Separating Martindale and Bannerdale (left) from Boardale (right) is Beda Fell – the long north-east ridge of Angletarn Pikes.

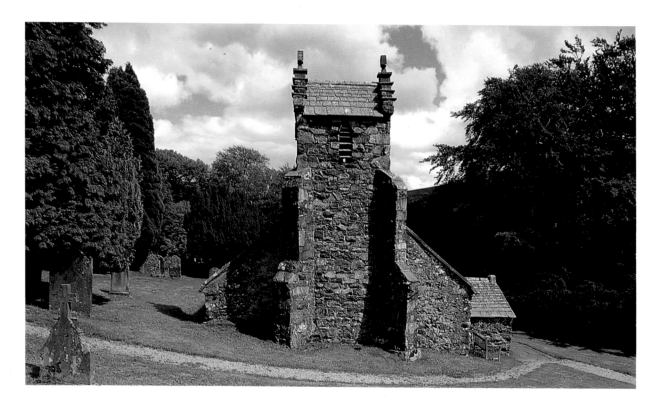

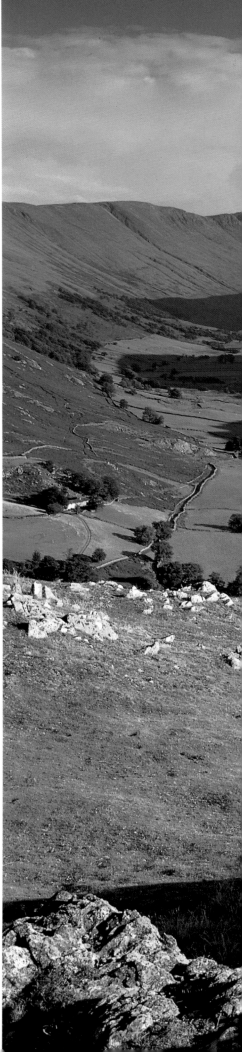

Matterdale Church

Dating from around 1573, the slate church at Matterdale – between Matterdale End and Dockray – is built on a simple rectangular plan, with nave and chancel in one. In 1848 the tower was rebuilt and the thatched roof replaced with one of slate. Matterdale lies high above Ullswater, north-west of Gowbarrow Park. From Dockray the road drops steeply down to the shore of the lake. It was while walking with his sister in the woods, west of the road (towards Patterdale), that Wordsworth was inspired to write his famous poem about daffodils. The huntsman Joe Bowman, celebrated in song like John Peel, was born at Matterdale in 1850. Known as 'Auld Hunty', he was huntsman with the Ullswater hounds for almost forty-five years, dying at the age of ninety.

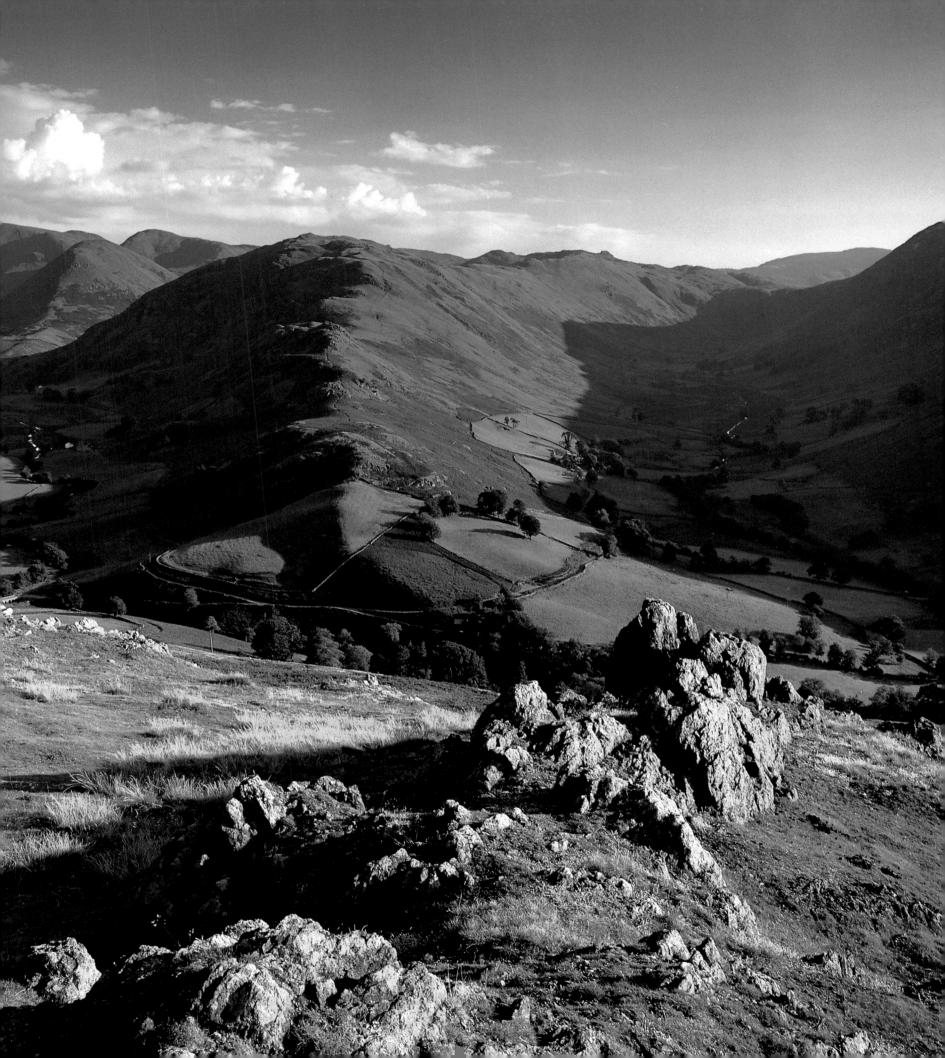

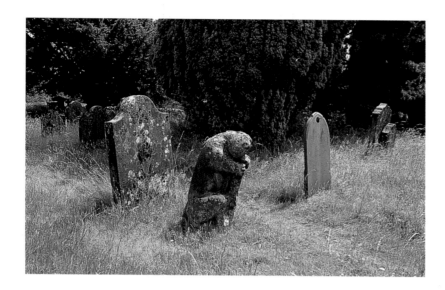

St Andrew's Churchyard, Dacre

Marking the four corners of the original churchyard of St Andrew's at Dacre, four miles south-west of Penrith, are four carved stone bears of unknown origin. In the late nineteenth century Chancellor Ferguson of Carlisle Cathedral suggested that 'they are a humorous rendering of a bear legend'. Starting with the figure in the north-west corner and proceeding anticlockwise, he claimed that they told the story of a single bear. Firstly, the bear is asleep, resting its head on top of a pillar. Secondly, it has been woken by a small animal jumping on its back. Thirdly, the bear is trying to grab or dislodge the animal. And finally, the bear is content – it has eaten its tormentor. Others suggest that they originally stood on the top of Dacre Castle.

Boardale, from Hallin Fell

From Boardale the walking route over Place Fell climbs 1,300 feet to Boardale Hause before descending steeply into Patterdale, at the head of Ullswater. On the Hause itself – which is crossed by the Hayeswater Aqueduct – are the ruins of a small building (marked on large-scale Ordnance map as 'Chapel in the Hause'). 'Looked down on Boardale', wrote Wordsworth in his guide, 'which, like Stybarrow, has been named from the wild swine that formerly abounded here; but it has now no sylvan covert, being smooth and bare, a long, narrow, deep, cradle-shaped glen, lying so sheltered that one would be pleased to see it planted by human hands, there being a sufficiency of soil; and the trees would be sheltered almost like shrubs in a green-house.'

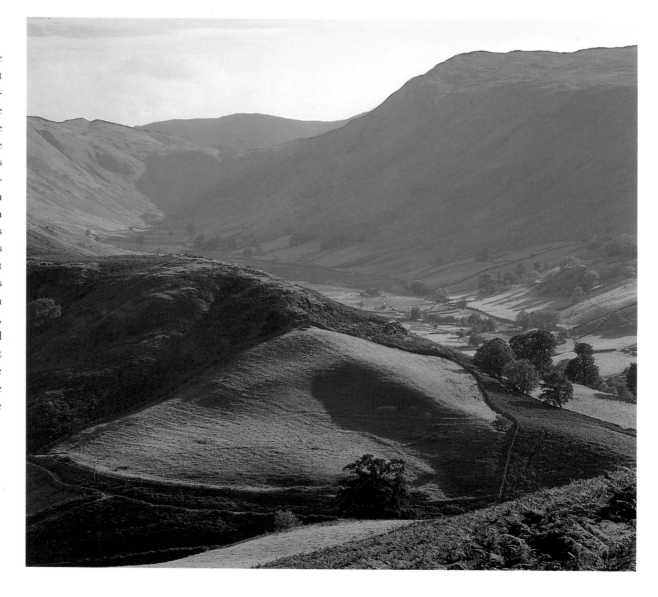

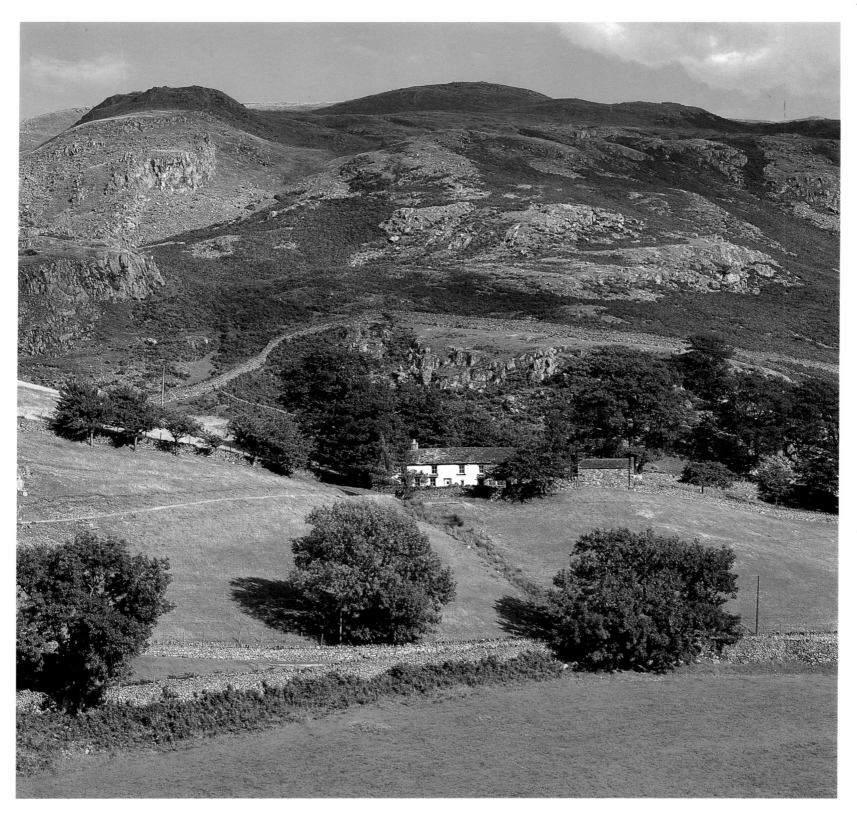

'Cotehow', Martindale

Although many of the farmhouses in Lakeland have been whitewashed, Wordsworth hated the fashion, recommending that if a property must be painted then it should be painted 'a cream and a dust-colour, commonly called stone colour' to blend in with the landscape, and not 'materially impair the majesty of a mountain'. 'In nature,' he wrote in his guide, 'pure white is scarcely ever found but in small objects, such as flowers; or in those which are transitory, as the clouds, foam of rivers, and snow. Mr. Gilpin, who notices this, has also recorded the just remark of Mr. Locke … that white destroys the gradations of distance; and, therefore, an object of pure white can scarcely ever be managed with good effect in landscape-painting.'

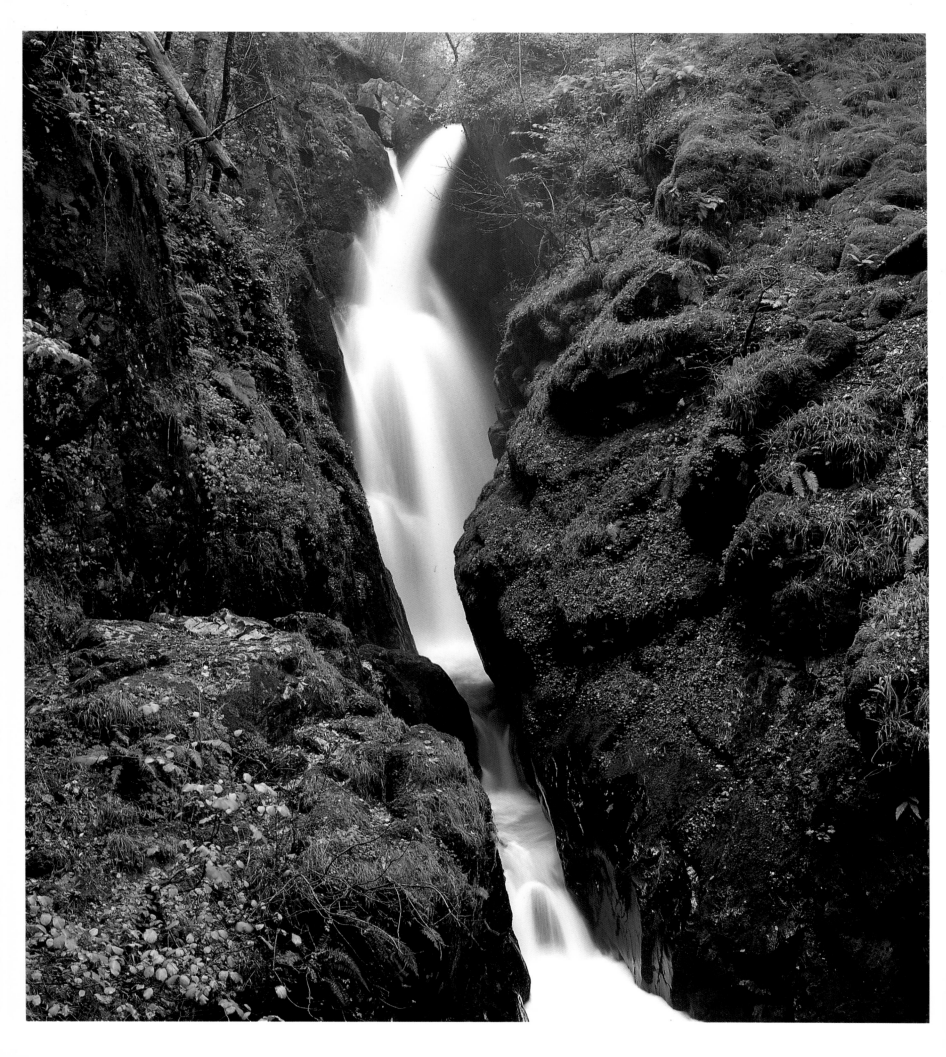

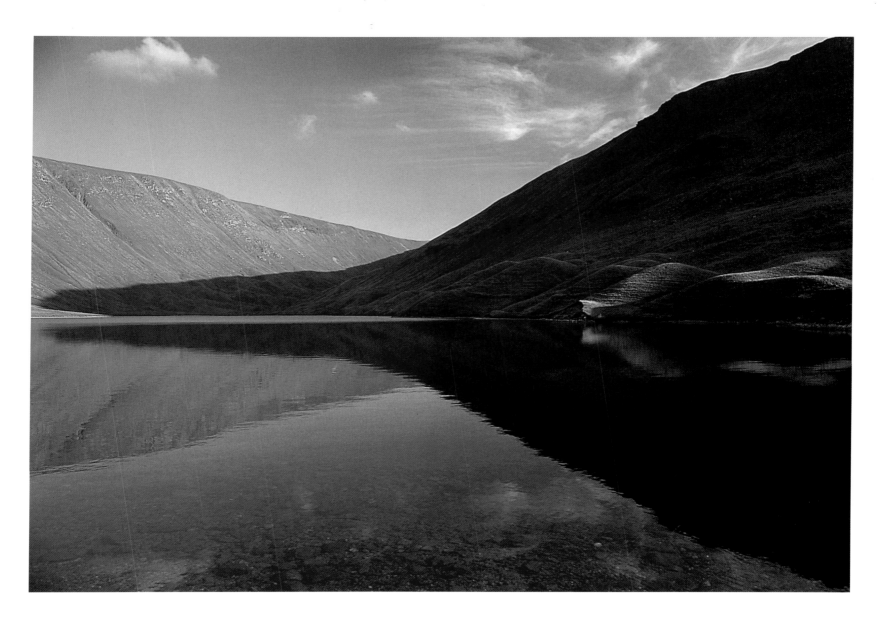

Aira Force, Ullswater

Dropping seventy feet into a deep, wooded glen, Aira Force is the scene of the tragic legend of Emma and Sir Eglamore, on which Wordsworth based his poem 'The Somnambulist'. Emma, who lived in a castle near the waterfall, was betrothed to Sir Eglamore, a heroic knight who went off to fight in the Crusades. Becoming ill with worry, Emma started to walk in her sleep. One night, Sir Eglamore returned unexpectedly to see her walking like a ghost above the falls. He hurried forward and touched her. She awoke with a start, slipped on the wet rocks and plunged to her death into the raging torrent below. The knight was heartbroken. He became a hermit and spent the rest of his days in a cave near the spot, mourning the loss of his intended bride.

Hayeswater

Immediately west of the great ridge of High Street is Hayeswater – a large and lonely tarn – surrounded on three sides by a steep wall of fells. At 1,383 feet above sea-level and dammed at its northern end, it is used as a reservoir to supply water to Penrith, twelve miles northeast. The remaining water flows down the valley as the Hayeswater Gill. Beyond Hartsop, the stream merges with the Goldrill Beck to eventually enter Ullswater, near Patterdale. The dark slopes (on the right of the photograph) rise to the steep-sided ridge of Gray Crag (2,286 feet). The mounds, catching the light at its foot, are glacial moraines. The scree slopes on the left form the western flanks of the narrow Straits of Riggindale and The Knott (2,423 feet).

Brothers Water

Formerly called Broad Water, Brothers Water is generally regarded as a lake, rather than a tarn. It received its present name after two brothers were drowned in its waters while ice-skating in 1785. A similar accident is said to have happened earlier – a coincidence that caused Dorothy Wordsworth to write in her *Journal* for 9 November 1805: 'It is remarkable that two pairs of brothers should have been drowned in that lake. There is a tradition, at least, that it took its name from two who were drowned there many years ago, and it is a fact that two others did meet that melancholy fate about twenty years since.' Brothers Water may have once been part of a much larger lake that included Ullswater, until it was separated by silt and debris washed down from the surrounding fells.

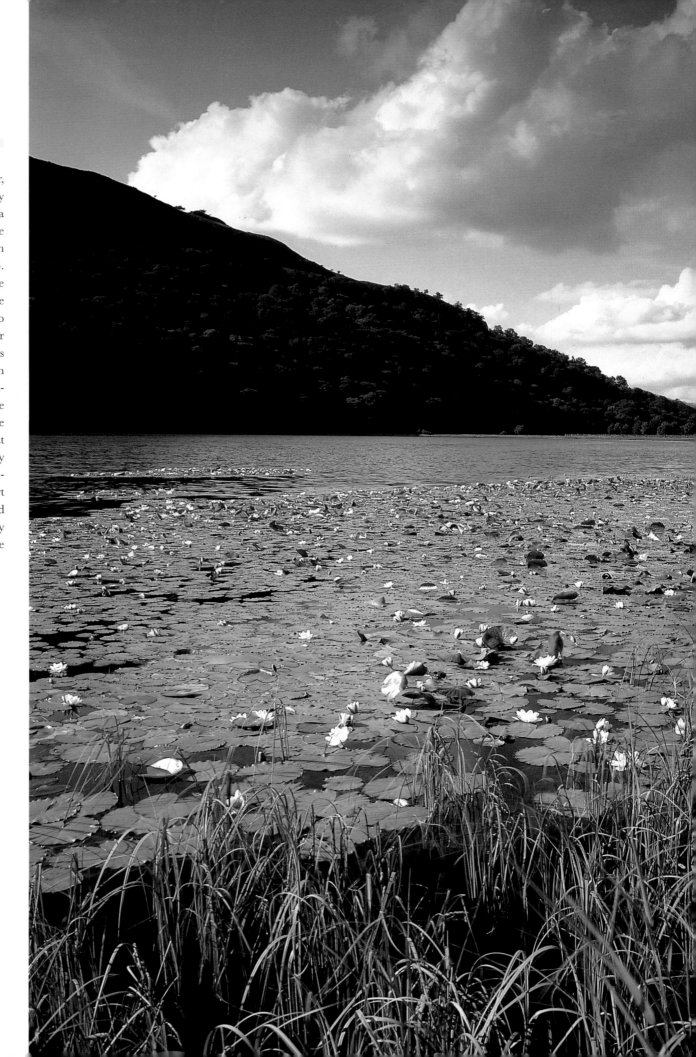

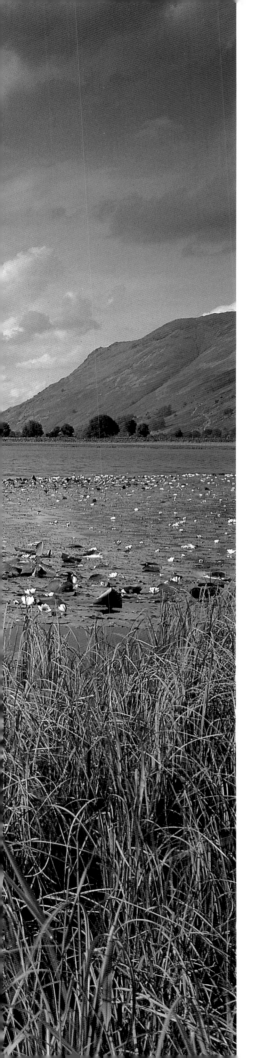

Parcey House, Hartsop

Like many of the houses in Hartsop – a small hamlet nestling in the valley north-east of Brothers Water – Parcey House probably dates from the early seventeenth century. Originally a farmhouse, the property is thought to derive its name from a man called Parcival Soulby, who was living in Hartsop in the 1640s. Thorn House, nearby, is noted for its timber-built 'spinning galley', which (unlike that at Yew Tree Farm, near Coniston) is part of the farmhouse. The name 'Hartsop' may derive from the Old English for 'the valley of the deer'. Given its present tranquil appearance – with no through road, no shops, and no public house – it is hard to believe that Hartsop once embraced sixteen working farms and over 100 inhabitants.

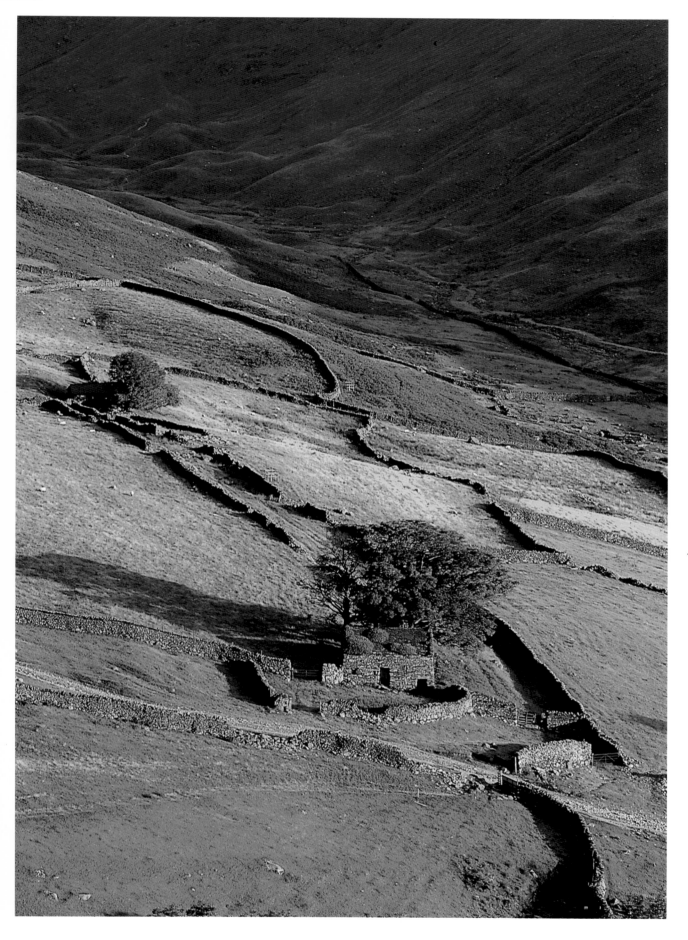

Pasture Bottom, near Hartsop

Rising on the slopes north-west of Thornthwaite Crag (2,569 feet) – the summit of which is marked by a fourteen-foot-high, chimney-like cairn or 'beacon' – Pasture Beck flows north-west down Threshthwaite Glen (Pasture Bottom) to join the Hayeswater Gill, above Hartsop. The valley was once part of a Norman hunting forest. During the nineteenth century it was mined for lead, evidence of which can still be seen. Today, the lower slopes are used by farmers for grazing animals, mainly Swaledale sheep. Although the volcanic rock hereabouts is an ideal walling stone, the fact that the traditional Lakeland wall is built without mortar makes it vulnerable to collapse – especially when the camstones on top are knocked off by people or animals.

Aughertree and Ireby, from Green How

Unlike that of central Lakeland, the countryside 'back o' Skidda' consists of open moorland, gentle, undulating hills, lush pastures and no lakes. Rising on the almost treeless moorland of Skiddaw Forest, the waters that form the River Ellen flow north-westward through Little Tarn, Over Water and the Chapel-house Reservoir, past Uldale and Ireby to eventually enter the Irish Sea at Maryport. The photograph, taken near Uldale, looks north-west across farmland to the Solway Firth and the distant hills of Scotland. The old market town of Ireby is noted for its butter-cross and moot hall. On Aughertree Fell, south-east of Ireby, are three ancient circular enclosures (two of which contained buildings) and a burial mound.

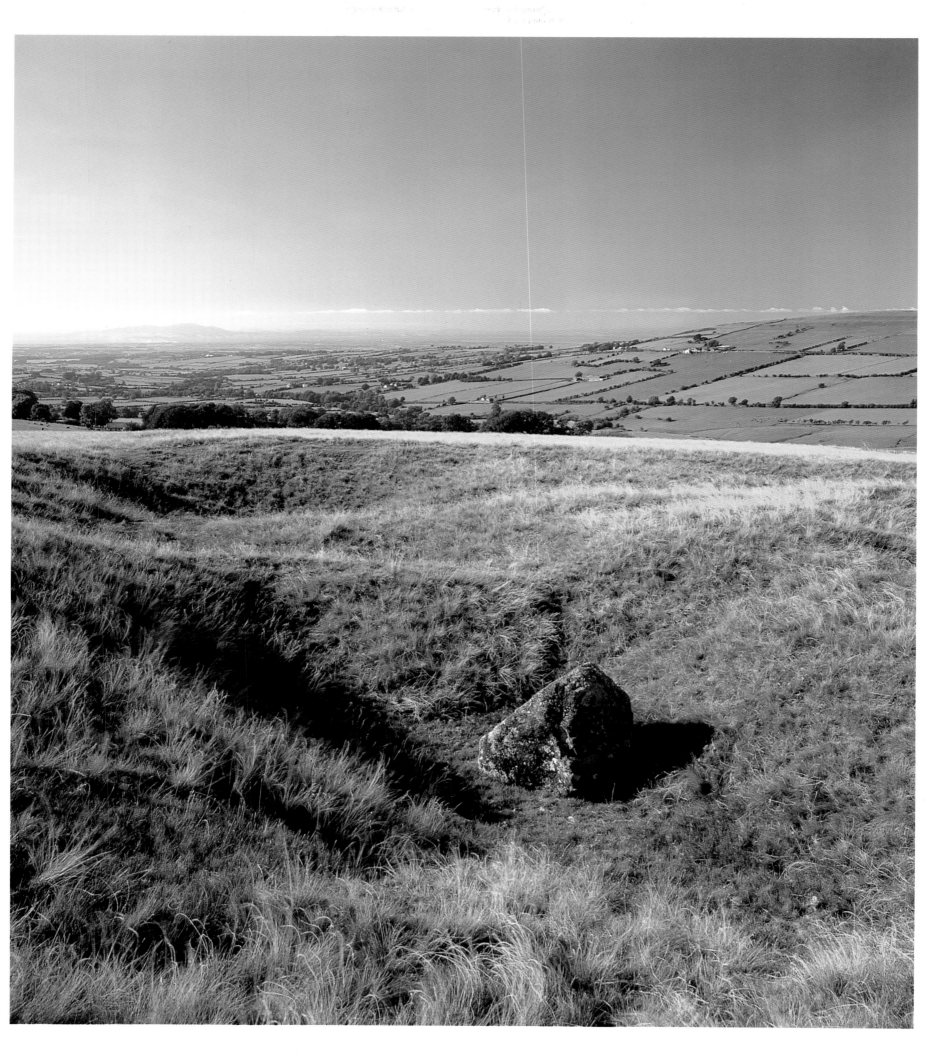

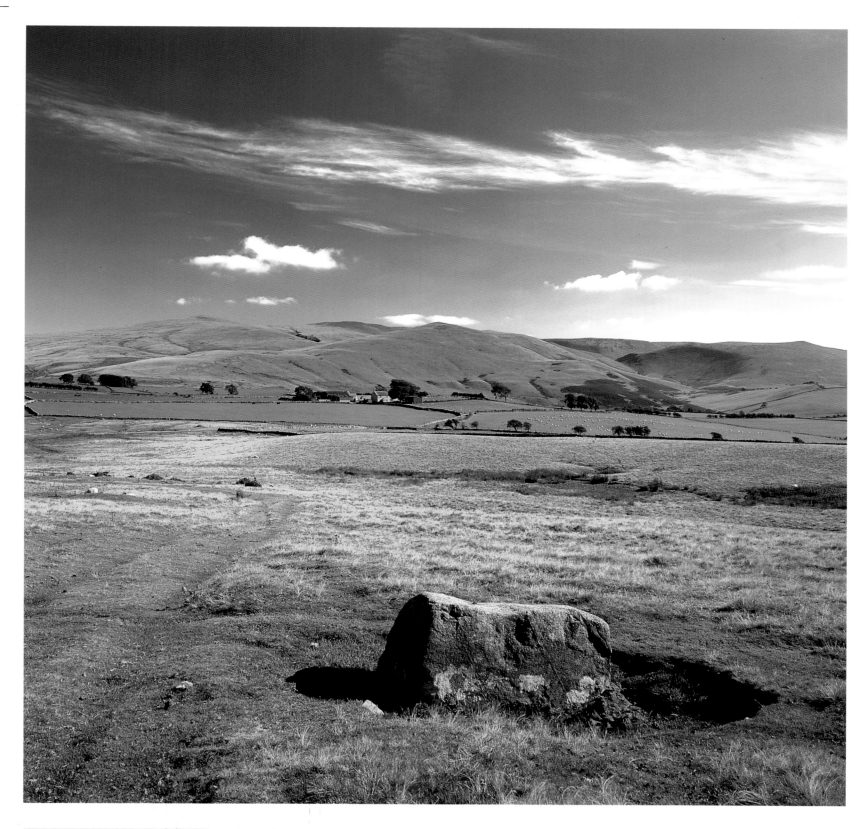

Baggra Yeat Farm, Longlands Fell

Rising to 1,580 feet above sea-level, Longlands Fell forms the north-western ridge of Great Sca Fell (2,131 feet). The ridge is an important watershed with the streams to the east becoming the Eden and those to the west the Ellen. Wainwright considered the 900-foot ascent from Longlands (just south of Baggra Yeat, near Uldale) so 'short and simple' that he advised anybody who cannot manage it 'to give up the idea of becoming a fellwalker'. In keeping with the vast majority of farmers in Lakeland, Baggra Yeat Farm is dependent on sheep for its livelihood. As much of the land 'back o' Skidda' is unfenced, the animals are allowed to roam freely (happily, a strong homing instinct tends to keep them in a particular area or heaf).

John Peel's Gravestone, Caldbeck

John Peel, the legendary huntsman, lies buried in St Kentigern's churchyard at Caldbeck. His distinctive gravestone – bearing the date of his death in 1854 and that of his wife, Mary, together with those of four of their thirteen children – is decorated with hunting symbols. It is reputed that he died of injuries sustained during a hunting accident, and that over 3,000 people attended the funeral. His name was made famous by his friend, John Woodcock Graves, who wrote the words to 'D'ye ken John Peel?' (the original song was put to new music in 1869 by William Metcalfe, the choirmaster of Carlisle Cathedral). The 'Maid of Buttermere', Mary Robinson (who married a Caldbeck farmer), lies buried in the same churchyard.

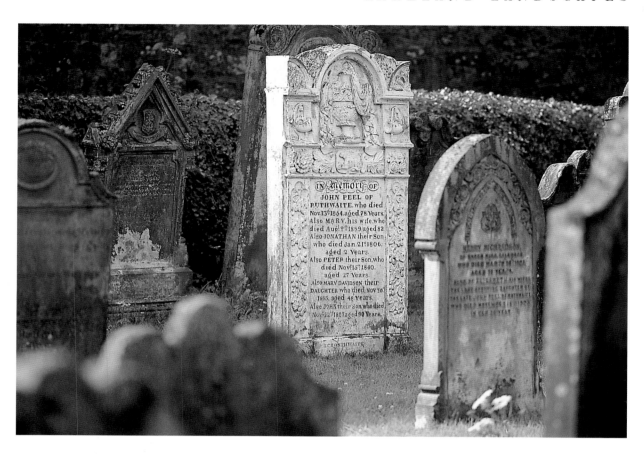

St Kentigern's Church, Caldbeck

Standing on the banks of a tributary of the River Caldew at Caldbeck, the long, low church of St Kentigern was built near the site of St Mungo's Well, the holy spring where St Kentigern (popularly known as St Mungo) used to baptize his converts in the sixth century. The present building is thought to date from around the middle of the twelfth century. Over subsequent centuries, however, it has been altered and enlarged. The tower was erected in 1727 by the Reverend Jeffrey Wyberg, who also built Priest's Mill, downstream from the church. Today the cornmill (later converted into a crushing and sawmill) has been transformed into craft workshops, a restaurant and so on. The public shelter (now a shop), opposite the church, was built as a memorial to John Peel.

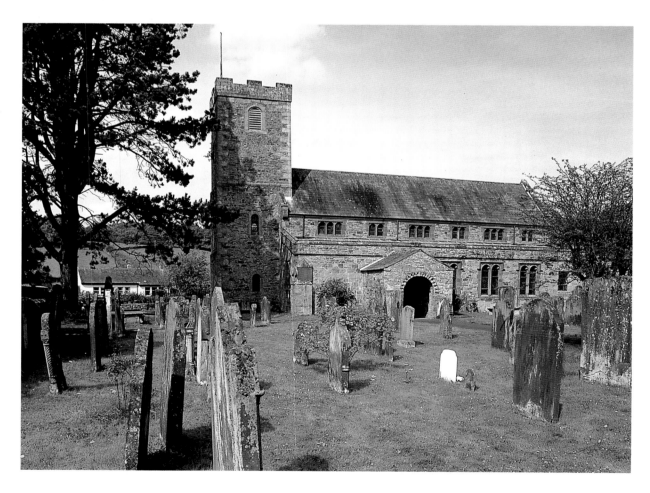

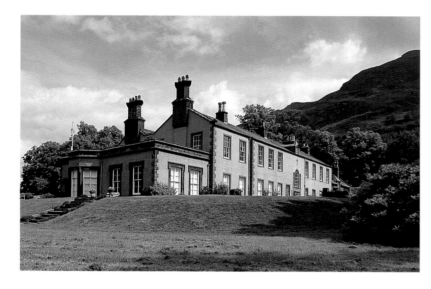

Mirehouse, Bassenthwaite

On the eastern shores of Bassenthwaite Lake, below the forested slopes of Skiddaw, stands Mirehouse, the home of James Spedding (1808–81), a friend of many writers and poets, including Wordsworth, Southey and Tennyson. It is thought that Tennyson composed much of his poem 'Morte d'Arthur' (published in 1842) while staying at the house. 'Many a time as I have paced the dewy pebbles of Bassenthwaite Lake in thought,' wrote Canon H. D. Rawnsley, 'and heard the ripple washing in the reeds or seen the water brighten to the moon, I have felt that in the writing and rewriting of that noble passage that tells of the passing of Arthur, the poet may have almost unconsciously woven into his verse the calm and sounds, the sight and scene of beautiful Mirehouse.'

Bassenthwaite Lake, from Dodd

The most northerly lake in Lakeland, Bassenthwaite was described by Gray in 1769 as 'narrower and longer than that of Keswick, less broken into bays, and without islands'. Near its head is Barf, a steep, hostile-looking pyramid of barren rock, 1,536 feet high. On its eastern scree slopes, overlooking the lake and directly above the Swan Hotel, is the Bishop of Barf, a striking, white-painted pinnacle that is repainted from time to time. Legend says that, in order to demonstrate his faith in God, a bishop once attempted to ride up the screes at this point, but his horse fell and both were killed. In 1977, on the day of Queen Elizabeth II's Silver Jubilee, it was mysteriously painted red, white and blue.

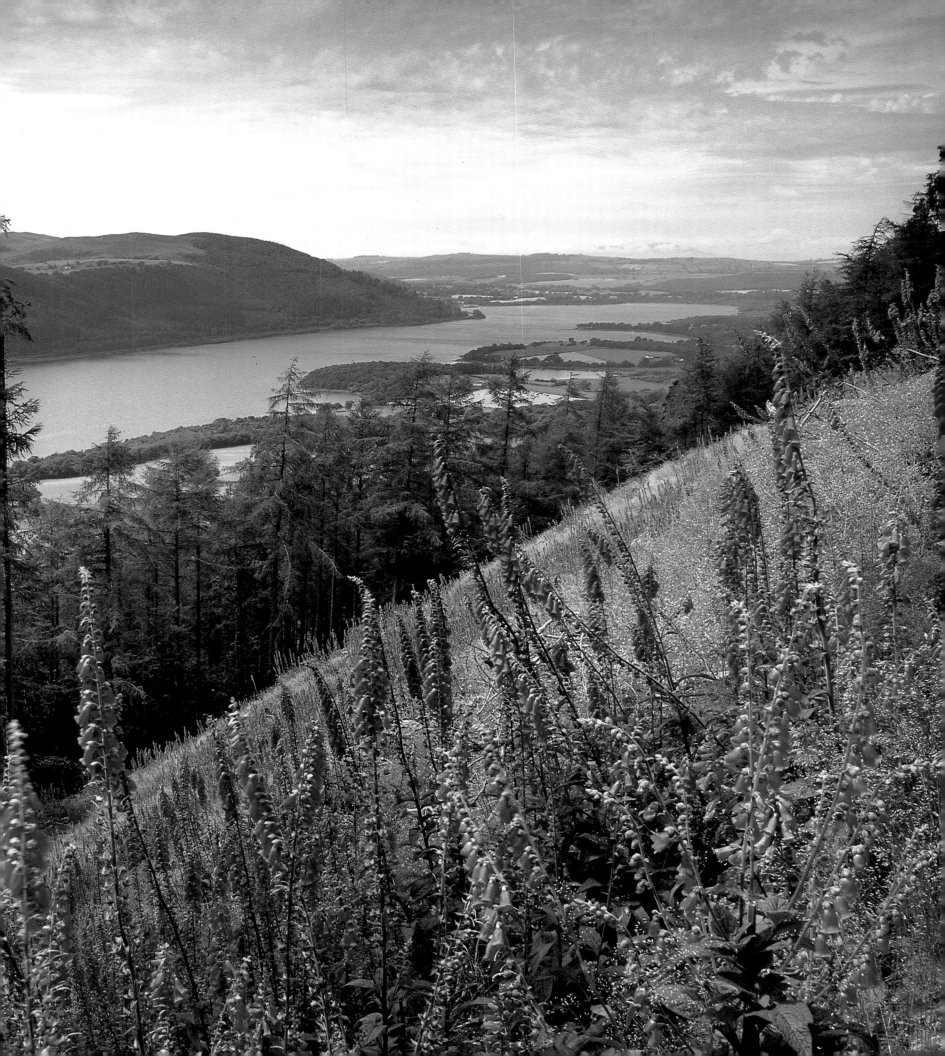

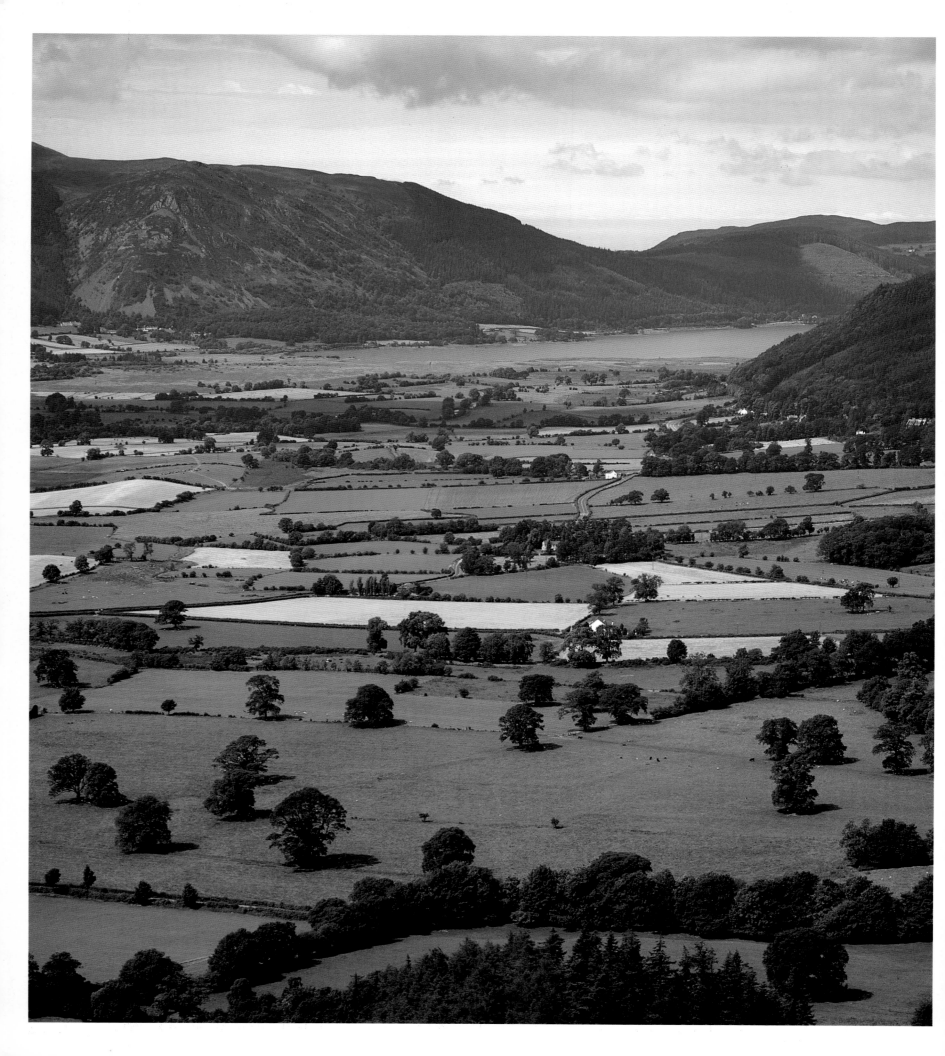

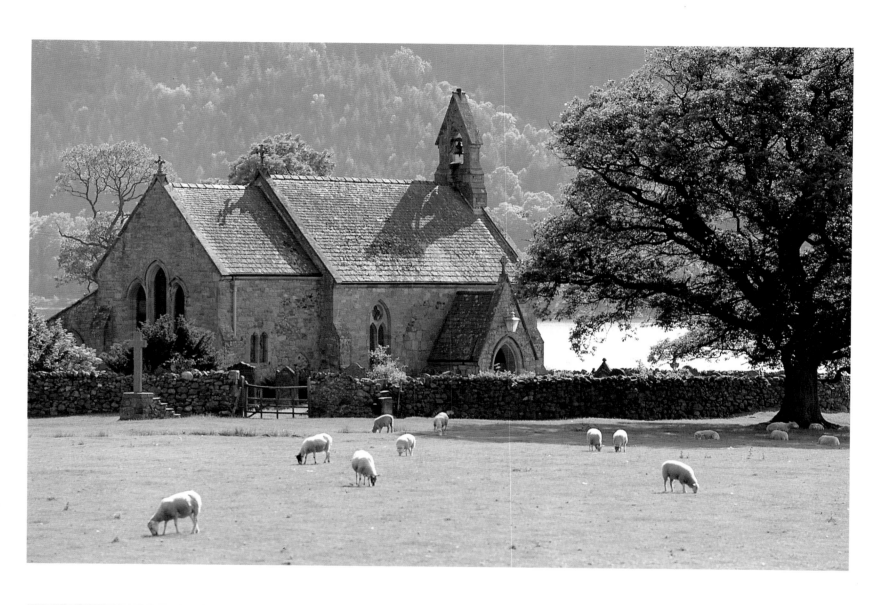

Bassenthwaite Lake, from Latrigg

Said to be the only true lake in Lakeland (because all the rest are either 'meres' or 'waters'), Bassenthwaite Lake lies between the ancient Skiddaw range and the lesser heights of Lord's Seat, Barf and Sale Fell. It is the fourth largest lake in Lakeland and also the fourth shallowest – reaching a maximum depth of only seventy feet. Three-quarters of a mile wide and four miles long, the lake is rapidly being reduced in size by the enormous quantities of sediment being deposited at its head by the rivers Greta, Derwent and Newlands Beck. Bassenthwaite Lake and Derwentwater, now separated by a mile-long alluvial plain of farmland, were once one immense sheet of water and occasionally, during serious floods, they are re-united.

St Bega's Church, Bassenthwaite

The tiny church of St Bega stands on the eastern shore of Bassenthwaite Lake, north-west of Mirehouse (the home of the Spedding family). Although drastically restored in 1874, the oldest parts of the building are thought to date from the tenth or eleventh century. St Bega (or St Bee) was the daughter of an Irish chieftain, who lived in the seventh century. Apparently, she vowed as a child to dedicate her life to God and not to marry. When her father arranged for her to wed the son of a Norse king, she fled across the sea to Cumberland, landing at St Bees Head. After establishing a nunnery just south-east of the headland, where she dedicated herself to caring for the sick and needy, she may have spent some time in the Bassenthwaite area.

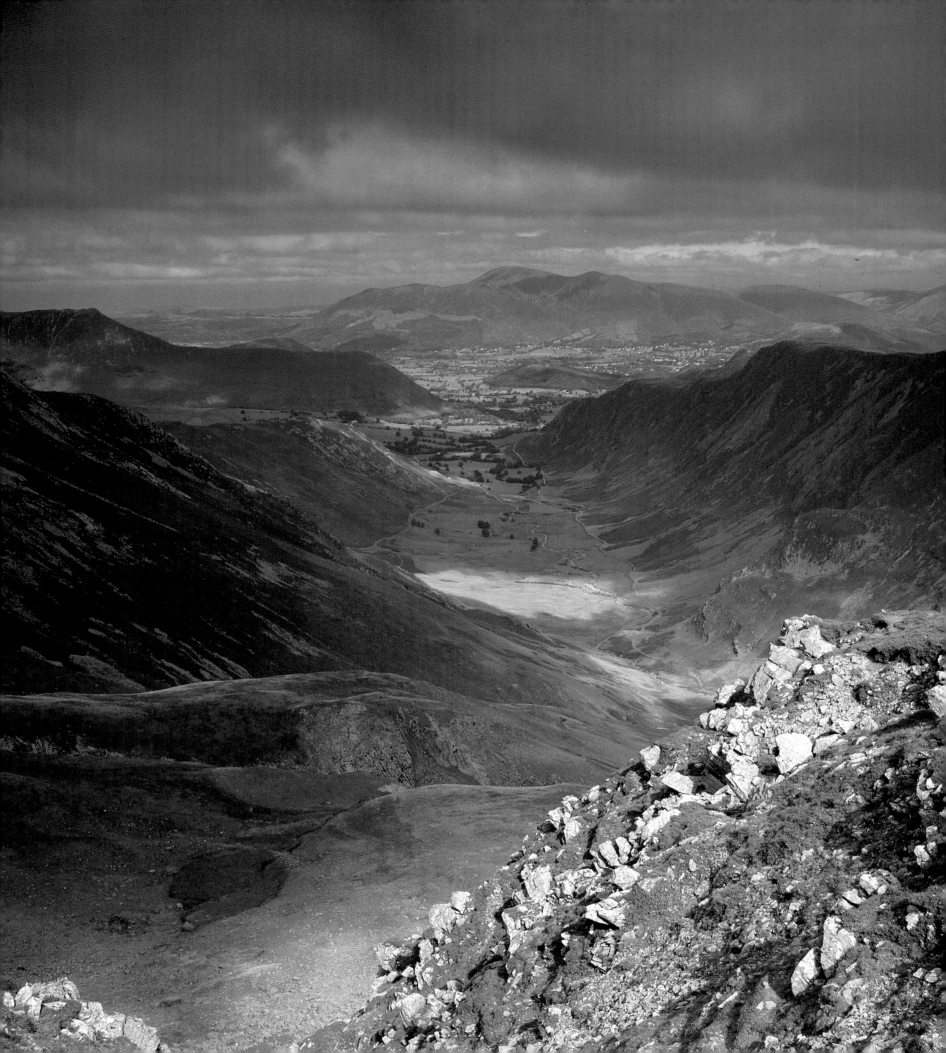

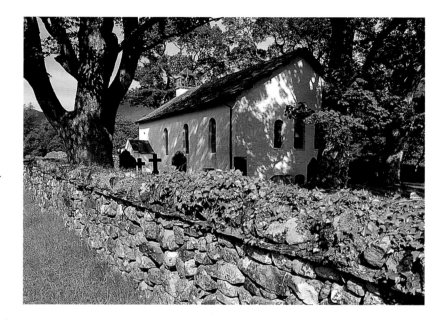

Newlands Valley & Skiddaw, from Dale Head

This extensive view looks northward down the entire length of Newlands Valley, and across the alluvial plain separating Derwentwater from Bassenthwaite Lake, to the solid bulk of the Skiddaw range. The fells on the right – descending from High Spy (2,143 feet) to Maiden Moor (1,887 feet) and then Cat Bells (1,481 feet) – form a long ridge separating Newlands Valley from Derwentwater. Scope End, the nearest ridge on the left, descends from Hindscarth by way of High Crags. In the middle distance (left) is Causey Pike (2,035 feet) and Rowling End (1,400 feet). The small wooded eminence at the entrance to Newlands is Swinside, Thomas West's 'Station V' viewpoint: from where Skiddaw, Keswick vale and both Bassenthwaite Lake and Derwentwater should be seen 'a little before sunset'.

Newlands Church, Newlands Valley

Near the confluence of Newlands Beck, Scope Beck and the Keskadale Beck, in the tiny hamlet of Little Town, is the small whitewashed church of Newlands, rebuilt in 1843 and restored in 1885. The building adjoining it was formerly a school, built by the parishioners in 1887, but closed in 1967. Wordsworth visited the earlier chapel in May 1826 and described his feelings in 'To May': 'How delicate the leafy veil / Through which yon house of God / Gleams 'mid the peace of this deep dale / By few but shepherds trod! / And lowly huts, near beaten ways, / No sooner stand attired / In thy fresh wreaths, than they for praise / Peep forth, and are admired.' It was in this valley, at 'the back of the hill called Cat Bells', that Beatrix Potter set *The Tale of Mrs Tiggy-Winkle* (1905).

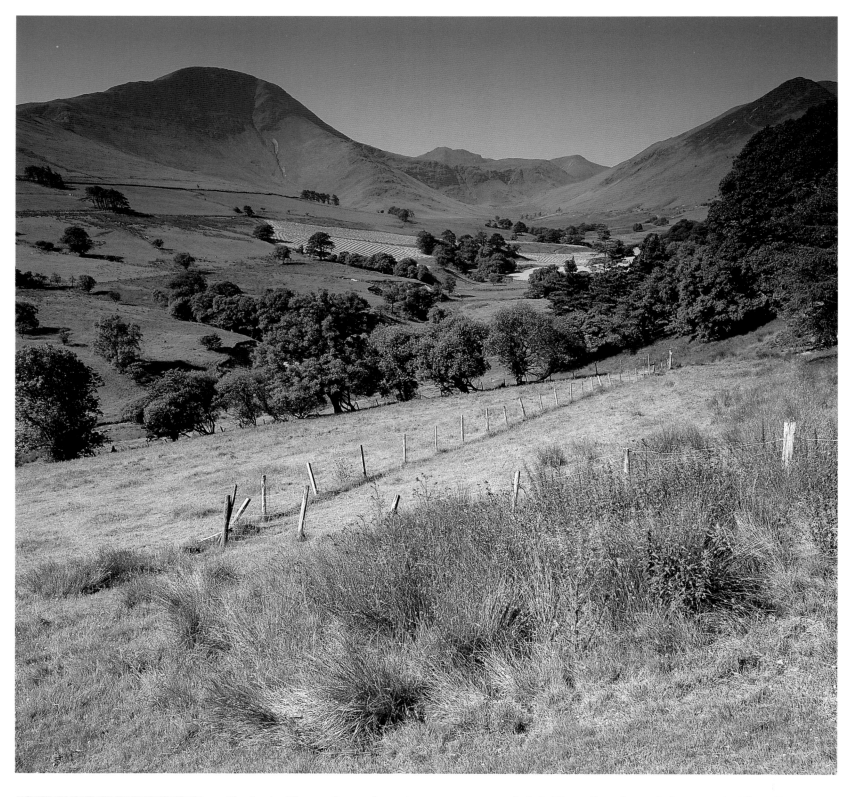

Newlands Valley, from Bawd Hall

The road south through Newlands Valley from Keswick (or Braithwaite) follows the Keskadale Beck to climb over the high pass of Newlands Hause, from where it drops dramatically to Buttermere and Crummock Water. Gilpin visited Newlands in his Lakes tour of 1772 and wrote: 'The mountain valleys we had hitherto seen, were wild, rocky and desolate. But here the idea of terror was excluded. The valley of Newlands was even adorned with the beauties of luxuriant nature, which were sometimes open, and sometimes close; with a sparkling stream, the common attendant of these valleys, accompanying us, through the whole scene.' The 'Buttermere Round' (the twenty-two-mile round trip from Keswick, via Borrowdale, Honister and Newlands) was extremely popular with early tourists.

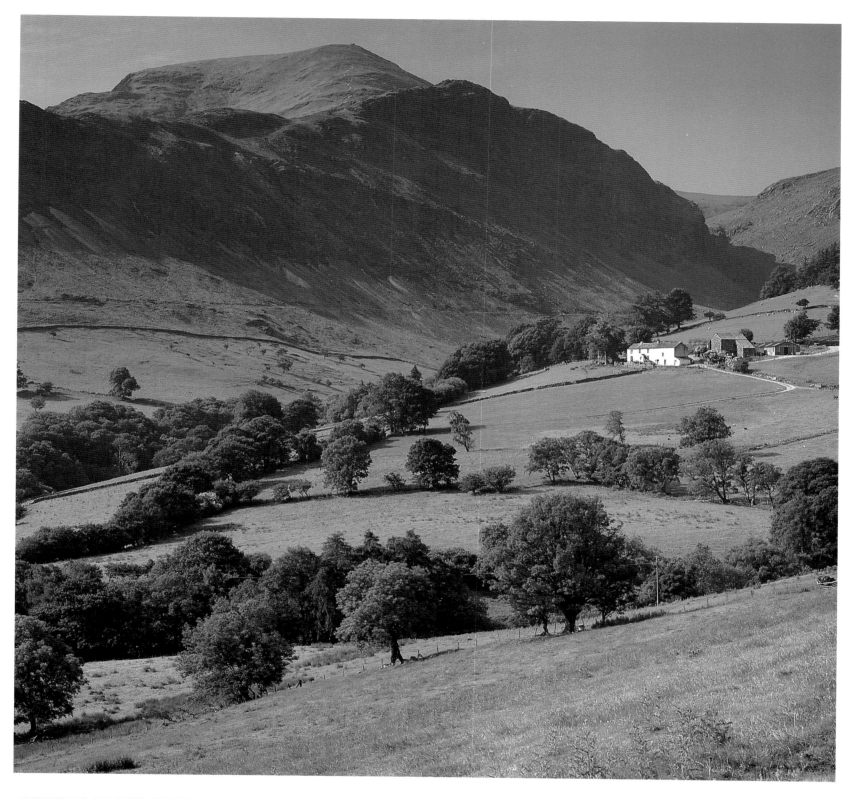

High Snab & Scope End, Newlands Valley

The 'new lands' referred to in this valley's name, were first cultivated in the fourteenth century, after Uzzicar Tarn was drained.

From Elizabethan times to the beginning of the nineteenth century, the fells around the head of the valley were mined for minerals, particularly copper and lead. The Goldscope Mine on the scarred eastern slopes of Scope End, above Newlands Beck,

was one of the oldest and richest in the area. It closed, not because the minerals (which included gold and silver) were exhausted, but because the depths of the workings made it too costly to mine. Despite appearances, Scope End (the promi-

nent fell in the photograph) is connected to Hindscarth (2,385 feet) by a rising ridge. The ridge rising from High Snab farm leads to Robinson (2,417 feet).

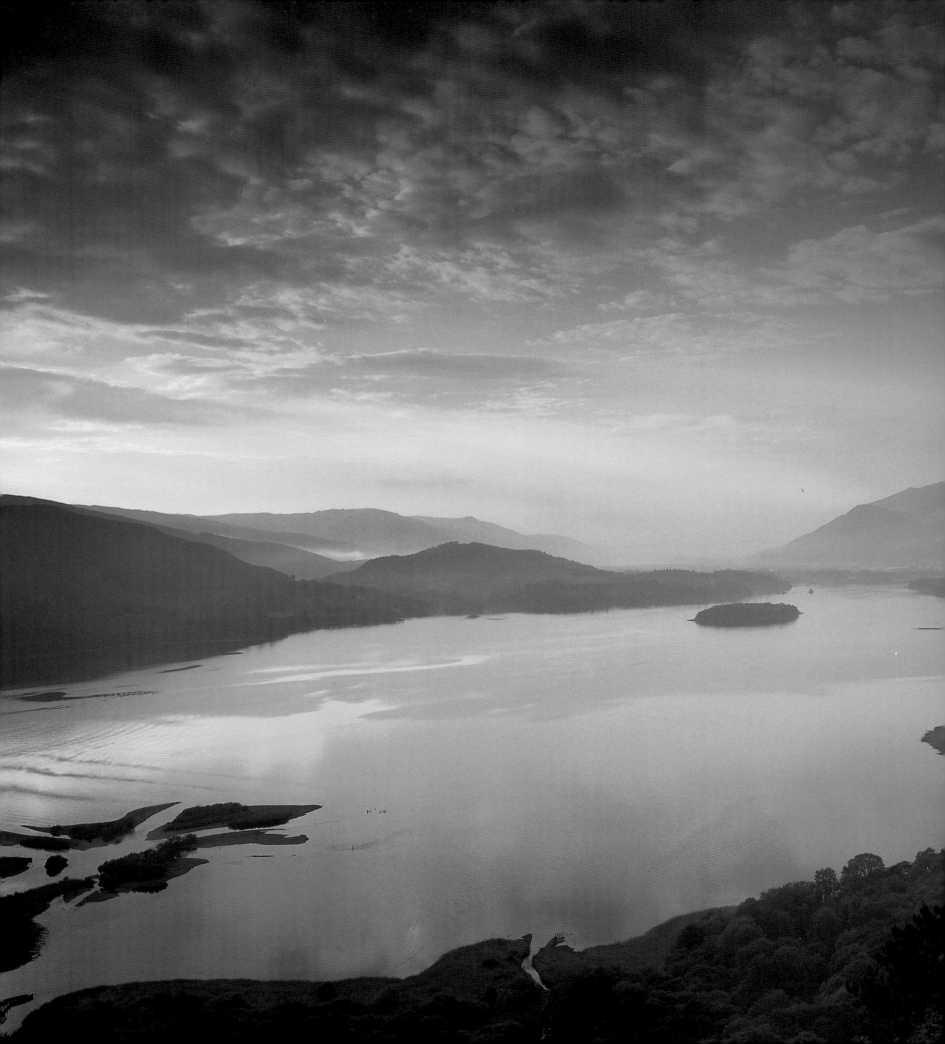

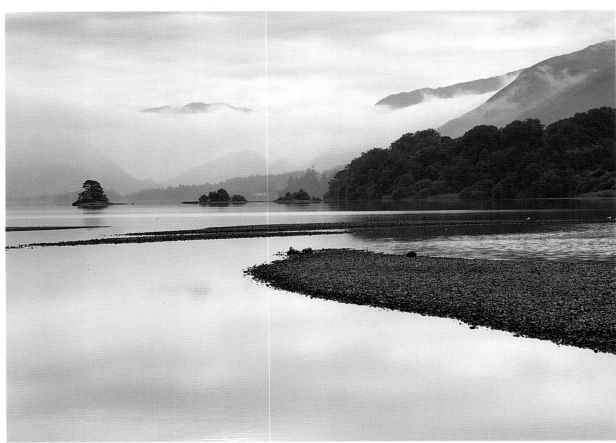

Derwentwater, from Surprise View

In *The Lakers* (1798), a comic opera, the Reverend James Plumptre satirized the cult of 'picturesque' tourism. At a 'station' overlooking Derwentwater, Beccabunga Veronica reaches for her Claude-glass: 'I must throw a Gilpin tint over these magic scenes of beauty. (Looks through the glass.) How gloomily glaring! Now the blue. (Pretends to shiver with cold.) How frigidly frozen! What illusions of vision! The effect is inexpressibly interesting. The amphitheatrical perspective of the long landscape; the peeping points of the many-coloured crags of the headlong mountains ... are so many circumstances of imagery, which all together combine a picture, which for its sentimental beauty and assemblages of sublimity, I never exceeded in the warmest glow of my fancied descriptions.'

Derwentwater

At Friars Crag, on the northern shore of Derwentwater and less than a mile south of Keswick are two memorials: one to Canon H. D. Rawnsley (1851–1920) and the other to John Ruskin (1819–1900). The latter bears the inscription: 'The Spirit of God is around you in the air that you breath – His glory in the light that you see, and in the fruitfulness of the earth and the joy of its creatures. He has written for you day by day His revelation, as He has granted you day by day your daily bread.' On the reverse, beneath Ruskin's portrait, are the words: 'The first thing which I remember as an event in my life was being taken by my nurse to the brow of Friars Crag on Derwentwater.' The photograph was taken from the lake's northernmost tip, north-west of Friars Crag.

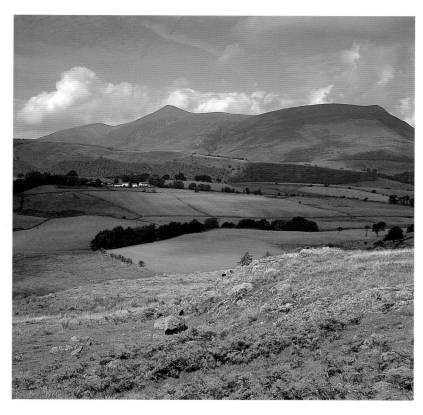

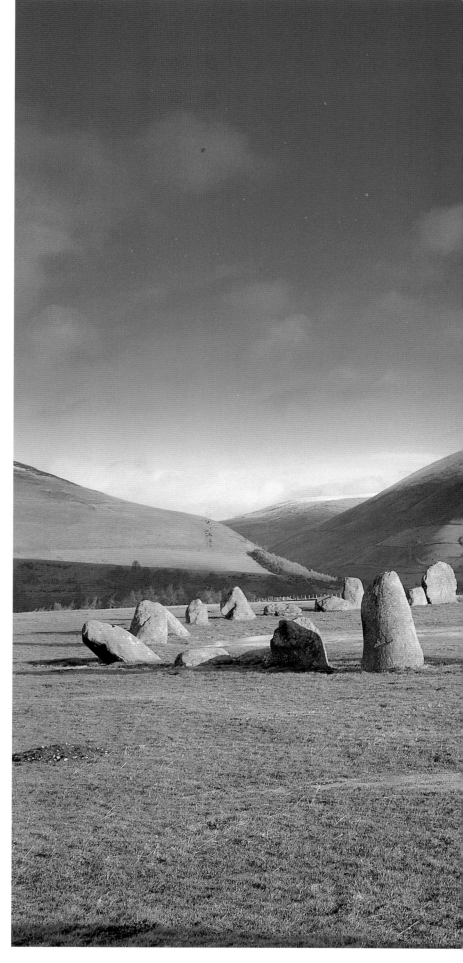

Goosewell Farm & Skiddaw, from Low Rigg

The view in the photograph looks north-westward across the valley of the Naddle Beck to the Skiddaw range. Hidden behind the trees to the left of Goosewell Farm is Castlerigg Stone Circle. The craggy ridge of High and Low Rigg is also known as Naddle Fell. Gray travelled through the valley of the Naddle Beck on his way from Keswick to Ambleside in October 1769: 'The road in some parts is not completed, yet good country road, through found but narrow stony lanes, very safe in broad daylight. This is the case about Causeway Foot, and among Naddle-fells to Langthwaite. The vale you go in has little breadth; the mountains are vast and rocky, the fields little and poor, and the inhabitants are now making hay, and see not the sun by two hours in a day so long as at Keswick.'

Castlerigg Stone Circle, near Keswick

Dramatically sited amidst an amphitheatre of high fells, including Blencathra or Saddleback (shown in the photograph), Castlerigg Stone Circle is thought to date from 2500–1300 BC, during the late Neolithic and Early Bronze Ages. Many eighteenth-century writers, including Gray, Gilpin and Wordsworth, misleadingly attributed its origins to the Druids. 'Their rude workmanship,' wrote Gilpin of stone circles in general, 'hands down the great barbarity of the times of the Druids: and furnishes strong proof of the savage nature of the religion of these heathen priests.' With specific reference to Castlerigg, he noted: 'If Stonehenge were a cathedral in its day; this circle was little more than a country church.'

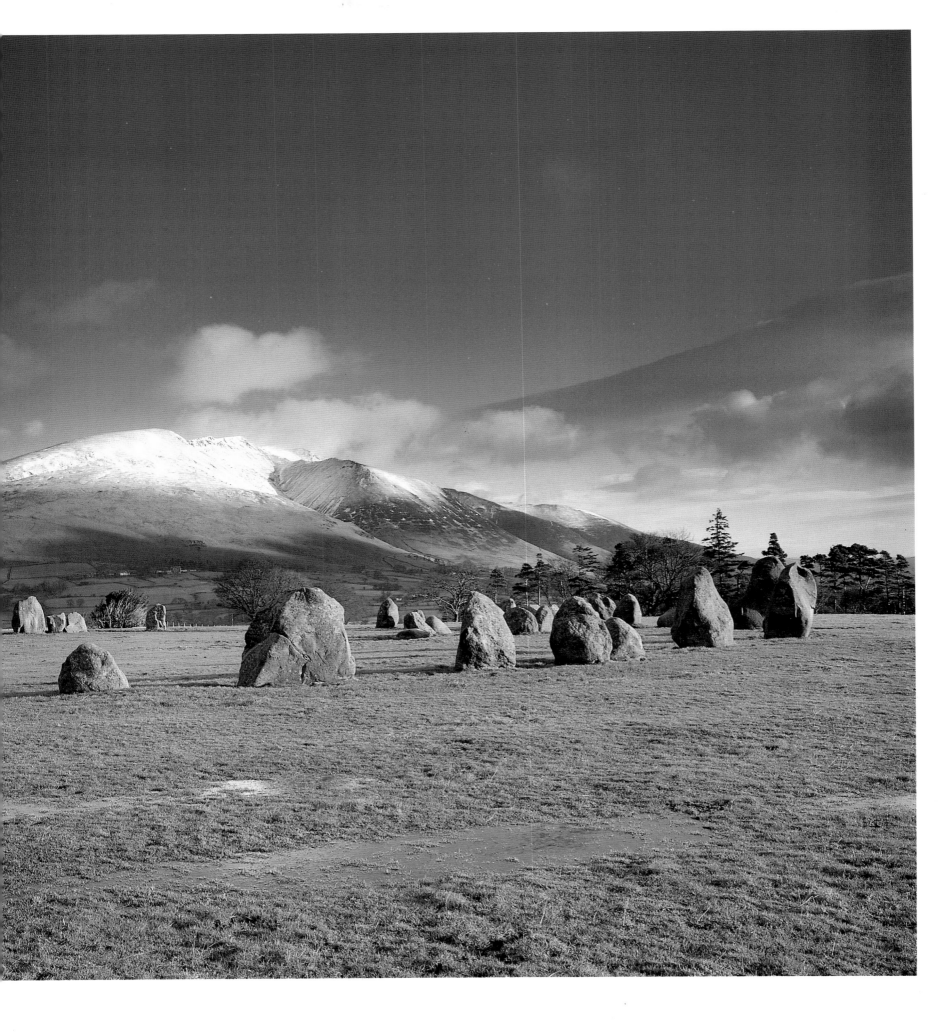

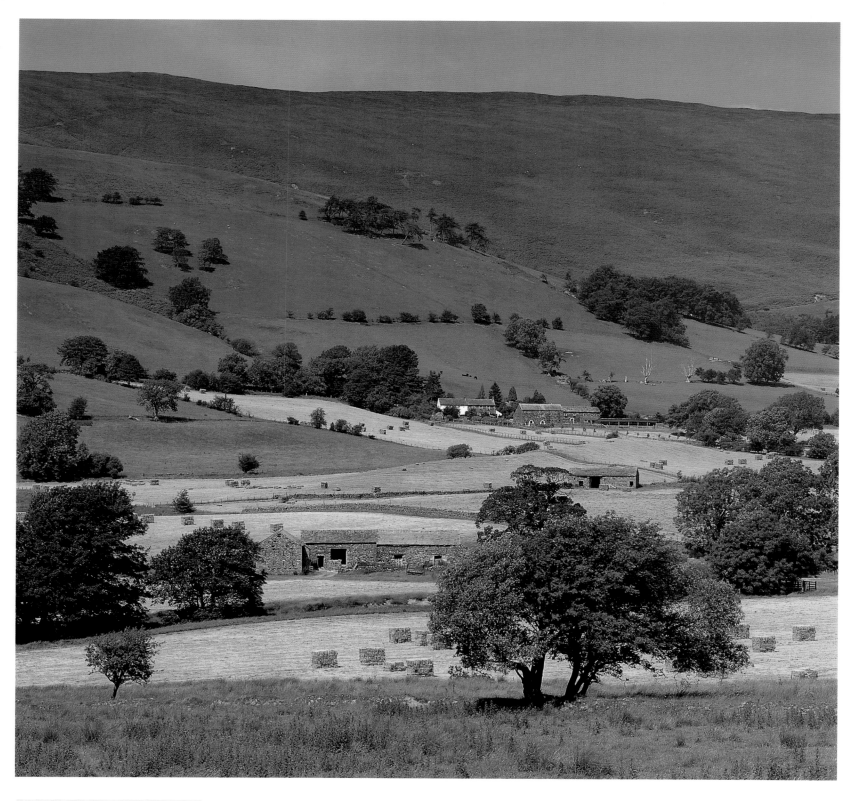

Souther Fell,
from Hutton Moor End

The most easterly of the mountain range that includes Skiddaw and Blencathra, Souther Fell (1,680 feet) is remarkable for two reasons – one natural, the other supernatural. Firstly, its base is inalmost encircled by the River Glenderamackin, to which all its waters drain. Secondly, during the eighteenth century, it was the scene of a series of ghostly apparitions. On Midsummer Eve 1735 a phantom army was seen for an hour marching across the eastern side of the summit. A few years later, again on Midsummer Eve, the army reappeared. They were last seen on the same evening in 1745, passing with horses and carriages over places that were impossible to negotiate had they been physically real. Investigation the next morning found no trace of their passage on the fell.

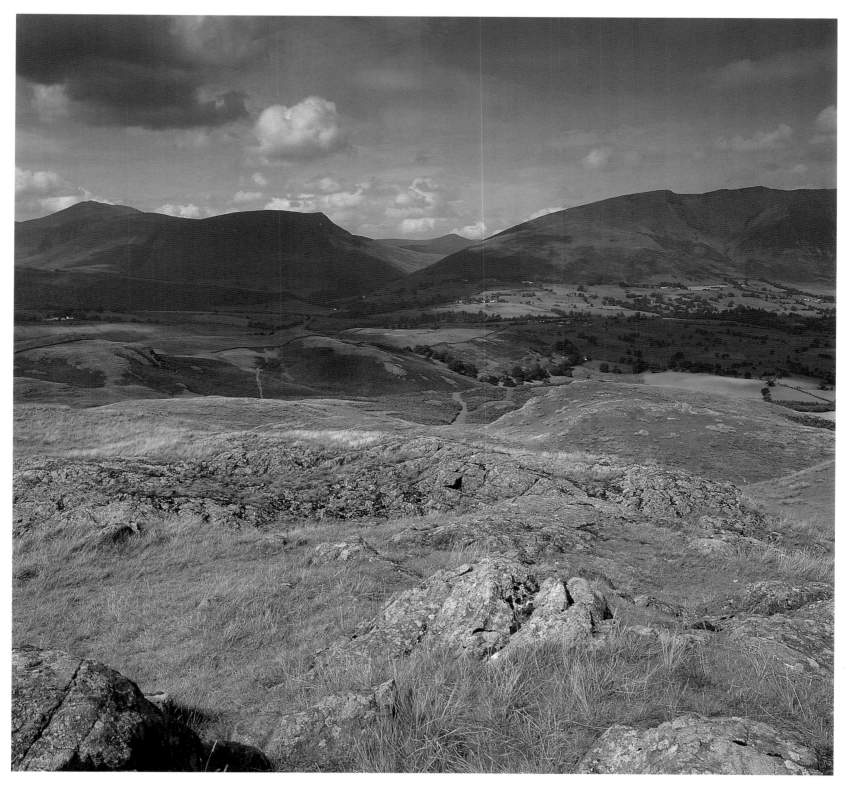

Skiddaw & Blencathra, from High Rigg

Despite its far from impressive appearance, Skiddaw (extreme left in the photograph) is the fourth highest peak in Lakeland, reaching 3,053 feet (only 110 feet lower than the highest, Scafell Pike). Among the circle of lesser heights which buttress its summit is Blencathra (right), also known as Saddleback (2,847 feet) and hailed by Wainwright as 'a mountaineers' mountain'. Separating it from the 2,344-foot Lonscale Fell (centre) is the deep, narrow valley of the Glenderaterra Beck, on the floor of which are traces of old mine-workings. On the track from Latrigg to Skiddaw, west of Lonscale Fell, stands a monument to the Hawells of Lonscale, 'noted breeders of prize Herdwick sheep'. Tewet Tarn can be seen in the centre of the photograph.

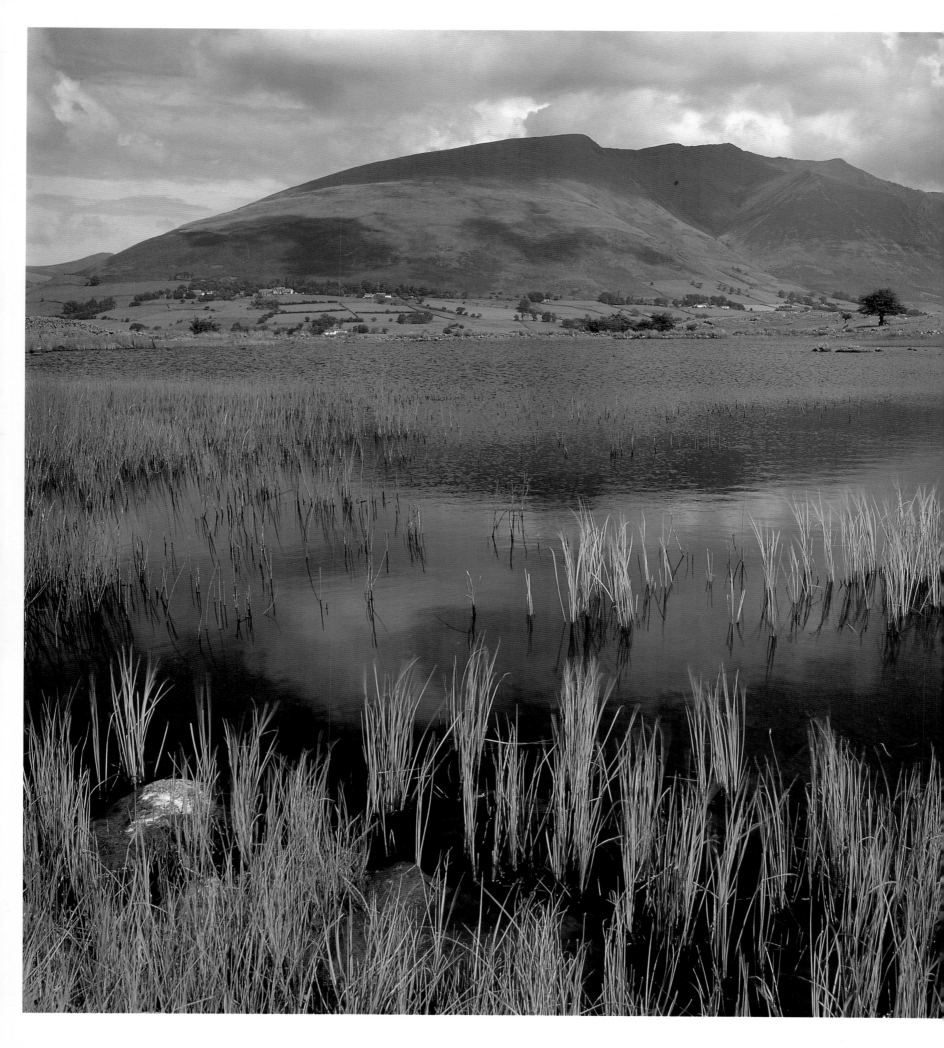

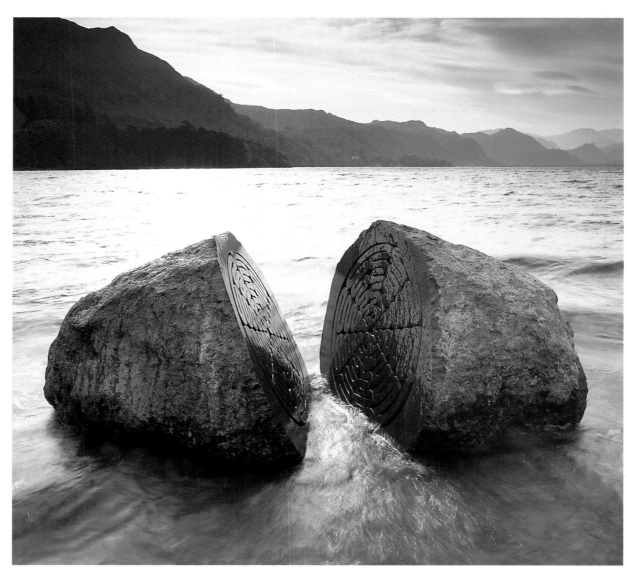

Tewet Tarn & Blencathra

The long, isolated ridge – running north–south between the Keswick–Penrith road and Thirlmere – reaches its greatest elevation on the 1,163-foot-high summit of High Rigg. To the west lies the valley of the Naddle Beck and to the east St John's in the Vale. Heading north along the ridge, towards Blencathra, the path descends 450 feet to the church of St John, before rising to the lesser height of Low Rigg, and then dropping to Tewet Tarn beyond. The tarn, lying on a tract of moorland at an altitude of about 980 feet, is also called Tewfit Tarn. Both names apparently refer to the peewit, a bird which often nests in the area. 'Being shallow,' wrote W. Heaton Cooper in *The Tarns of Lakeland* (1960), 'the tarn freezes early, and is a favourite place for the skaters of Keswick.'

Hundred Year Stone, Derwentwater

As part of its 1995 centenary celebrations the National Trust commissioned the Hundred Year Stone by Peter Randall-Page. Created from a Borrowdale glacial boulder, the sculpture was originally going to be sited at Crow Park, on the south-western outskirts of Keswick. After protests by local residents, however, it was decided to position the work further south, overlooking Calfclose Bay on the eastern shores of Derwentwater. A National Trust spokesman said: 'We felt it was very important to have local people on our side and to get those who had objected to work with us and look for an alternative site.' (*Weekend Telegraph*, 16 March 1996.) Placing art works in the landscape, it seems, can be controversial – for some they are objects of beauty, for others modernist eyesores.

St John's in the Vale & Thirlmere

Walter Scott walked with Wordsworth to St John's in the Vale in 1805 and, shortly after, composed 'The Bridal of Triermain': an Arthurian poem inspired by Castle Rock, the distinctive crag on the western side of Great Dodd, at the southern end of the valley. From a distance, according to legend, the rock is transformed into an enchanted castle, but when approached it becomes a heap of rubble. In Scott's poem, King Arthur finds the 'castle' deserted, blows his horn and brings it to life. Days turned to months before the king was able to break the spell and tear himself away, from what was only 'fragments of rock and rifted stone'. The photograph was taken from High Rigg. Castle Rock (or 'Castle Rock of Triermain') can be seen on the far side of the valley.

Sosgill Bridge, St John's in the Vale

After expressing his disappointment with the general appearance of St John's in the Vale, as it offered 'the eye too much at once – a confusion, rather than a succession, of scenery', Gilpin described a terrible storm which swept through the valley on 22 August 1749. 'During this storm the cataract fell upon the mountain, on the north side of the vale; or as some people thought, tho' I should suppose without any probability, burst from the bowels of it. The side of that mountain is a continued precipice, through the space of a mile. This whole tract, we were told, was covered, in an instant, with one continuous cascade of roaring torrent (an appearance which must have equalled the fall of Niagara) sweeping all before it from the top of the mountain to the bottom.'

St John's Church, St John's in the Vale

The old road from Matterdale passed through Wanthwaite in St John's in the Vale, then climbed west over the pass between High Rigg and Low Rigg to drop steeply into the valley of the Naddle Beck. The church of St John's – standing high on the pass, beside the road – was, therefore, conveniently situated to serve the parishioners of both valleys. The present building, incorporating fragments of an earlier foundation, dates from 1845. In addition to a small well, the churchyard contains the grave of John Richardson, a Cumbrian dialect poet of some distinction. Born in 1817 at Piper House, Naddle, he helped his father rebuild the school, next to the church (now a Youth Centre), in which he later taught. He died in 1886 at Bridge House, St John's in the Vale.

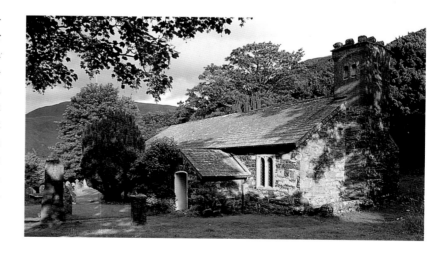

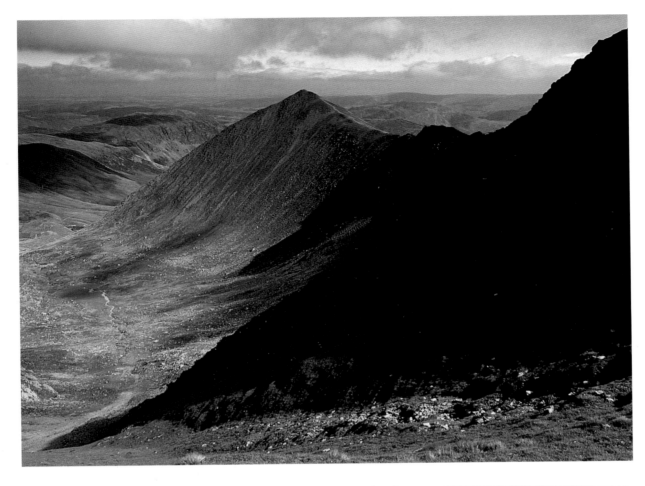

Harrop Tarn, above Thirlmere

Harrop Tarn lies in a conifer-planted hollow, beneath the fierce cliffs of Tarn Crags on the north-eastern slopes of Ullscarf. Its name is thought to derive from the Old English meaning 'the tarn in an overhanging valley littered with rocks'. In *The Tarns of Lakeland*, W. Heaton Cooper – long aware that Harrop contained 'plenty of good trout' – noted that the husband of Sarah Nelson (of Grasmere gingerbread fame) used to fish in the tarn. Because it was almost impossible to reach the water's edge, he used a method known as 'cross lining', which involved two men holding opposite ends of a baited line of hooks while hauling it across the tarn. Coleridge thought that the noise coming from the waterfall below the tarn was 'the loudest in the whole country'.

Swirral Edge & Catstye Cam, from Helvellyn

On the eastern side of Helvellyn – at 3,118 feet, the third highest mountain in Lakeland – are the sharp bony arms of Swirral Edge and Striding Edge, the former terminating in the grassy cone of Catstye Cam. Red Tarn, reaching a maximum depth of around eighty feet, lies in the basin between both edges. The diminutive Brown Cove Tarn (shown in the photograph), on the northern side of Swirral Edge, was (like Red Tarn) once dammed, and much larger. A third tarn, Kepplecove Tarn, once stood to the northeast of Brown Cove. It too was dammed. Boring, however, weakened the natural moraine which held the waters in, and, in 1927, after a day of exceptionally heavy rain, the barrier gave way, releasing a tidal wave of destruction on the unsuspecting village of Glenridding.

Wythburn Chapel, Thirlmere

All that remains of the village of Wythburn, submerged by the rising waters of the Thirlmere reservoir, is the long, low chapel (described by Wordsworth as a 'modest house of prayer, as lowly as the lowliest dwelling'). Nearby are the ruins of the Nag's Head, formerly called the Horse Head Inn. Early guide books recommended it as a good starting point for visitors intending to climb Helvellyn. About

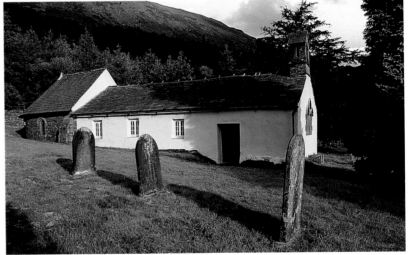

a half a mile north, stood the Cherry Tree Inn, the boisterous scene of 'the village Merry-Night' in Wordsworth's 'The Waggoner'. A little further north is the original site of the famous 'Rock of Names' (now at Grasmere). Carved on it are the initials of three Wordsworths, two Hutchinson sisters and Coleridge.

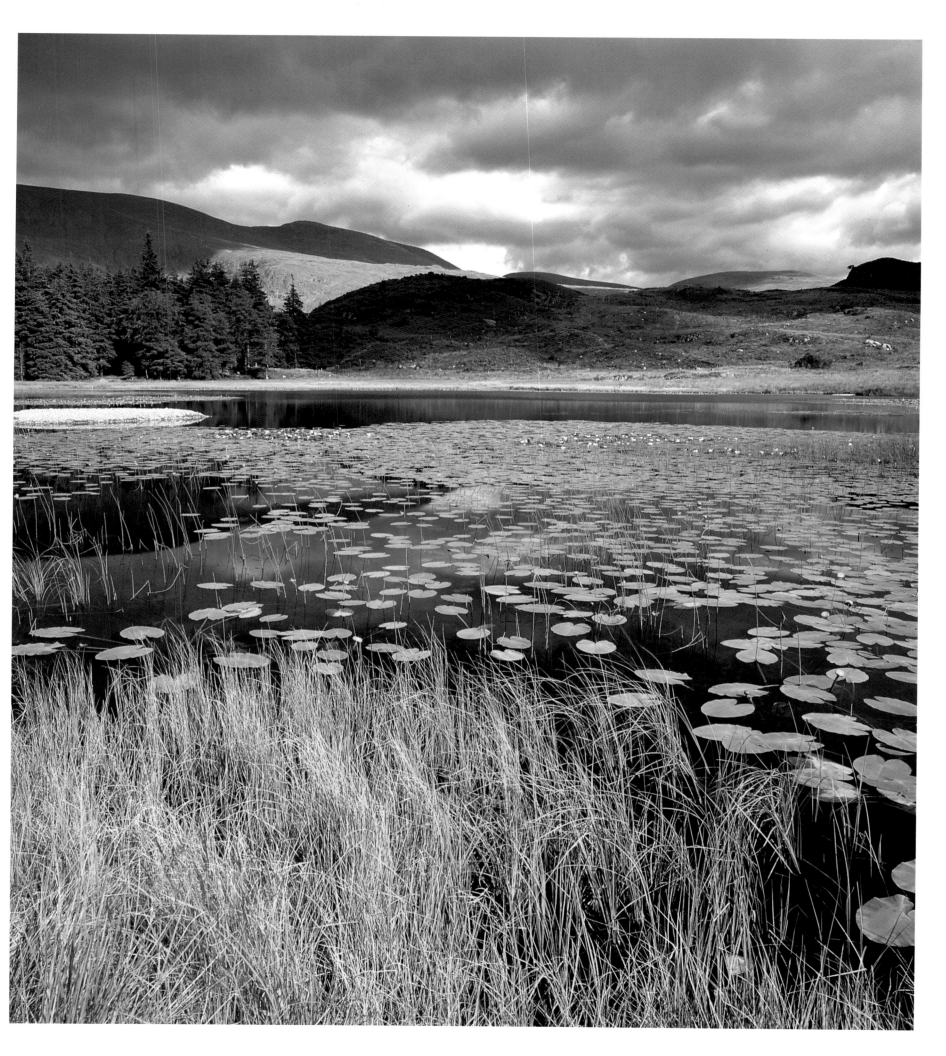

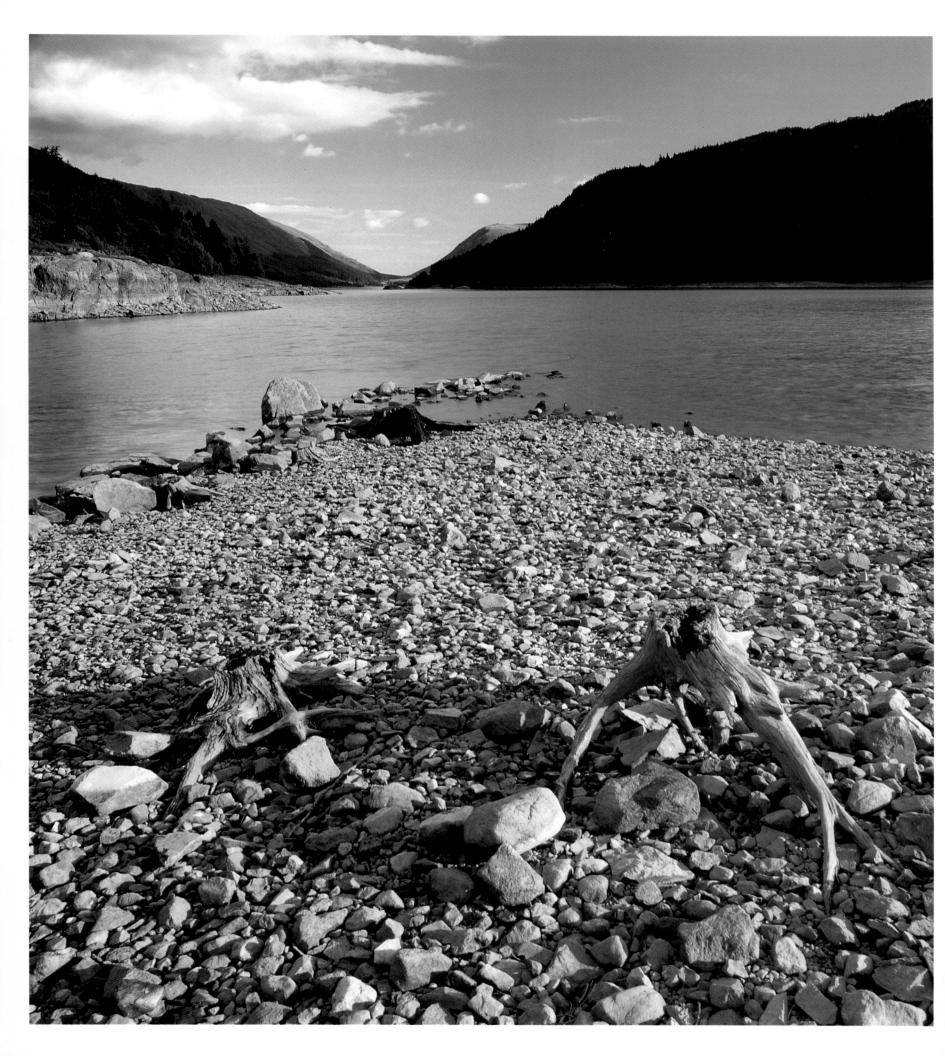

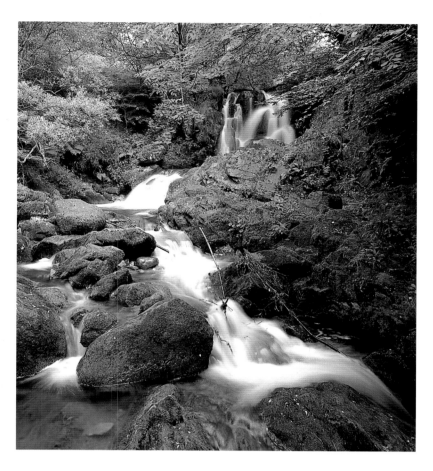

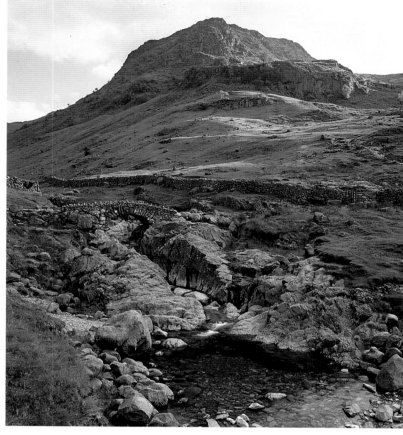

Thirlmere

When Gilpin visited Thirlmere (or Wythburn-Water) in his Lakes Tour of 1772, he found it 'an object every way suited to the ideas of desolation, which surround it. No tufted verdure graces its banks, nor hanging woods throw rich reflections on its surface: but every form, which it suggests, is savage, and desolate'. Just over a century later, the lake and catchment area, covering almost 12,000 acres, was purchased by Manchester Corporation Water Works. Despite protests, a dam was built at the northern end of the valley, and what were originally two lakes, separated by 'an Alpine bridge', became one vast reservoir, nearly four miles in length. In the process the old farming village of Wythburn was drowned. Planting of the lower fellsides with conifers began in 1908.

Helvellyn Gill, Thirlmere

The Helvellyn Gill tumbles down the western slopes of Helvellyn, through a dense swathe of conifer plantation, to eventually merge with the waters of Thirlmere. On average, the lake's sixteen-square-mile catchment area receives about ninety inches of rainfall a year. 'The cascade', wrote Gilpin of waterfalls in general, 'may be divided into the broken, and the regular fall. The first belongs most properly to the rock; whose projecting fragments, impeding the water, break it into pieces – dash it into foam – and give it all the spirit, and agitation, which that active element is capable of receiving … In the regular fall the water meets no obstruction; but pours down, from the higher grounds to the lower, in one splendid sheet. Each kind hath its beauties.'

Stockley Bridge, near Seathwaite

On the ancient packhorse route linking Borrowdale with both Wasdale (via Sty Head Pass) and Great Langdale (via Esk Hause), Stockley Bridge was badly damaged in the storm floods of 1966. At Seathwaite, further down the valley, the floodwater poured through the farmhouse, tore up the cobbling of the farmyard and deposited vast quantities of rocks and gravel on the fields. It was to be many years before the damage was repaired. Nowadays, the farming community is dependent on sheep and tourism. Yet, during Elizabethan times Seathwaite was an important 'wad'-mining centre. As well as pencils, the 'black lead' was used for medicinal purposes, glazing, and in the casting of round shot. The mineral was so valuable that the mines had to be guarded.

Grange, Borrowdale

On the west bank of the River Derwent, below the steep, craggy fellsides of Borrowdale, the tiny hamlet of Grange – consisting of a Victorian church, a Wesleyan chapel and a cluster of stone cottages – is noted for its double-arched pack-horse bridge, dating from 1675. The village end of the bridge is constructed on *roche moutonnée*, rock that has been worn smooth and deeply scratched by the pressure of grinding ice during the Ice Age. In Hugh Walpole's *Rogue Herries* (1930) old Mrs Wilson, suspected of being a witch, was thrown from the bridge into the river and drowned. The hamlet derives its name from the fact that, before the Dissolution of the Monasteries, it was the grange, or granary, of the Cistercian monks of Furness Abbey.

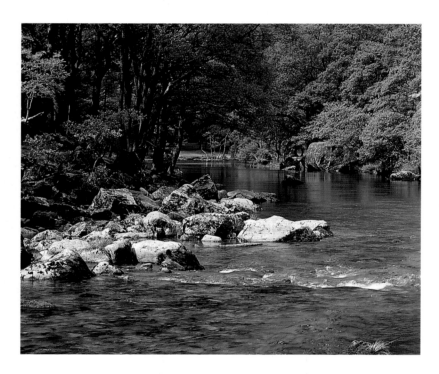

River Derwent, near Bowder Stone

Rising on the soaring heights above Seathwaite, the River Derwent flows north through Borrowdale to enter Derwentwater; eventually reaching the Irish Sea at Workington, by way of Bassenthwaite Lake and Cockermouth (the town in which Wordsworth was born). On the eastern, wooded slopes of Borrowdale, below King's How, stands an enormous cube-shaped boulder, poised on its edge and estimated to weigh around 2,000 tons. Known as the Bowder Stone, it is roughly thirty-six feet high and sixty-two feet long, with wooden steps up one side to allow visitors access to the top. It was popularly thought that the boulder had fallen from the crags above, but it is far more likely to have been deposited in its delicately balanced position by melting glacial ice.

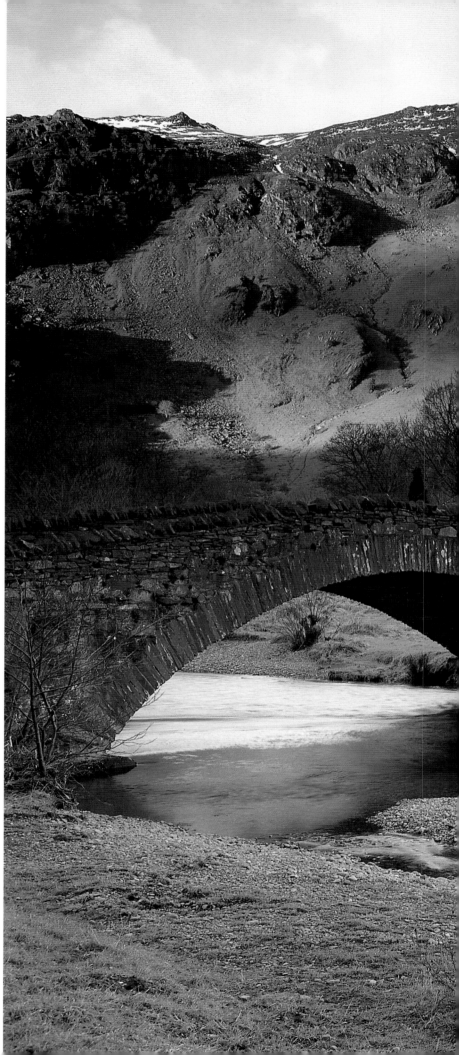

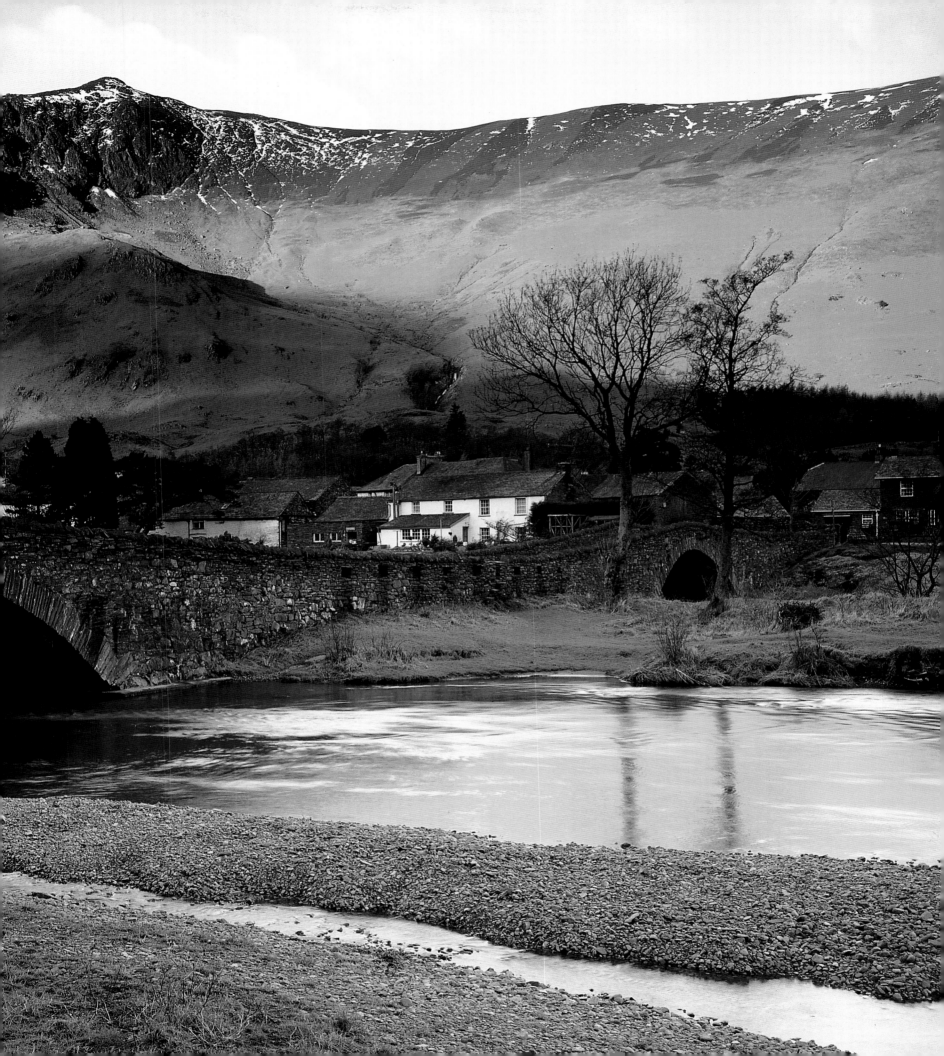

Langstrath Beck, Borrowdale

On her 'Great Journey to New-castle and to Cornwall' in 1698, Celia Fiennes wrote about Lakeland's mountain streams and waterfalls: 'From these great fells there are several springs out of the rock that trickle down their sides, and as they meet with stones and rocks in the way when something obstructs their passage and so they come with more violence that gives a pleasing sound and murmuring noise; these descend by degrees, at last fall into the low grounds and fructify it which makes the land so fruitful in the valleys.' The Langstrath Beck has its source in Angle Tarn, on the dark, sunless side of Bowfell (2,960 feet). After merging with the Stonethwaite Beck at Smithymire Island, its waters enter the River Derwent, near Rosthwaite.

Yew Tree Farmhouse, Stonethwaite

Although most of Borrowdale belonged to either Furness Abbey or Fountains Abbey, ownership of the land around Stoneth-waite – being ideal for dairy farming – was claimed by both monasteries. In the early fourteenth century, the Crown reclaimed the disputed land and sold it to the monks of Foun-tains, who, for a short period, man-aged it as a 'vaccary' or cattle ranch. The monks also smelted iron ore at a 'bloomery' on 'Smithymire Island' (near the confluence of the Stoneth-waite Beck, the Langstrath Beck and Greenup Gill). After the Dissolution all the monastic land in Borrowdale passed to the Crown, and was even-tually sold to private individuals. In the seventeenth and eighteenth cen-turies many of the farmhouses were enlarged or rebuilt with solid stone walls, then lime-washed.

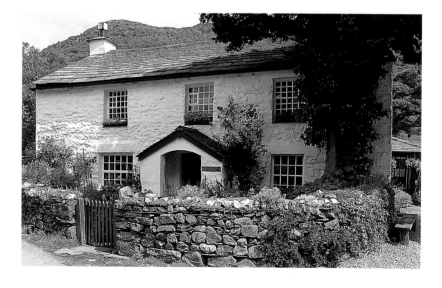

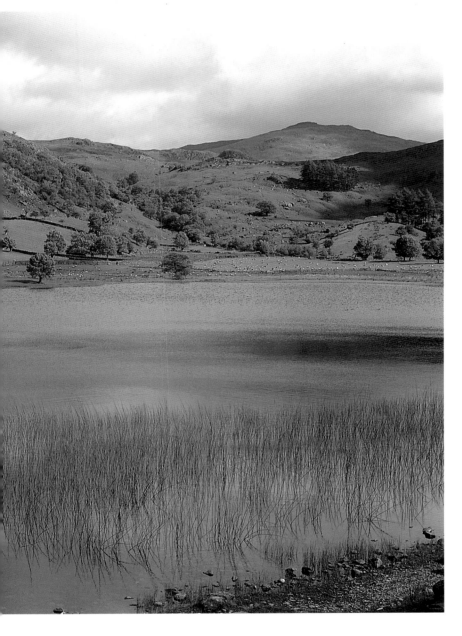

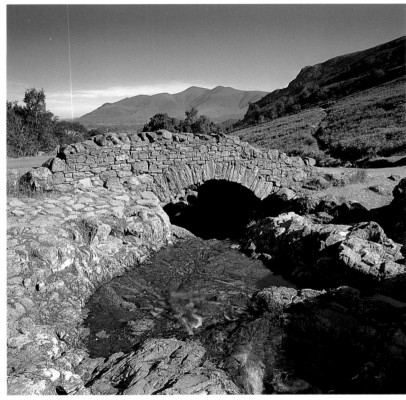

Watendlath Tarn

From Blea Tarn, below Coldbarrow Fell, Bleatarn Gill flows northward into the trout-stocked Watendlath Tarn to emerge as the Watendlath Beck. When owned by the medieval monks of Fountains Abbey the cultivated fields around the tarn were enclosed by a stone wall or 'ring-garth', to regulate the movement of grazing sheep and cattle. After the Dissolution, more and more of the fellsides were gradually enclosed as 'intakes', mainly for pasture. By the mid-eighteenth century the fell tops had also been enclosed, while the fields within the 'ring-garth' were divided up by walls (as they had ceased to be farmed 'in common'). Today, the fields – owned by the National Trust, as is all of Watendlath – are mainly used for grazing sheep and cattle.

Ashness Bridge

Probably built at the beginning of the eighteenth century, Ashness Bridge was originally used by packhorses on the old route from Keswick to Watendlath. It is also wide enough to be used by cars. Situated on the narrow, winding road above Borrowdale, three miles south of Keswick, it is the most famous and most photographed bridge in Lakeland. Looking north-westward the view includes Derwentwater, and Bassenthwaite Lake beyond, with distant Keswick nestling at the foot of the Skiddaw range. Ashness Gill – the stream which runs under the bridge to eventually enter Derwentwater – rises on the heather-clad slopes of High Seat (1,995 feet). Nearby, Ashness Wood, owned by the National Trust, supports not only ash trees, but oak, holly, sycamore, beech and fir.

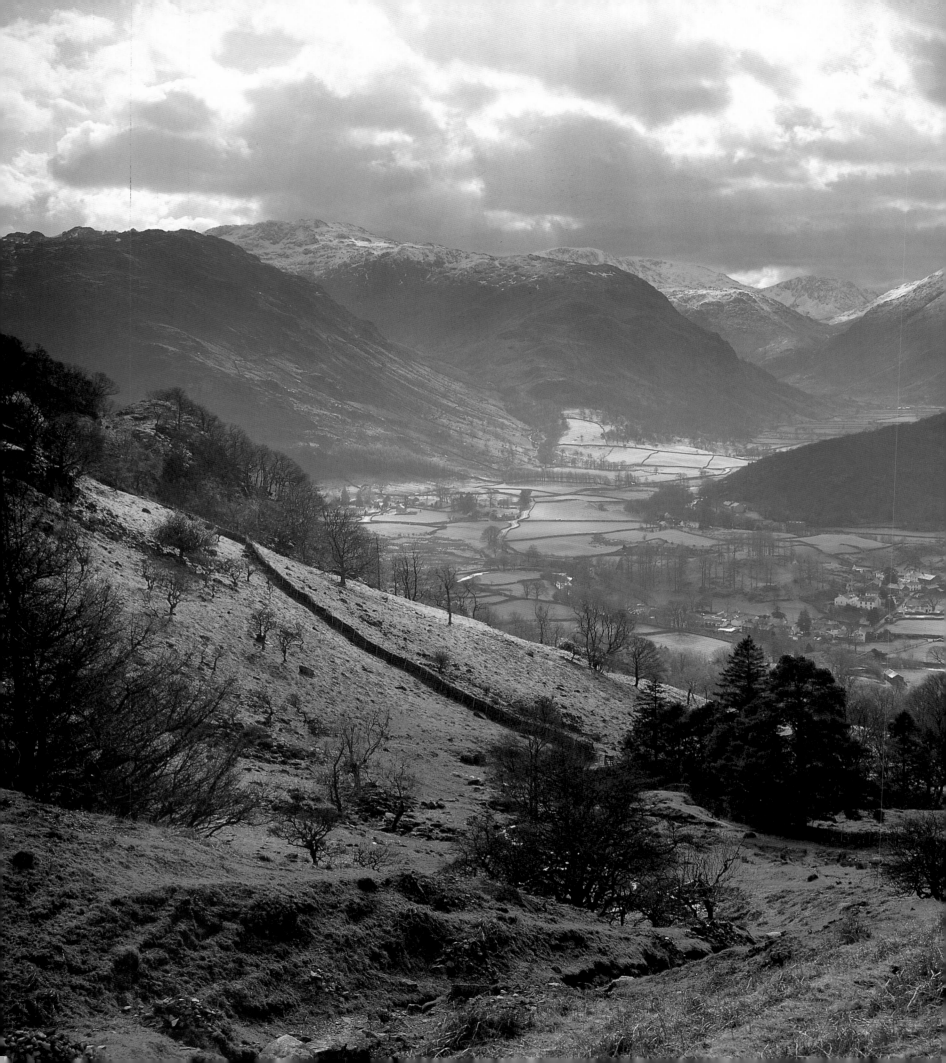

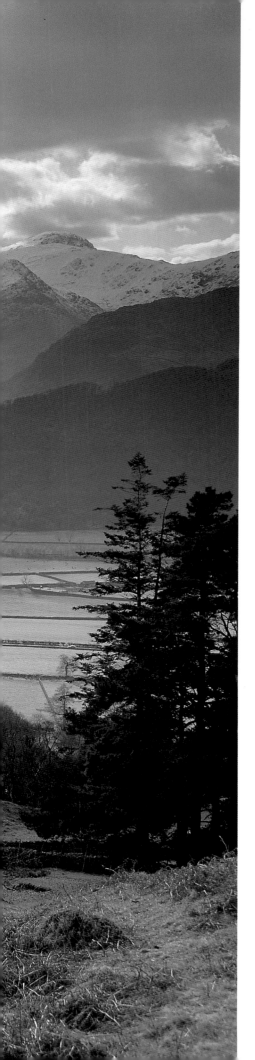

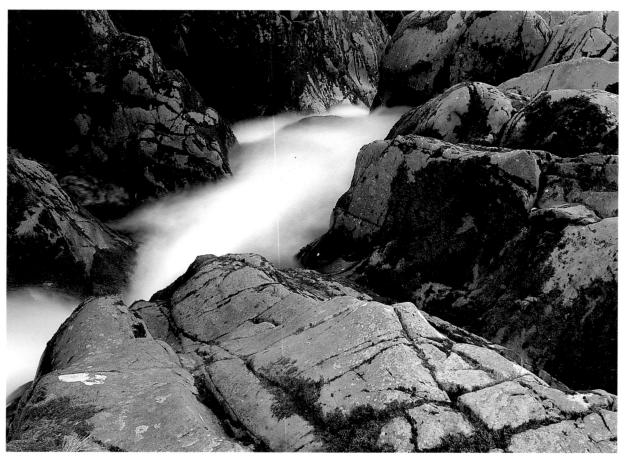

Rosthwaite & Stonethwaite, Borrowdale

Travelling south from Keswick the steep fellsides narrow dramatically towards the Jaws of Borrowdale, only to open, beyond, into a broad patchwork of green meadows and lush pastures, with scattered farmsteads and hamlets, nestling beneath a ring of some of the most striking fells in Lakeland. Rosthwaite, the largest of the four settlements in upper Borrowdale, consists of a cluster of farmsteads and cottages centred on two hotels and a general store. Stonethwaite is about a mile south-east of the hamlet; while Seatoller and Seathwaite lie on the western side of the valley. When Gilpin journeyed south towards Borrowdale in 1772 he narrowly escaped being struck by 'some large stones', pushed from the cliffs above by a 'fat group of mountaineer children', unaware of those below.

Galleny Force, Borrowdale

One route up Ullscarf (2,370 feet) from Stonethwaite follows the valley of the Stonethwaite Beck to Galleny Force, from where it climbs up the tributary valley of Greenup Gill. Galleny Force, one of Lakeland's many small and unsung waterfalls, lies near the confluence of the Langstrath and Stonethwaite becks. After heavy rainfall the streams at the head of Borrowdale can rapidly rise to flood proportions. Picking up stones and boulders on their downward course, the rushing torrents can damage or destroy anything that gets in their path, including houses and bridges. Following the destructive floods of 1966, defensive measures have been taken to reduce the impact of flash floods in Borrowdale, including straightening sections of certain streams.

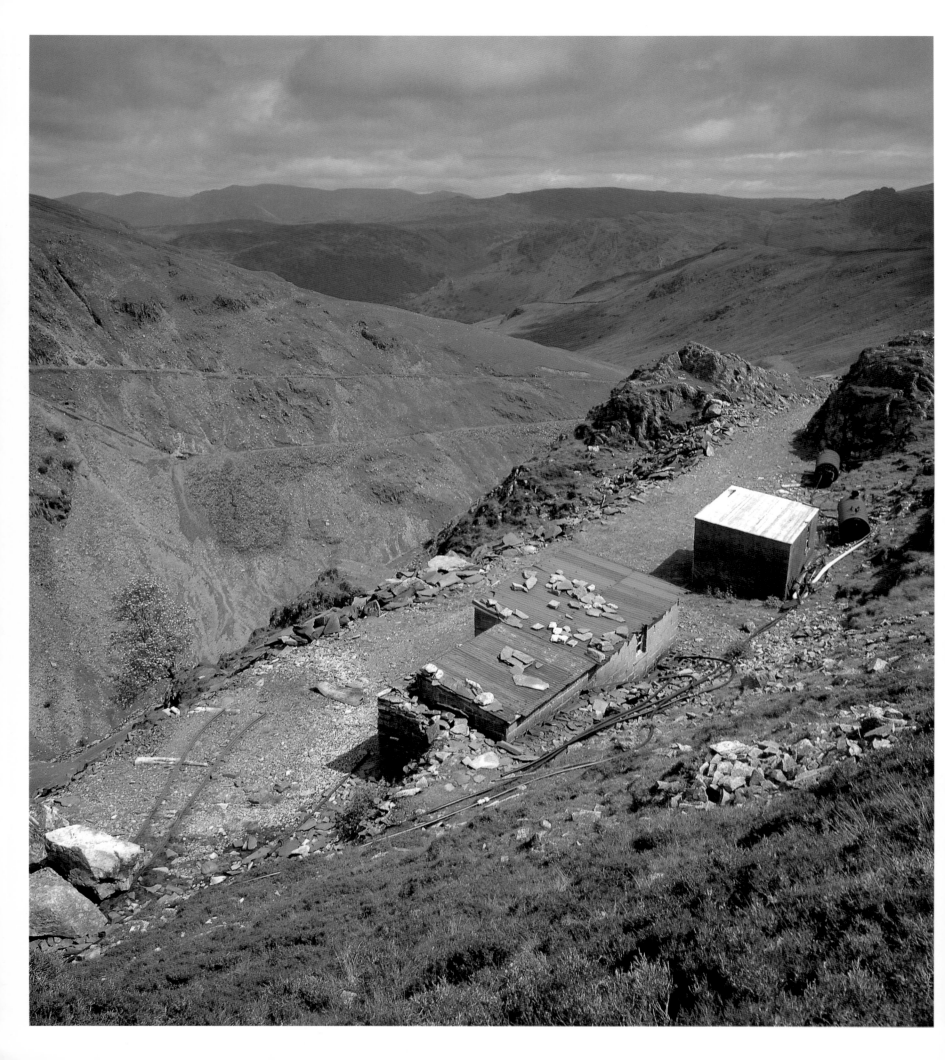

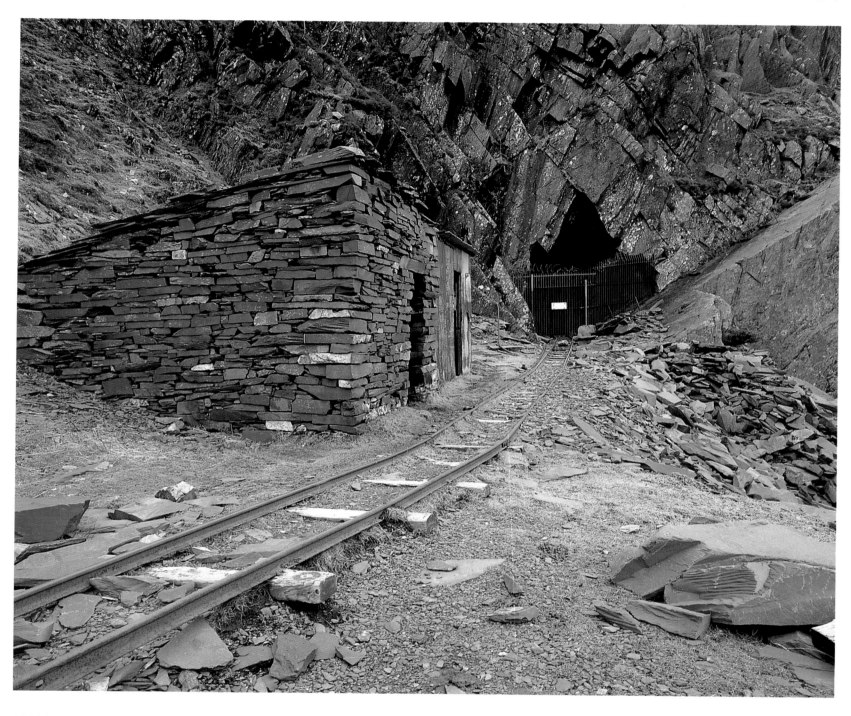

Honister Quarry

Before the construction of a gravitational railway in the late nineteenth century, bringing slate down from Honister Crag was extremely hazardous, as it involved the quarryman running at speed in front of the loaded sled, having 'nothing more to do than keep it in the tract, and prevent it from running too fast.' (James Clarke, *A Survey of the Lakes of Cumberland, Westmorland and Lancaster*, 1787). Although the average daily run was seven to eight journeys – carrying about a quarter of a ton of slate each time – a Stonethwaite man, Joseph Clarke, is reputed to have achieved the incredible feat of bringing down almost five tons in seventeen descents. Today the workings are closed. And barring the harsh, echoing cry of the scavenging ravens, all is silent.

Honister Crag

Immediately after leaving Seatoller, the Borrowdale road from Keswick climbs steeply to Honister Hause (1,190 feet), before descending into the Buttermere valley. Honister Crag, a towering cliff overlooking the boulder-strewn pass, has been quarried for its attractive green volcanic slate since at least the mid-seventeenth century. The crag is honeycombed by a vast labyrinth of tunnels that penetrate the rock at different levels. The photograph was taken at the Road End entrance of the abandoned workings. The two-foot-wide rails once carried trucks into and out of the underground tunnels, while the cabins were used for rest and shelter. Further evidence of extensive quarrying can be seen on Yew Crag on the opposite side of the valley.

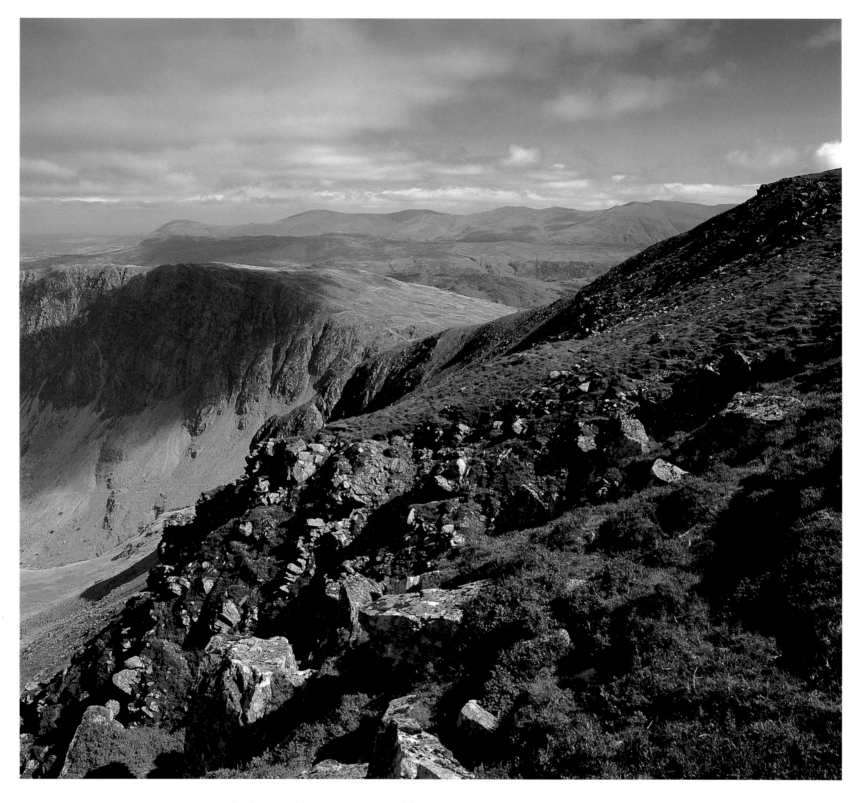

Dale Head & Eel Crags

Although Dale Head (2,473 feet) dominates the northern side of Honister Pass, the fell received its name from its commanding position at the head of Newlands (the valley further north). Wainwright considered it to have one of the 'most satisfying summits in the north western area'. Scars of copper mining, including spoil heaps and ruined buildings, can be found on the Newlands side of the fell, while evidence of slate quarrying abounds on its southern flanks. Adjoining Dale Head to the north-east is the formidable mile-long precipice of Eel Crags, rising to the summit of High Spy. Several small ridge tarns, including Dalehead Tarn, Launchy Tarn and High Scawdel Tarn, lie on the moorland east of Dale Head summit. Near the former is an old sheepfold, used to hold sheep before dipping.

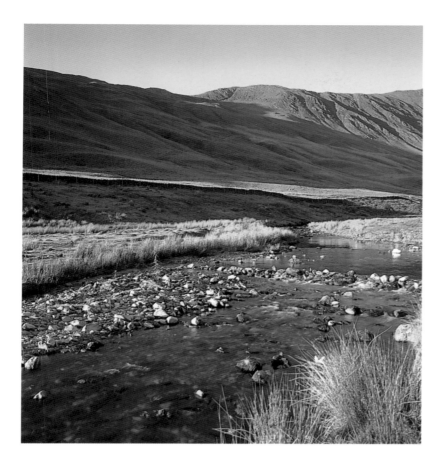

Gatesgarthdale Beck, Honister Pass

East of the Honister Hause watershed the streams that drain into the Buttermere valley (which include the Gatesgarthdale Beck) become the River Cocker; while those to the west become the Derwent. Both rivers eventually unite at Cockermouth. Honister Pass, the boulder-strewn valley of the Gatesgarthdale Beck, runs north-westward from the Hause for some two miles to Gatesgarth – from whence an old packhorse route climbs up the neighbouring valley of Warnscale Bottom to Scarth Gap Pass. For those Victorian tourists doing the 'Buttermere Round' the highlight of the trip was undoubtedly the journey through Honister Pass. Invariably, when the road became too steep for the horses to climb with a full load, the passengers had to get out of the carriage and walk.

Buttermere & Warnscale Bottom, from Crag Wood

Rising from the deep trough of Warnscale Bottom, near Gatesgarth, Haystacks – despite reaching 1,900 feet – is almost encircled by much loftier fells. The rocky summit supports two main tarns, both located on the routes from Honister Pass and Warnscale Bottom: Blackbeck Tarn, the largest; and Innominate Tarn, so called because it was 'unnamed'. One of the routes to the Haystacks' summit follows the old quarry road from Gatesgarth up to the slate-heaps of the abandoned Dubs Quarry. Haystacks stands in the middle of the photograph (not in shadow), with Fleetwith Pike on the left, and High Crag on the right. Near Crag Wood, on the northern side of Buttermere lake, is a short tunnel cut out of the solid rock, now closed for safety reasons.

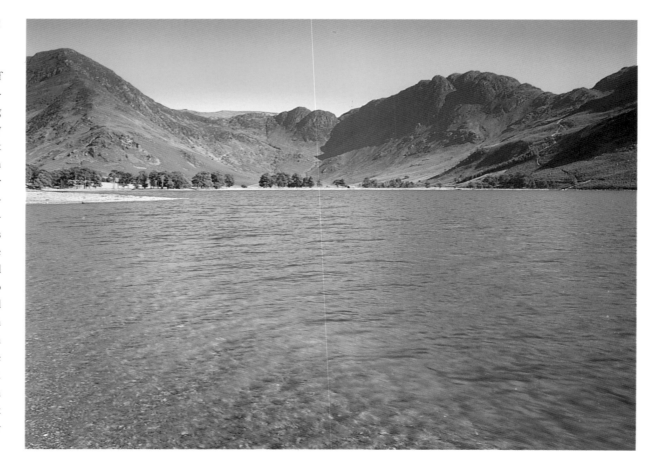

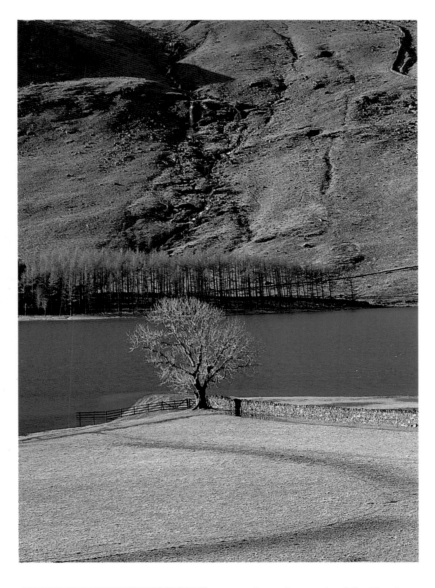

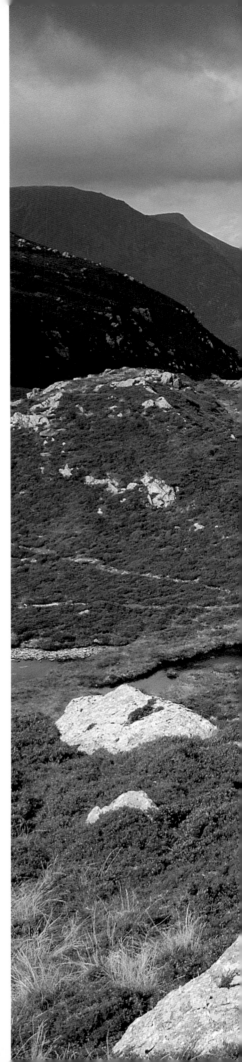

Buttermere Valley, from Fleetwith Pike

The view north-westward down the Buttermere valley from Fleetwith Pike (2,126 feet), includes Buttermere, Crummock Water and Loweswater. 'Buttermere' is derived from the Old English butere and mere meaning 'the lake by the dairy pastures' – a reference to the lush, green meadows of the alluvial plain separating Buttermere and Crummock Water (two lakes that were once one). Buttermere village stands on the northern side of the plain. From its tiny church, one route to Keswick climbs steeply up to Newlands Hause (1,096 feet), before descending into the Newlands Valley. The valley of Buttermere and Crummock Water was featured in Nicholas Size's historical romance entitled *The Secret Valley* (1930), in which the Lakeland army of Earl Boethar vanquish the Normans at the battle of Rannerdale.

Burtness Comb, Buttermere

During the Ice Age the enormous power of glacial erosion deepened the main Buttermere valley, and left a small 'hanging' valley beneath the summits of High Stile and Red Pike. After prolonged or heavy rain the water that collects in this upper valley spills over, down the steep walls of the fellside in a number of attractive falls, like those formed by Burtness Comb and Sour Milk Gill. The latter is fed by Bleaberry Tarn. These mountain streams wash soil and rock down into Buttermere and the resulting silt is deposited in the gradually widening plain that separates the lake from Crummock Water. The larch plantation of Burtness Wood, owned by the National Trust, is gradually being replaced with native oaks.

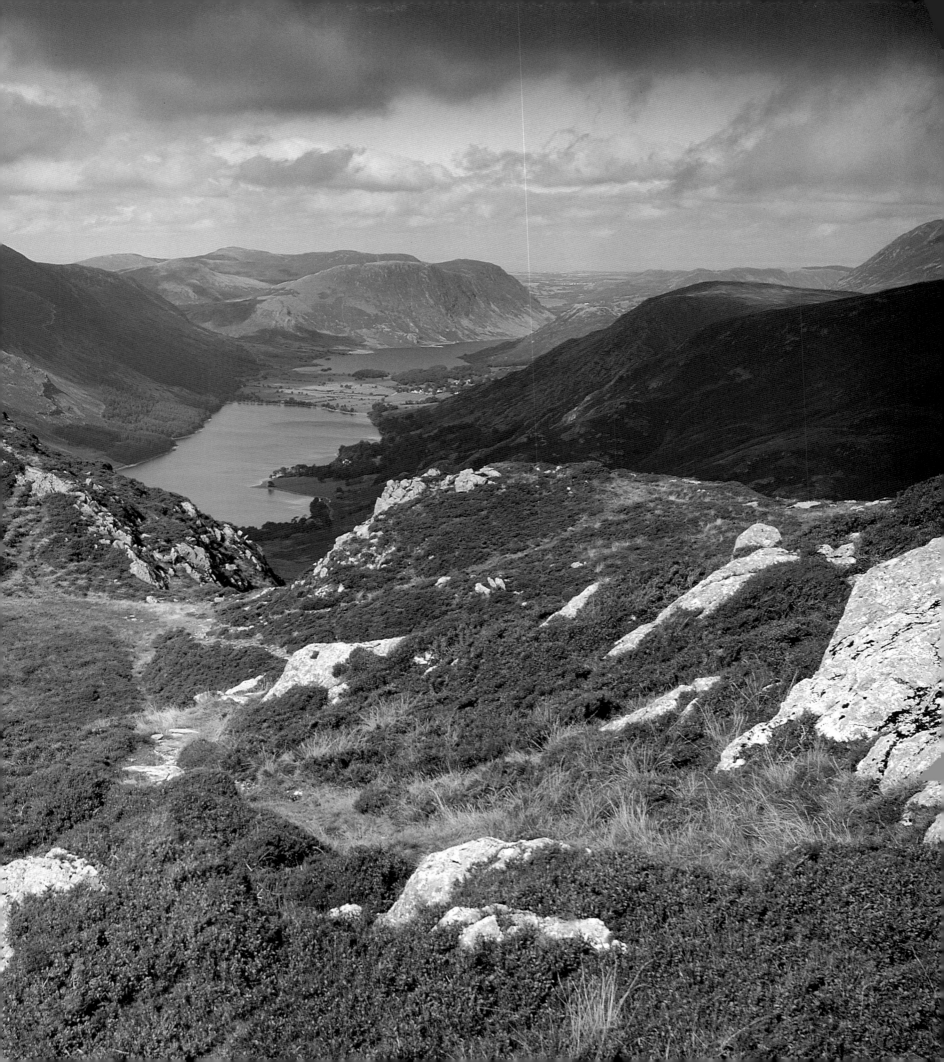

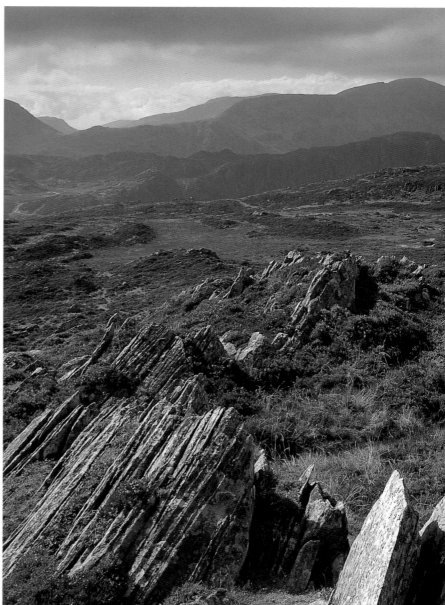

St James's Church, Buttermere

In his *Guide* Wordsworth wrote: 'A man must be very insensible who would not be touched with pleasure at the sight of the chapel of Buttermere, so strikingly expressing, by its diminutive size, how small must be the congregation there assembled, as it were, like one family; and proclaiming at the same time to the passenger, in connection with the surrounding mountains, the depth of that seclusion in which people live, that has rendered necessary the building of a separate place of worship for so few.' Standing on elevated ground above the village of Buttermere (with its two inns and a cluster of stone-built cottages), the present church of St James dates from 1840. Inside is a memorial window to Wainwright, through which Haystacks, 'his favourite place', can be seen.

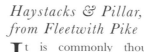

Haystacks & Pillar, from Fleetwith Pike

It is commonly thought that Haystacks got its name from its similarity in shape to a haystack, but it is more likely to be derived from the Old Norse word meaning 'high rocks'. In 1991 the ashes of Alfred Wainwright, the legendary fellwalker, were scattered on the rocky summit of the fell, under the watchful eyes of Pillar and Great Gable. In *Fellwanderer* (1966) he anticipates the event, but warns with typical self-mocking humour: 'And if you, dear reader, should get a bit of grit in your boot as you are crossing Haystacks in the years to come, please treat it with respect. It might be me.' In the photograph, Haystacks can be seen in the middle distance, in front of the massive bulk of Pillar. Lying between the two fells is upper Ennerdale.

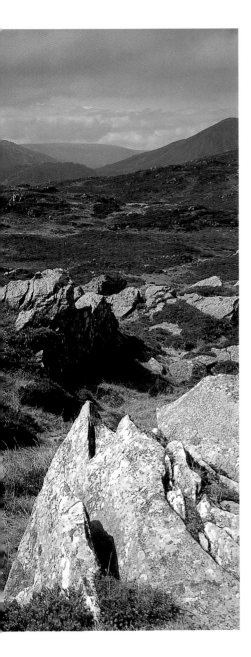

Buttermere, from Dale Head

Soaring steeply above the Honister Pass road (shown in the photograph), and opposite the ridge between Dale Head and Robinson, is the craggy northern face of Fleetwith Pike (of which Honister Crag is a part). From Gatesgarth, near the head of Buttermere, the direct route up to its summit, passes a prominent white cross, erected in memory of Fanny Mercer, who fell to her death on the rocks in 1887. Rising from the southern shore of Buttermere is a steep and rugged wall of fells, topped by three distinct summits – High Crag (2,443 feet), High Stile (2,644 feet) and Red Pike (2,479 feet). Wainwright considered that 'no mountain range in Lakeland is more dramatically impressive than this, no other more spectacularly sculptured, no other more worth climbing and exploring'.

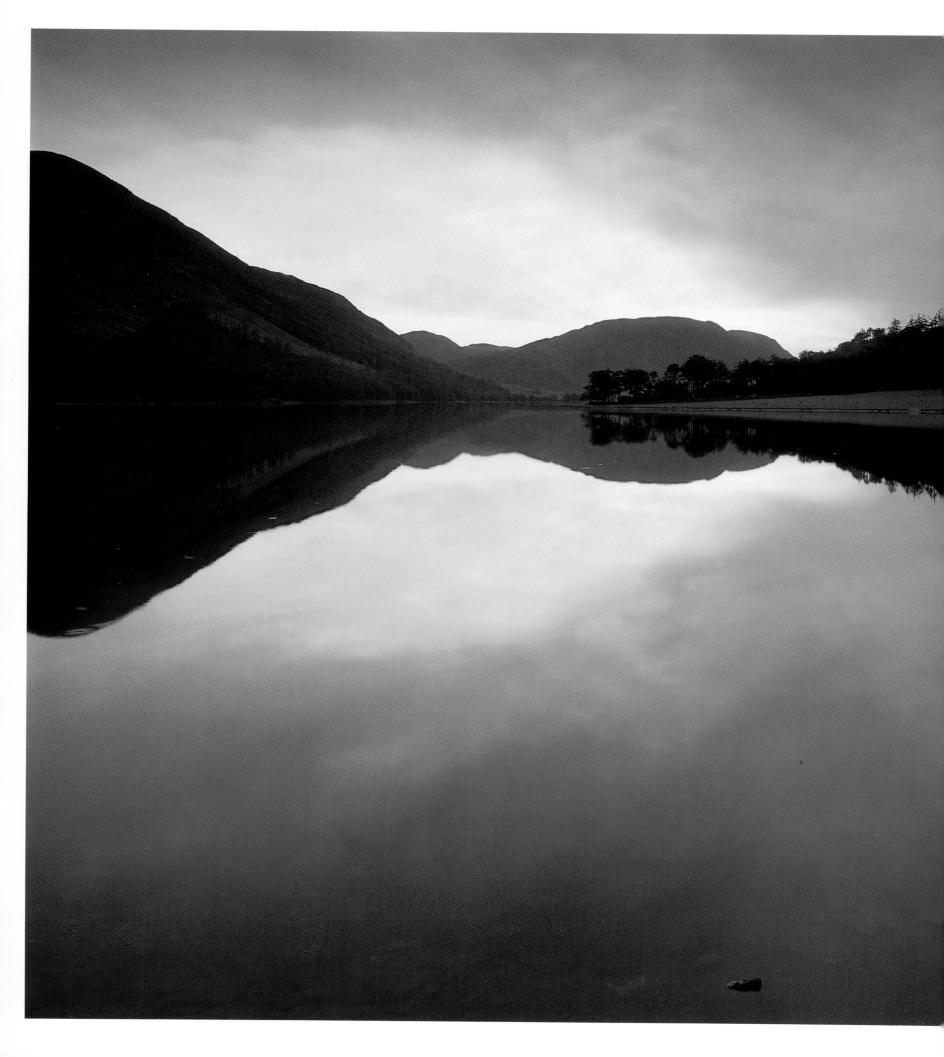

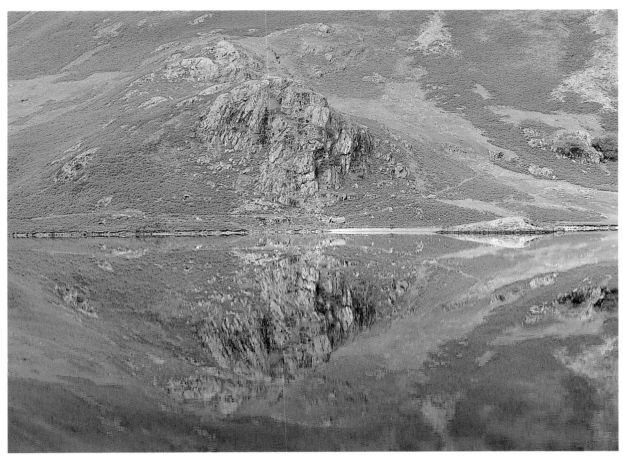

Buttermere, from Gatesgarth

In 1802 Buttermere village made national headlines when it was discovered that Mary Robinson, the daughter of the landlord of the Fish Inn, had been tricked into marriage by a man calling himself the Hon. Augustus Hope, MP. He turned out to be a rogue, an impostor and a bigamist. Mary became a local celebrity after being mentioned (incorrectly as Sally) by Captain Joseph Budworth in his best-selling book *A Fortnight's Ramble in the Lakes* (1792); and the Fish Inn became an essential stopping-place on the itinerary of the 'Lakers'. Hope, whose real name was John Hatfield, stood trial at Carlisle in 1803 and, after being found guilty of forgery, was hanged. Mary, known as the 'Maid of Buttermere', later married Richard Harrison of Caldbeck.

Ling Crags, Crummock Water

Strung out along a glacial valley, the three lakes of Buttermere, Crummock Water and Loweswater lie almost entirely on Skiddaw Slate, the oldest rock in Lakeland and one of the oldest in the world. An ancient mud-rock, it breaks easily into small fragments to form screes and eventually soil. Particularly striking are the scree slopes on the eastern side of the isolated Mellbreak (1,676 feet), which drop steeply to the shore of Crummock Water. After visiting the valley, West wrote in his Lakeland *Guide* of 1778: 'Here the rocky scenes and mountain landscapes are diversified and contrasted with all that aggrandises the object in the most sublime style, and constitute a picture the most enchanting of any in these parts.'

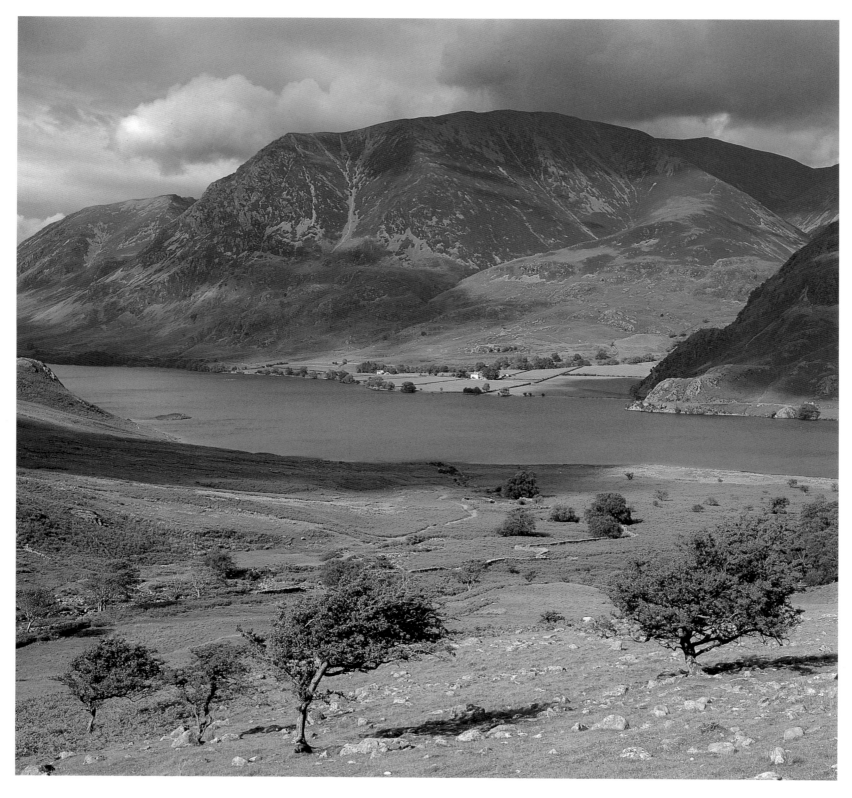

Crummock Water & Grasmoor, from Scale Knott

The fells of north-western Lake-land culminate in the massive bulk of Grasmoor, which rises from the eastern shores of Crummock Water to a broad, grassy plateau (the actual summit is marked by a huge wind-shelter cairn 2,791 feet above sea-level). From the level pastures of Rannerdale (centre of photograph), there are two alternative routes of ascent: one via the scree slope of Red Gill, and the other via the curving ridge of Lad Hows. The latter, despite being longer, is less arduous and offers more extensive views. Although its name is often said to mean 'grass moorland', the first part of 'Grasmoor' – like 'Grisedale' or 'Grizedale' – is derived from the Old Norse for 'swine' or 'wild boar'. Few traces now remain of the medieval settlement of Rannerdale.

Scale Force, Buttermere Valley

With a single drop of 172 feet, Scale Force is the biggest waterfall in Lakeland. In a letter to Sara Hutchinson, dated 25 August 1802, Coleridge compared it with 'Buttermere Halse Fall' (Moss Force, by Newlands Hause) and Lodore (near Keswick): 'never were there three Waterfalls so different from each other ... Scale Force is a proper Fall between two very high & narrow Walls of Rock, well tree'd – yet so that the Trees rather add to, than lessen the precipice Walls. – Buttermere Halse Fall is a narrow, open, naked Torrent with three great Water-slopes individualised in it one above another, large, larger, largest –. Lodore has its Walls, but they are scarcely Walls, they are wide apart, & not upright, & their beauty & exceeding Majesty take away the Terror.'

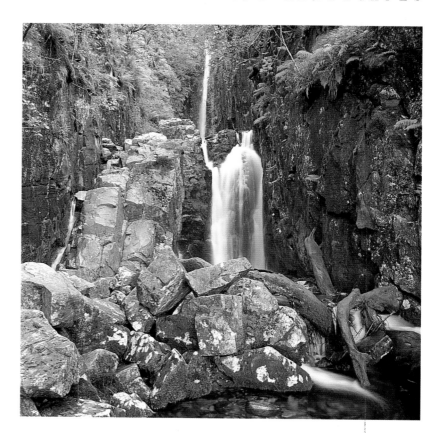

Crummock Water, from Nether How

Almost double the size of Buttermere, Crummock Water is some two-and-a-half miles long, over half-a-mile wide and 144 feet deep. Its name probably means 'the lake of the crooked river' – a reference to the River Cocker which emerges from its northern end. ('Cocker' is thought to be derived from the British or Celtic word for 'crooked'.) The lake, incidentally, is fed by water from Buttermere and by numerous streams which rise on the surrounding fells, including Scale Beck (noted for its waterfall). Mellbreak is on the left in the photograph, and Rannerdale Knots, part of Whiteless Pike (2,159 feet), on the right. In the distance are the grassy, rounded hills of Fellbarrow and Low Fell – the former (being slightly higher than the latter) reaching 1,363 feet.

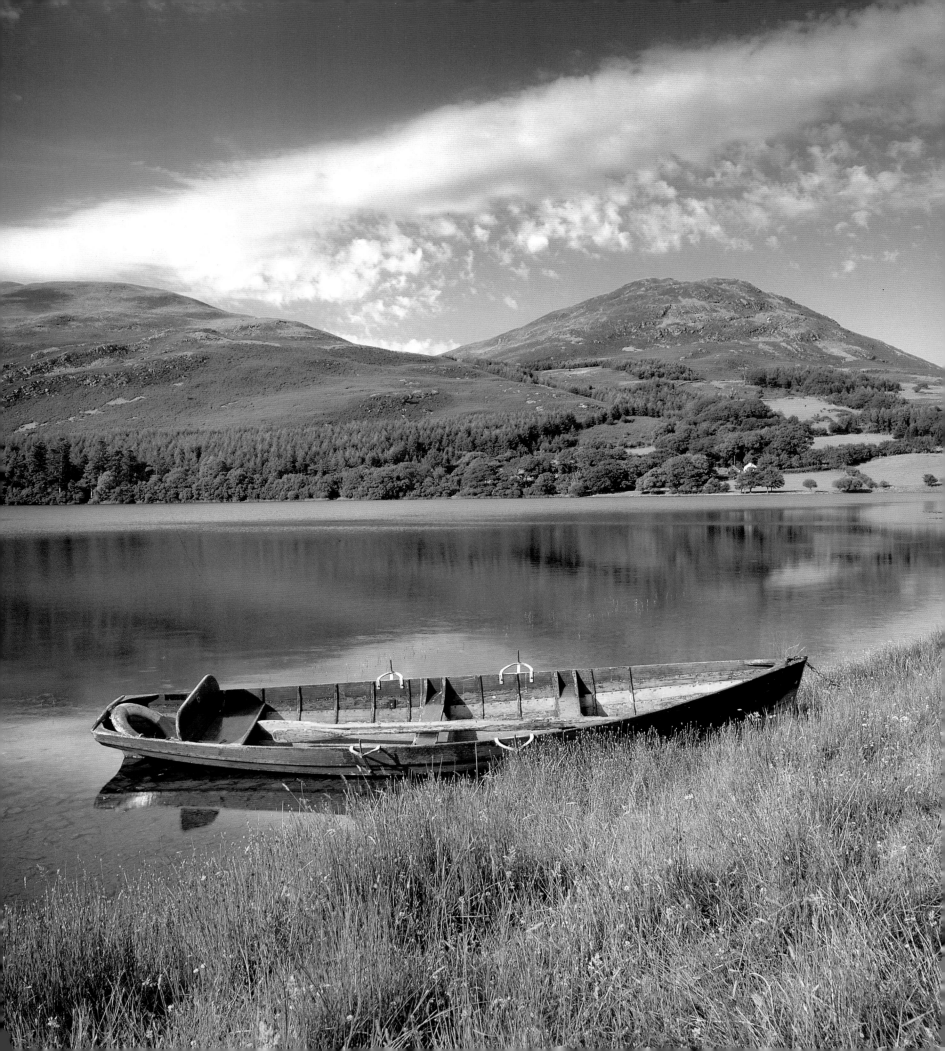

Loweswater & Low Fell

Loweswater is the only lake with an outlet flowing inwards towards the centre of Lakeland. This outlet, Park Beck, crosses a flat, fertile alluvial plain to enter the northern end of Crummock Water. Scattered across the plain are the farms and cottages of Loweswater village. The parish church of St Bartholomew was almost entirely rebuilt in 1884 in anticipation of a significant increase in parishioners following the opening of the nearby Godferhead lead mine. In the event, the mine failed and the population remained static. The occupants of Crabtree Farm (in the photograph) were tragically killed when a dam burst on Low Fell, above, in 1828. Traditional clinker-built rowing boats, used by local fishermen for catching trout, are available for hire during the season.

Mockerkin Tarn, near Ullock

Lying amid rolling farmland at the foot of the Lakeland fells, some five miles south-west of Cockermouth, Mockerkin Tarn is traditionally the site of the palace of Morken, a Cumbrian king. According to Jocelyn, a monk of Furness Abbey and the author of the *Life of St Kentigern* (*c.* 1180), Morken was buried in his royal town at 'Thorpe Morken' (Mockerkin?). In *Cumbriana* (1875) William Dickinson recorded, in ballad form, 'The Legend of Mockerkin Tarn'. From his fortress at Mockerkin, the evil 'Sir Mochar the dwarf' and his followers tyrannized the surrounding countryside. One night, after finding his gatekeeper asleep, he vowed to kill every man, 'if his castle sank twenty miles deep'. It did. He and his charger, 'black Rook', reputedly haunt the tarn.

Loweswater, from Holme Wood

Loweswater is just over a mile long, half-a-mile broad and about sixty feet deep. In his *Guide* West wrote of the lake: 'The extremities are rivals in beauty of hanging woods, little groves, and waving inclosures, with farms seated in the sweetest points of view.' On the south-western shore of the lake is Holme Wood, a mile-long swathe of woodland owned – like all three lakes in the Buttermere valley – by the National Trust. Hidden amid the trees is a small waterfall, Holme Force. The wood itself consists of conifers on the higher slopes, with oak, ash, alder, elm and birch below. The red squirrel, whose favourite habitat is conifers, can be found in the locality. The farmhouse (shown in the photograph) is Miresyke, on the south-western slopes of Low Fell.

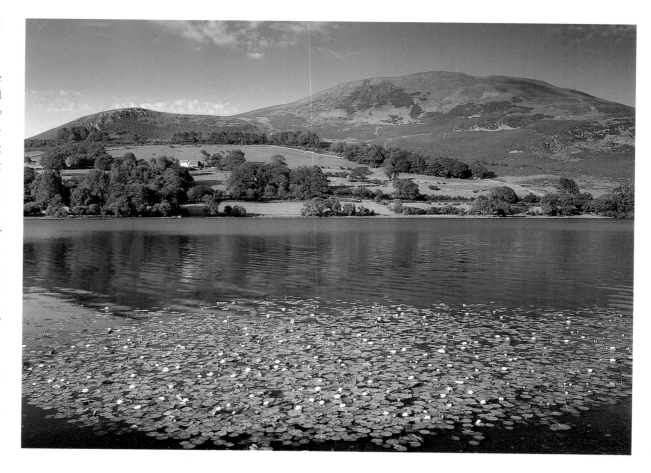

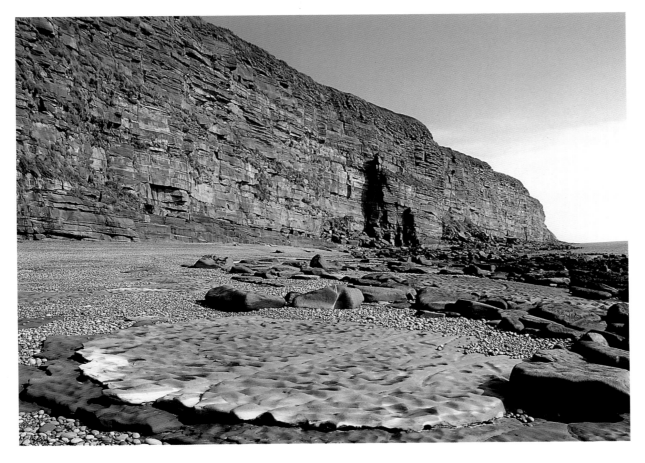

St Bees Head

North-west of the historic village of St Bees, with its wide promenade and sandy beach, are the precipitous red sandstone cliffs of St Bees Head, topped by a lighthouse, dating from 1866. Rising to a height of over 300 feet, the cliffs jut prominently out to sea to form the southern headland of Whitehaven bay, once one of the busiest shipping harbours in England. The strange patterns in the rocks at the foot of the cliffs were sculpted by waves. 'St Bees' is derived from the seventh-century St Bega, who founded a nunnery on the site of the present Priory Church (in the village). The sea wall is the start of Wainwright's 190-mile-long 'Coast to Coast Walk' to Robin Hood's Bay, crossing three National Parks – the Lake District, the Yorkshire Dales and the North York Moors.

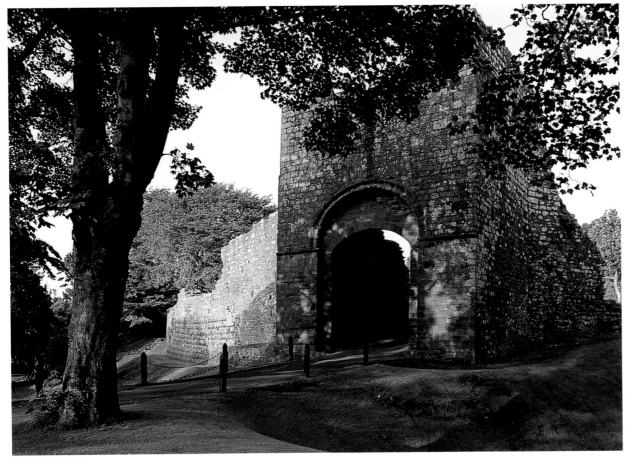

Egremont Castle

Five miles south-east of St Bees Head, on an eminence overlooking the valley of the River Ehen at Egremont, are the ruins of a sandstone castle, built by William Meschin in about 1130. The small market town of Egremont subsequently grew up around it. Wordsworth based his poem 'The Horn of Egremont Castle' on 'a Cumberland tradition' not originally associated with Egremont. In the story the horn could only be sounded by the rightful heir 'to Egremont's Domains and Castle fair'. The town is noted for its annual Crab Fair, so-named because when it was founded in 1267 visitors were given crab apples. One highlight of the fair is the 'gurning' world championship – in which competitors, stick their heads through a horse collar, and try to pull the most grotesque face.

Ennerdale Water & The Side

The most westerly of the sixteen lakes, Ennerdale Water is two-and-a-half miles long, half-a-mile wide and 148 feet deep at its maximum. West of the eminences of Bowness Knott and Anglers' Crag, the lake broadens to almost double its width. Since the mid-nineteenth century, the lake has been used as a reservoir, supplying the towns and industries of the coast. In the late 1970s, the water authority planned to raise the water level, but the scheme was abandoned after fierce opposition. Rising on the rough and stony slopes of Great Gable, the River Liza winds for some five miles through a dark forest of conifers before entering the lake. It re-emerges as the River Ehen, which eventually enters the Irish Sea near the Sellafield nuclear power station.

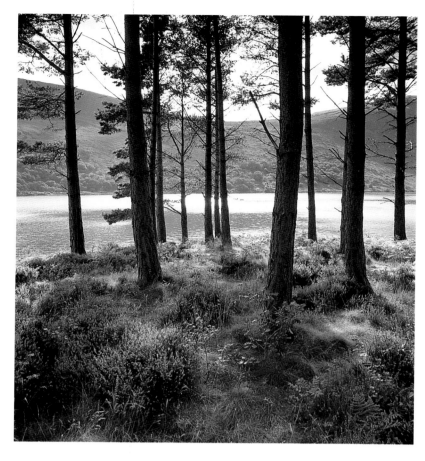

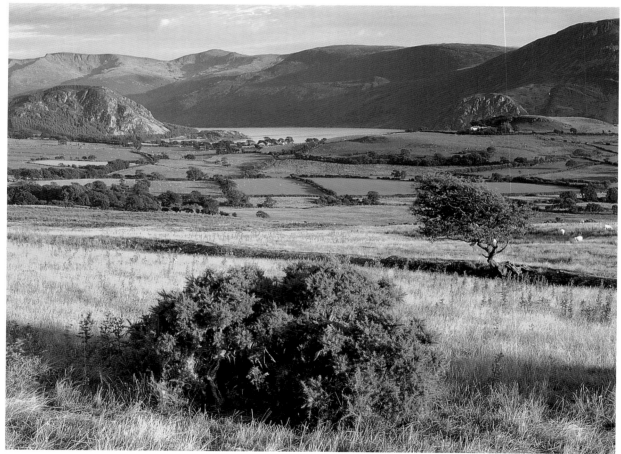

Ennerdale, from Cauda Brow

Early in the nineteenth century, north-western Lakeland was terrorized by a killer dog, known as the 'Wild Dog of Ennerdale'. According to William Dickinson: '"T" girt dog" was talked about, and dreamt about, and written about, to the utter exclusion of nearly every other topic in Ennerdale and Kinni-side, and all the vales round about there; for the number of sheep he destroyed was amazing, and the difficulties experienced in taking him were beyond belief.' The animal appeared to 'be a cross between mastiff and greyhound. Strongly built and of good speed, being both well fed and well exercised, his endurance was very great'. It was eventually shot by John Steel, who received 'his well-earned reward of ten pounds, with the hearty congratulations of all assembled'.

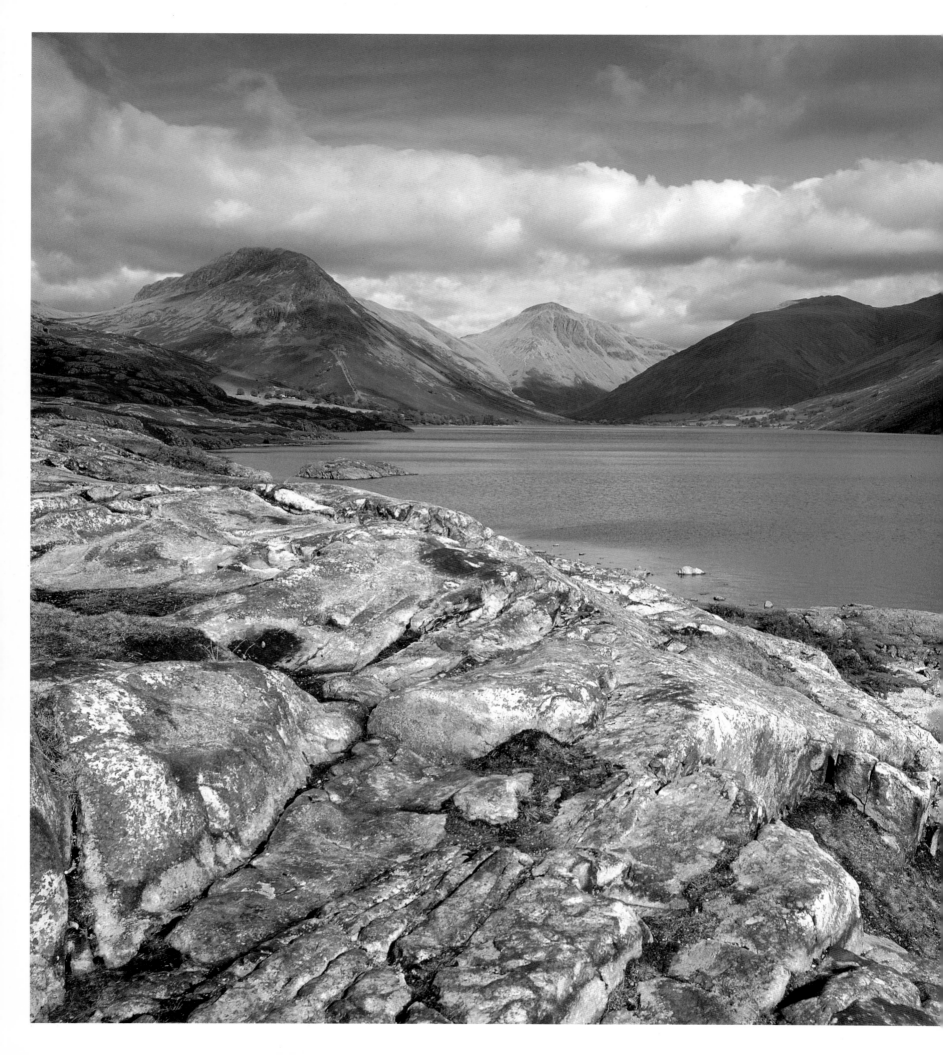

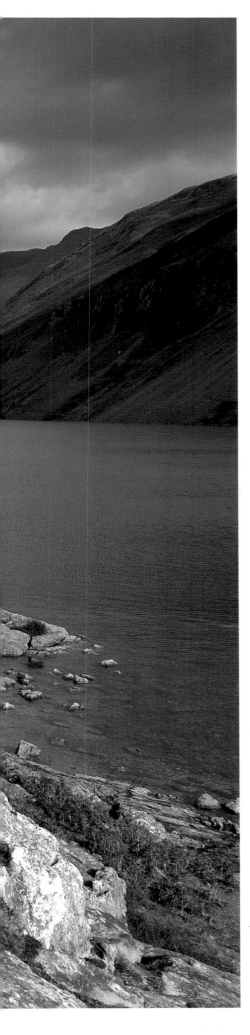

Overbeck Bridge & Yewbarrow

Yewbarrow, the narrow ridge which extends for some two miles along the western side of Wasdale, reaches 2,058 feet above sea-level. The ascent from Overbeck Bridge passes between Dropping Crag and Bell Rib to reach the ridge at the huge cleft of Great Door. Under the heading 'The use of the Bottom in Mountaineering' Wainwright wrote: 'when descending steep grass or rocks such are met on the ridge of Yewbarrow the posterior is a valuable agent of friction, a sheet anchor with superb resistance to the pull of gravity'. In Wasdale Head, on the eastern side of the ridge, is the tiny church of St Olaf, originally a chapel belonging to St Bees Priory. Its main roof beams are reputed to have come from Viking ships wrecked on the Cumbrian coast.

Wastwater

Three miles long, half-a-mile wide and 258 feet deep, Wastwater is the deepest of Lakeland's sixteen lakes. Lying in the shadow of the Scafell Pikes, the wild glacier-gouged valley was colonized by Norse farmers in the ninth and tenth centuries. Thought to be refugees rather than invaders, these sheep-breeders came to Cumbria from the west, having migrated from Ireland and the Isle of Man. Instead of settling in the coastal areas, they penetrated into the heart of the fells and there discovered an environment similar to that of their original Scandinavian homeland. Their culture and way of life has been preserved in many of the customs and traditions of the dalesmen. 'Thwaite', 'tarn', 'fell' and 'beck' are all derived from Old Norse words.

Great Gable, from Wasdale Head

Reaching 2,949 feet above sea-level, Great Gable dominates not only the head of Wasdale, but also the head of Ennerdale. Just below the summit on its southern flank (shown in the photograph) are the celebrated rock-climbing bastions of the White Napes (left) and the Great Napes (right), separated by the prominent scree-channel of Little Hell Gate. Napes Needle, a slender pinnacle, dramatically detached from the Great Napes cliff, was climbed solo in nailed boots by Walter Parry Haskett Smith in 1886, with, to quote his own famous words, 'no ropes or other illegitimate means'. It has since become the symbol of the birth of rock climbing as a sport. Another much-photographed pinnacle is the Sphinx Rock. The stream in the photograph is the Lingmell Beck.

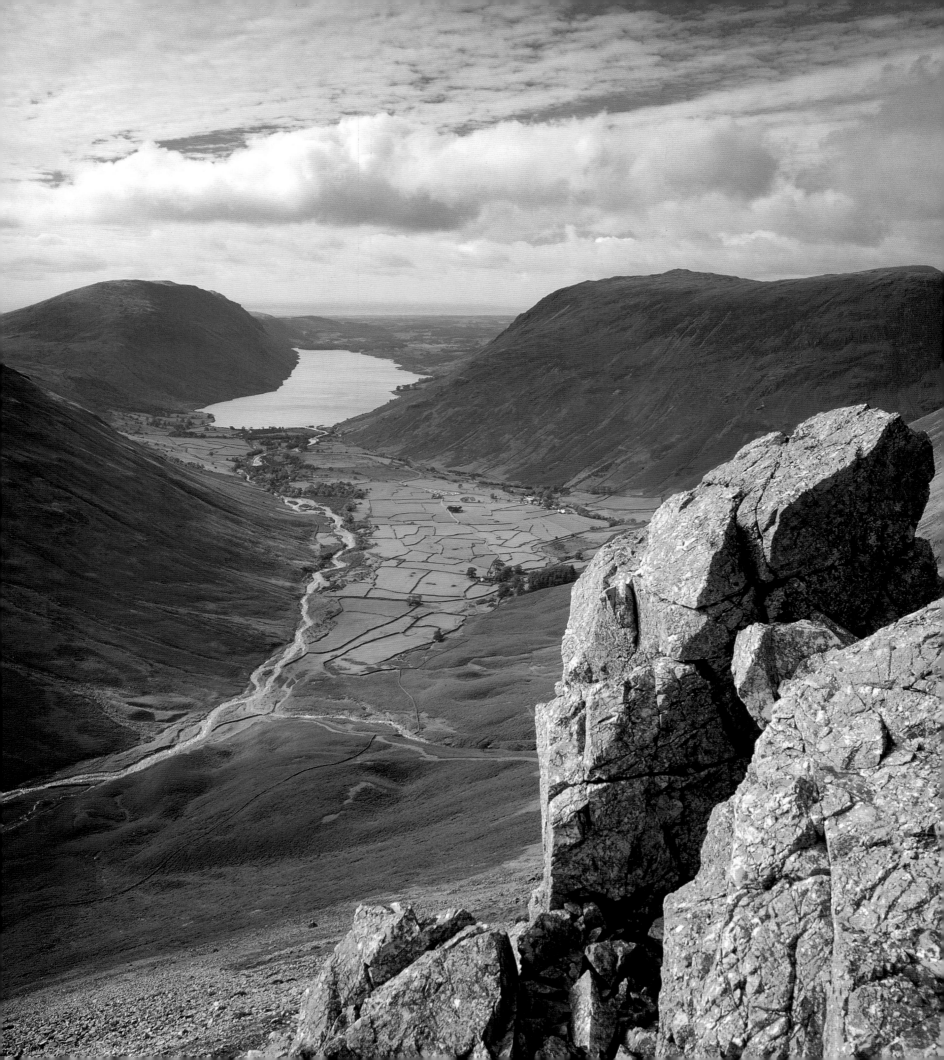

Wasdale, from Great Gable

Describing Wasdale from the classic vantage point of Great Gable, Wordsworth wrote: 'Look down into and along the deep valley of Wasdale, with its little chapel and half a dozen neat dwellings scattered upon a plain of meadow and corn-ground intersected with stone walls apparently innumerable, like a large piece of lawless patchwork, or an array of mathematical figures, such as in the ancient schools of geometry might have been sportively and fantastically traced out upon sand. Beyond this fertile plain lies, with a bed of steep mountains, the long narrow, stern and desolate lake of Wasdale.' The walls enclosing the small, irregular fields at Wasdale Head were built with stones found carpeting the valley floor. They had been brought down from the high fells by floodwater.

Gosforth Cross

Standing in the cemetery of St Mary's church at Gosforth, on the western boundary of the National Park, is a beautifully carved sandstone cross, dating from the tenth century. Almost fifteen feet high, the tall and extremely slender cross displays a fascinating fusion of Christian and pagan symbols; seemingly representing the passing of the old pagan Norse gods and the coming of Christ, who conquered the forces of darkness. When it was first erected, over 1,000 years ago, it was probably brightly painted. A few miles south-east, in the churchyard of St Paul's Church at Irton, is a ninth-century Anglian cross, standing about ten feet high. Its tapering, red sandstone shaft is intricately decorated with interlaced patterns and runic inscriptions.

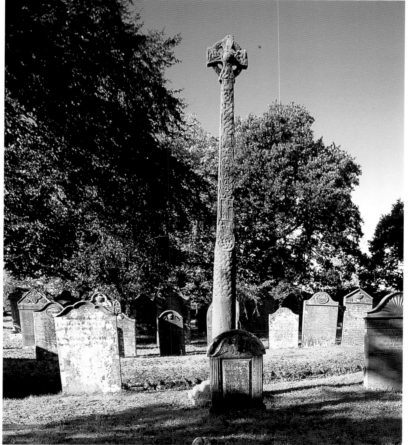

Esk Estuary, near Ravenglass

Although there are no public rights of way across the sands of the Esk estuary at Ravenglass (it is, in fact, marked on O.S. maps as a Ministry of Defence 'Danger Area'), such routes exist across the Duddon Sands and Morecambe Bay in southern Lakeland. Because of the danger of quicksands and fast-moving tides, members of the public are warned to avoid going onto the sands unless accompanied by a guide. Yet even the experienced can get into trouble. On the morning of 26 August 1996, for example, one Flookburgh fisherman, having been trawling for shrimps, had a lucky escape when his tractor, according to Mike Addison of the *Westmorland Gazette*, 'was swallowed up by the glutinous sands, leaving him stranded three miles from the shore'. Fortunately, he managed to escape without injury.

Eskdale, from Hardknott

Rising near Esk Hause – at 2,490 feet above sea-level the highest foot pass in Lakeland – the River Esk flows westward for some thirteen miles to enter the Irish Sea at Ravenglass. From its birth in the rocky grandeur of the huge amphitheatre of towering fells which dominate the head of Eskdale, the river courses through a contrasting variety of landscapes, among which are the green meadows and dappled woodlands of the plain and the sandy mudflats of the estuary. Long after the Romans had built their military road from Ravenglass to Ambleside (which followed the valley of the River Esk to climb over Hardknott Pass) the route became notorious for smuggling. Among the commodities to pass illegally through the port of Ravenglass was 'wad' stolen from the mines of Borrowdale.

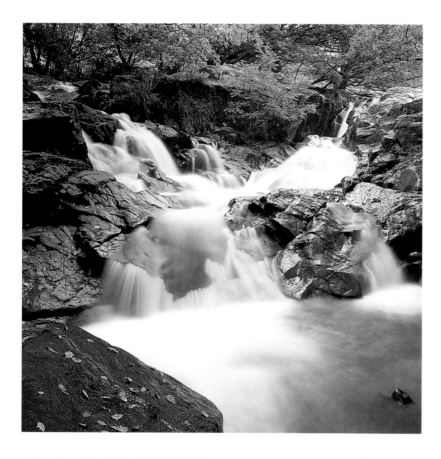

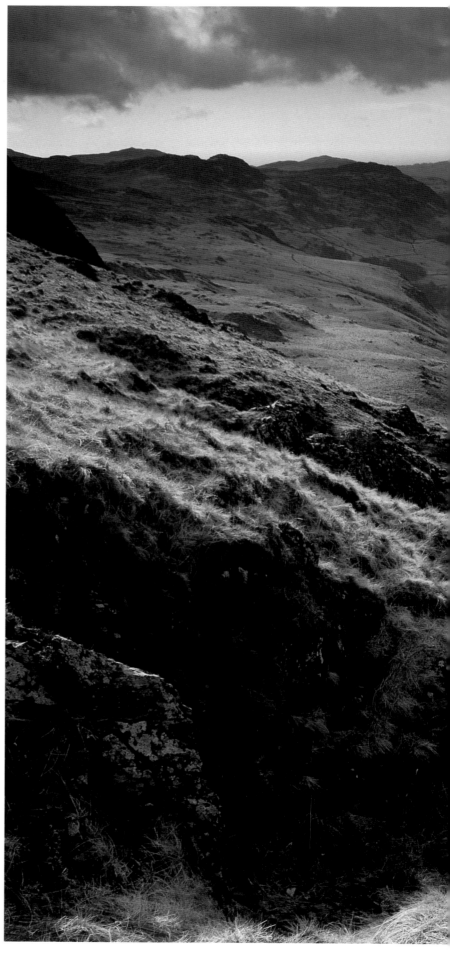

Waterfall, Boot

From Burnmoor Tarn, high on the desolate moorland between Eskdale and Wasdale, the waters of the Whillan Beck race south to Boot and the River Esk, by way of a series of attractive waterfalls. Eskdale Mill at Boot, dating from the sixteenth century, was restored in the 1970s. Still retaining its original machinery, including two water-wheels, the cornmill also houses a fascinating exhibition on the whole milling process. Before the church at Wasdale Head was granted burial rights, those who died in the valley had to be buried in St Catherine's churchyard at Eskdale. The quickest route, known as the Corpse Track, was across Burnmoor. There are many chilling stories of coffins being lost in the mist while being carried on horseback across the moor.

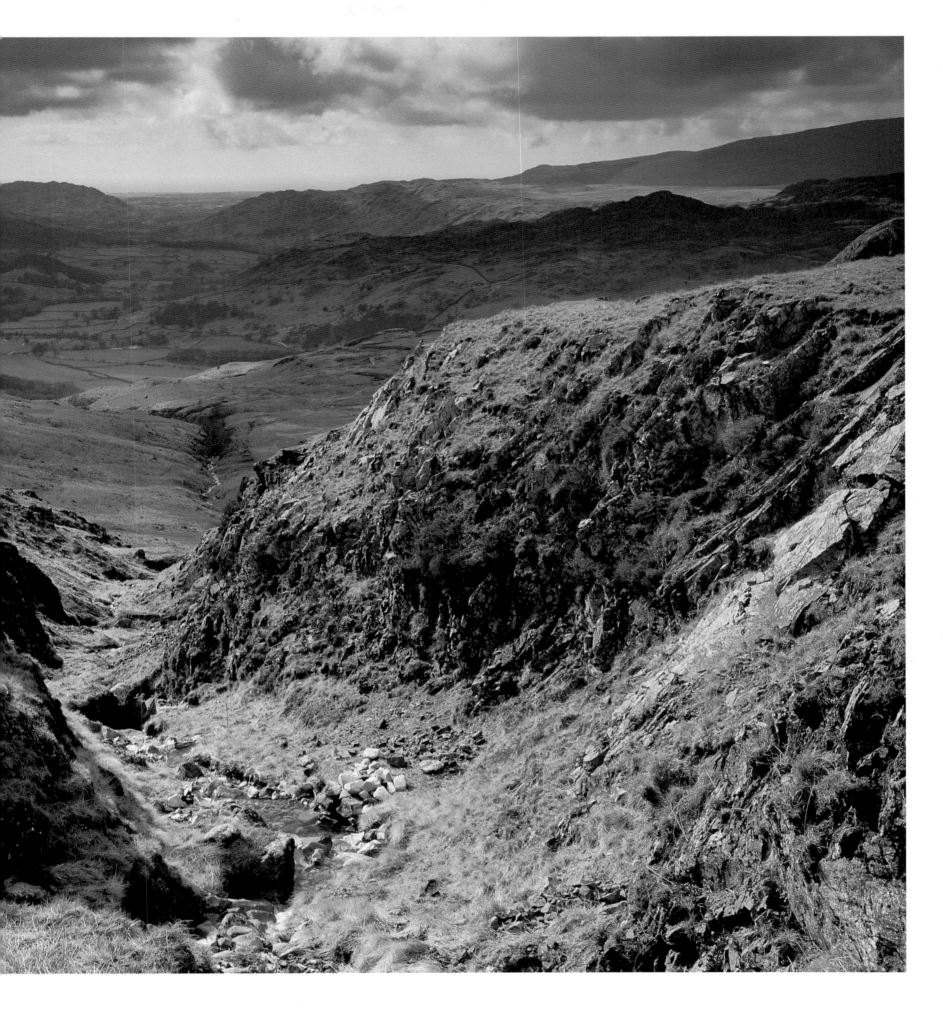

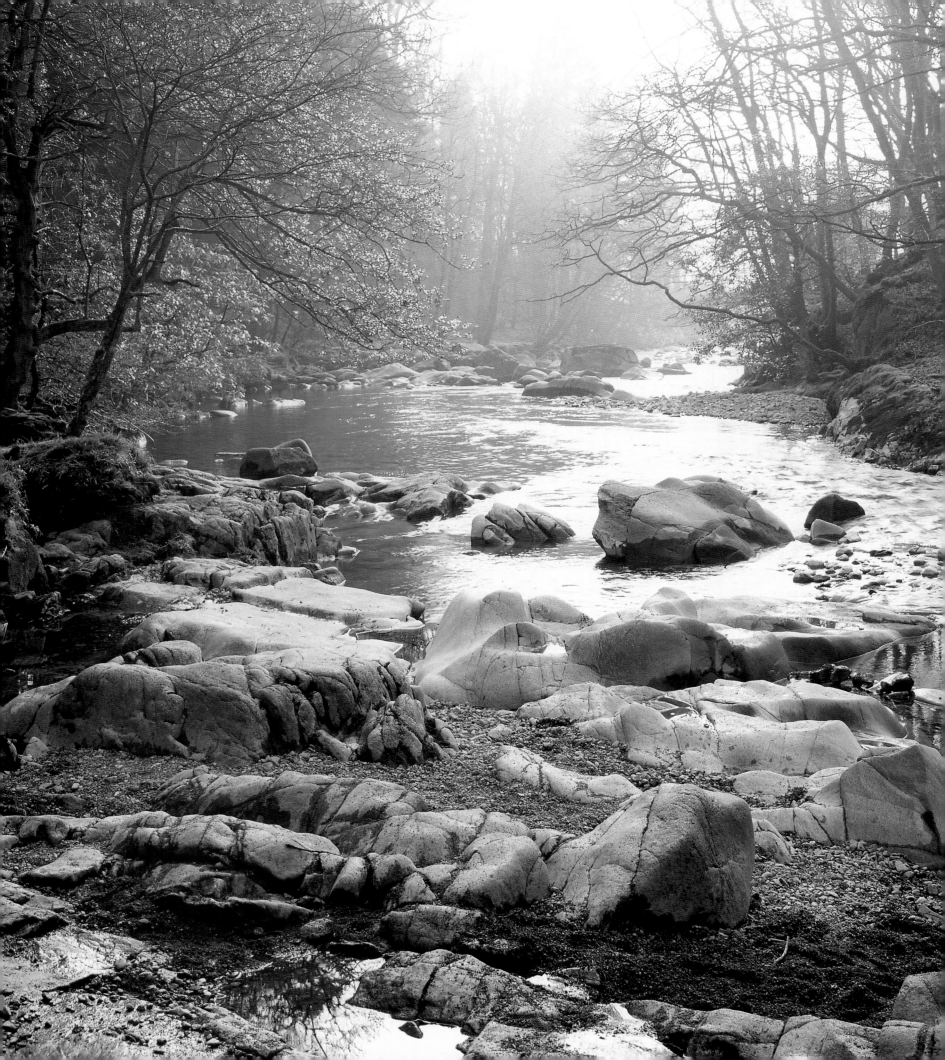

River Esk, near Dalegarth

After climbing the slopes of Muncaster Fell, the seven-mile-long Ravenglass & Eskdale Railway descends into Eskdale at Eskdale Green and runs along the northern banks of the River Esk to Dalegarth. The line was built in 1875 to transport the ore of the Whitehaven Iron Mines Co. Ltd from its Nab Gill workings at Boot to Ravenglass. Opened to passengers the following year, the line remained in operation until 1913, when the company was forced to close down. In 1915–17 the railway was converted to a smaller gauge. It continued to carry passengers (and also granite from local quarries) until the late 1950s, when it became too expensive to run. Purchased by a preservation society in 1960, 'La'al Ratty' is now a popular method of transport into lower Eskdale.

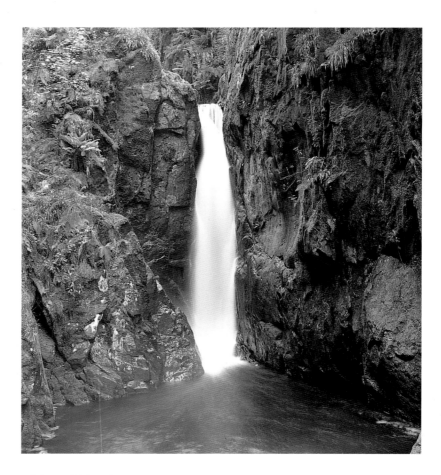

Stanley Ghyll Force, Dalegarth

Rising on the rough moorland of Birker Fell, the waters of the Stanley Ghyll flow north into a narrow gorge to plunge more than 160 feet in a series of three vertical cascades, the main one dropping thirty-seven feet into a deep pool. Crossed by several footbridges, the steep-sided ravine is set amid luxuriant woodland, which includes hazel, oak, sycamore and rhododendron. The rock itself is covered with a rich variety of mosses, liverworts, ferns and lichens, all of which thrive in the damp atmosphere. The fall is named after the Stanley family who once lived at Dalegarth Hall. It can be reached on foot from the tiny, riverside church of St Catherine. Its churchyard contains the grave of Tommy Dobson, Master of the Eskdale and Ennerdale Pack for over half a century, who died in 1910.

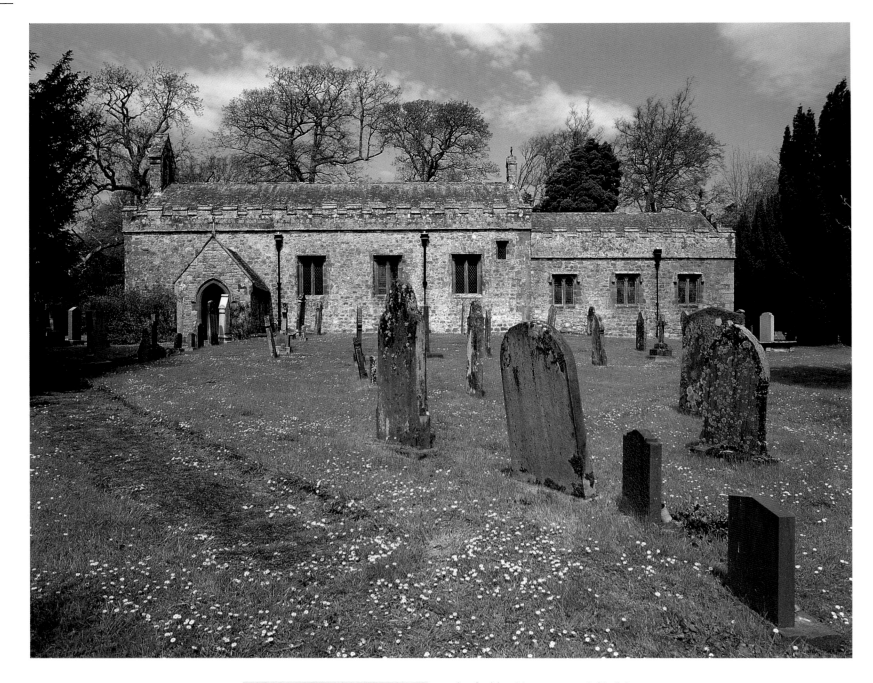

St Michael's Church, Muncaster

The battlemented church of St Michael, adjoining the parkland of Muncaster Castle, dates from the twelfth century. The north transept was added in Victorian times. Among the memorials outside the church is a wall plaque to Sir John Pennington (1393–1470), who received the 'Luck of Muncaster' from Henry VI. Tradition says that in gratitude for giving him refuge, the fugitive king presented Sir John with his enamelled glass drinking-bowl, saying that as long as it remained intact, the Pennington family would live and prosper at Muncaster Castle. Built of local pink granite, the castle – now essentially a Victorian country house – still belongs to the family. Occupying the site of a Roman fort, the oldest part of the present building is the pele tower of 1325. It is open to the public.

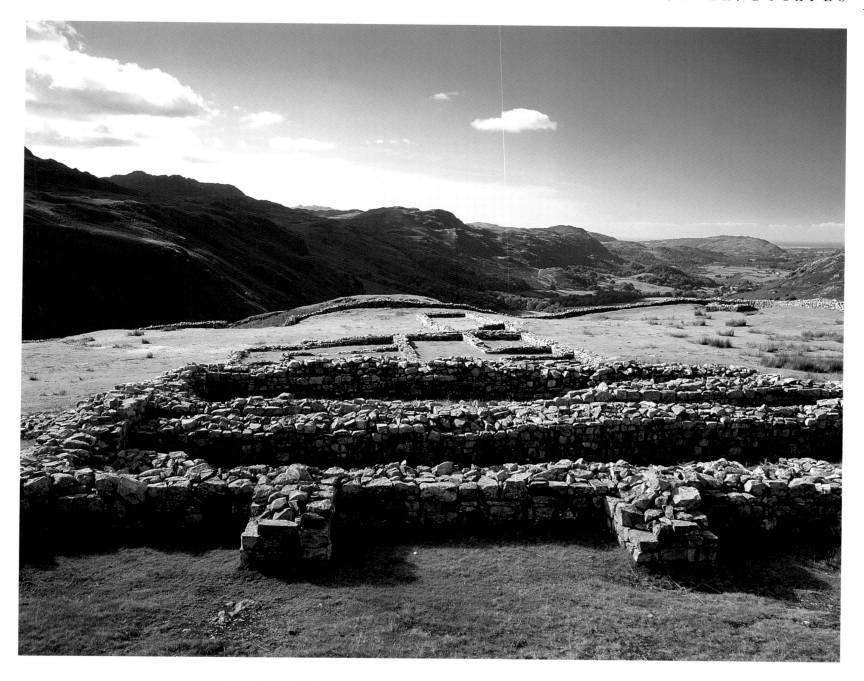

Hardknott Roman Fort

Although the Roman legions rapidly conquered southern England after their invasion in AD 43, it was some thirty years before they penetrated Lakeland. The fort at Hardknott – one of the loneliest outposts in the whole of the Roman Empire – dates from the reign of the Emperor Hadrian (AD 117–138), and was built to control the military road from the fort and port of Glannoventa (Ravenglass) to the fort of Galava (Ambleside). Known as Mediobogdum, meaning 'the fort in the middle of the bend', it was designed to hold a cohort of 500 men. The remains include a bath house, granaries, a commandant's house and parade ground. At Ravenglass there are substantial ruins of a Roman bath house, known locally as Walls Castle. Both sites are in the guardianship of English Heritage.

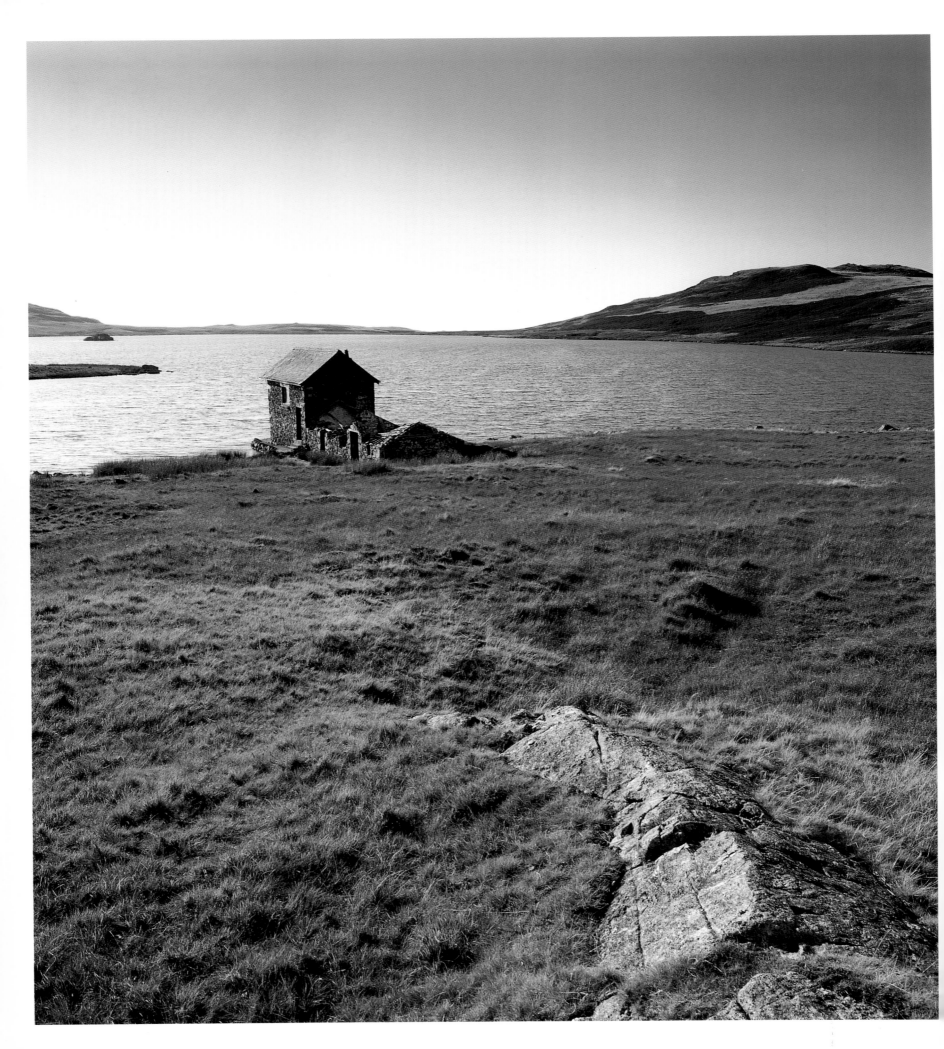

Devoke Water, Birker Fell

Larger than Elterwater and about the same size as Rydal Water, Devoke Water is nevertheless classified as a tarn, and as such is the largest in Lakeland. Dammed by a low glacial moraine at the western end, its outflow enters the River Esk, south of Eskdale Green. The name 'Devoke' is thought to mean 'the dark one'. At the eastern end of the tarn is a small stone boathouse and fishing lodge, built by the Penningtons of Muncaster Castle. W. Heaton Cooper in *The Tarns of Lakeland*, considered that 'the trout, in the tarn are especially good, sweet and pink fleshed, for did not the monks of Furness stock it with trout brought from Italy? And I am sure the breed has been renewed by later owners'. In 1987, however, the tarn was found to contain the most radioactive freshwater fish in England.

Moorland, Birker Fell

Clearance of the dense forest that covered much of Lakeland was begun by Neolithic farmers some 6,000 years ago. On the desolate uplands of Birker Moor, between Eskdale and Dunnerdale, there is extensive evidence of prehistoric settlement, including hut circles, walled enclosures and burial mounds (most of which date from the Bronze Age). Within a two-mile radius of Devoke Water, for example, Roy Millward and Adrian Robinson assert in *The Lake District* (1970) that 'twelve hundred cairns have been counted'. The most important site in this area is at Barnscar, south-west of the tarn, where two Middle Bronze Age burial urns were unearthed. Local tradition maintains that the place was a 'Danish city' inhabited by the 'lads of Drigg and the lasses of Beckermet'.

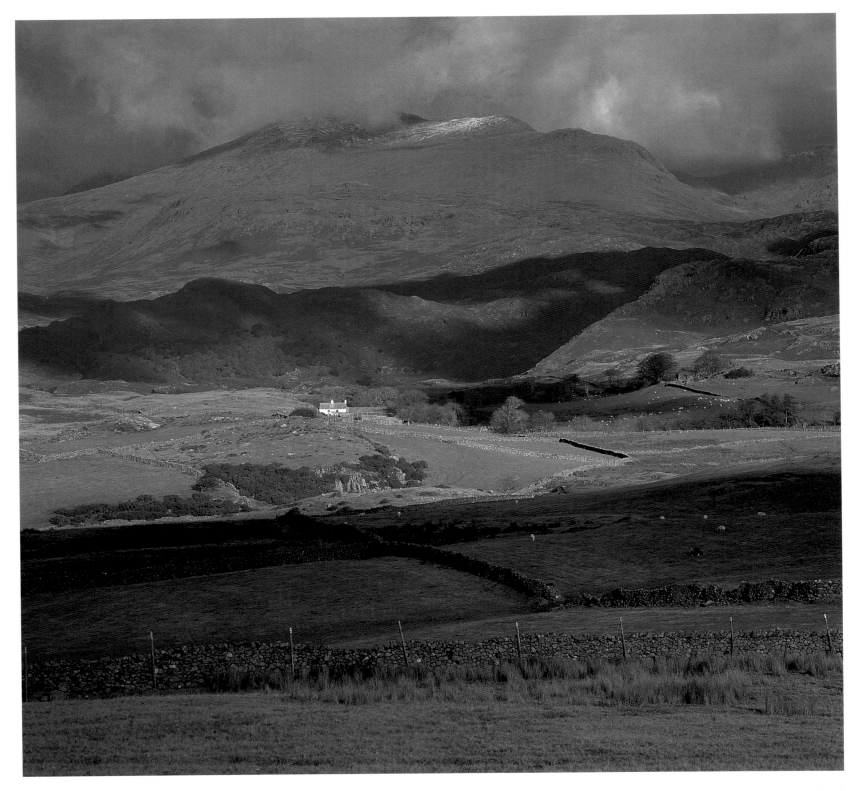

Low Ground, Birker Fell

The road between Eskdale Green and Ulpha, which crosses the high and sparsely populated moorland of Birker Fell, offers excellent views, including the scene depicted in the photograph – a remote farmstead with snow falling on the distant summits of the Scafell range. Although most of the farms in this barren region are situated on the lower slopes of the plateau, Woodend, on an exposed upland site south-east of Devoke Water, once supported a small community of Quakers. In *Greater Lakeland* Norman Nicholson considered that they 'must have been one of the most isolated Quaker communities in Cumberland – above the snow-line much of the winter, below the cloud-line much of the summer, and walled off in Quaker silence throughout the year'. Some of their graves are by the tarn.

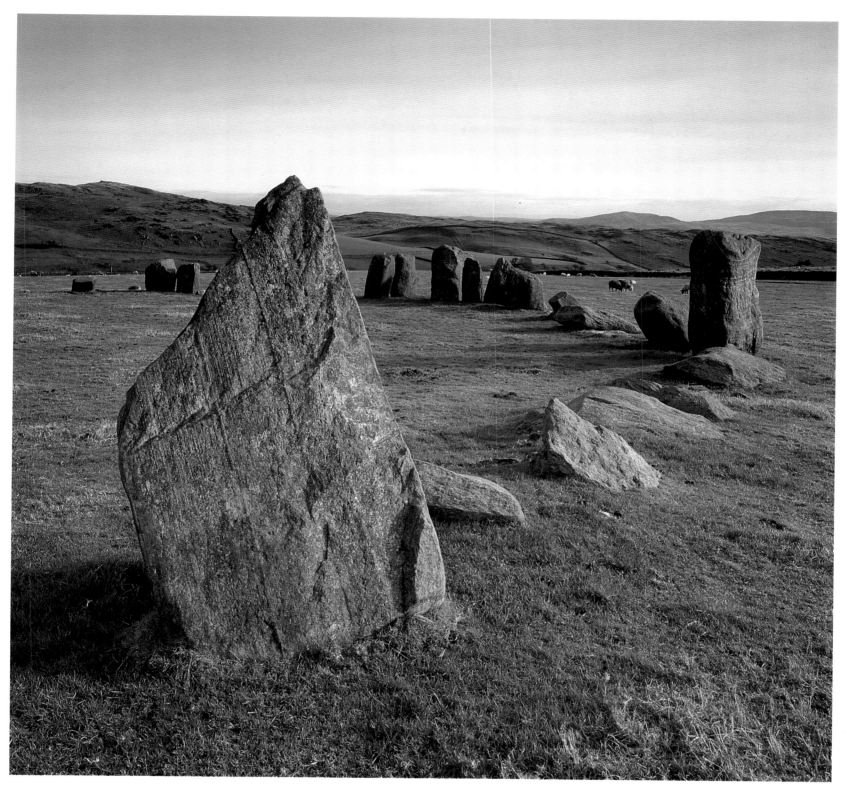

Swinside Stone Circle

The smallest of the three major stone circles in Lakeland, Swinside forms an almost perfect circle, some ninety feet in diameter. Containing over fifty stones, it stands on the north-eastern slopes of Black Combe, two miles west of Broughton-in-Furness. Unlike Castlerigg and Long Meg and her Daughters, however, its location is far less well known. Indeed, Norman Nicholson in *Portrait of the Lakes* remarked that 'there must be nearly 150,000 people living within twenty or thirty miles of it and I doubt if more than one in five has seen it'. Also known locally as 'Sunkenkirk' or 'Sunken Church', Swinside Stone Circle is thought to be of Bronze Age origin and, therefore, over 3,500 years old. Wordsworth referred to it as 'that mystic Round of Druid frame' in *The River Duddon* (Sonnet XVII).

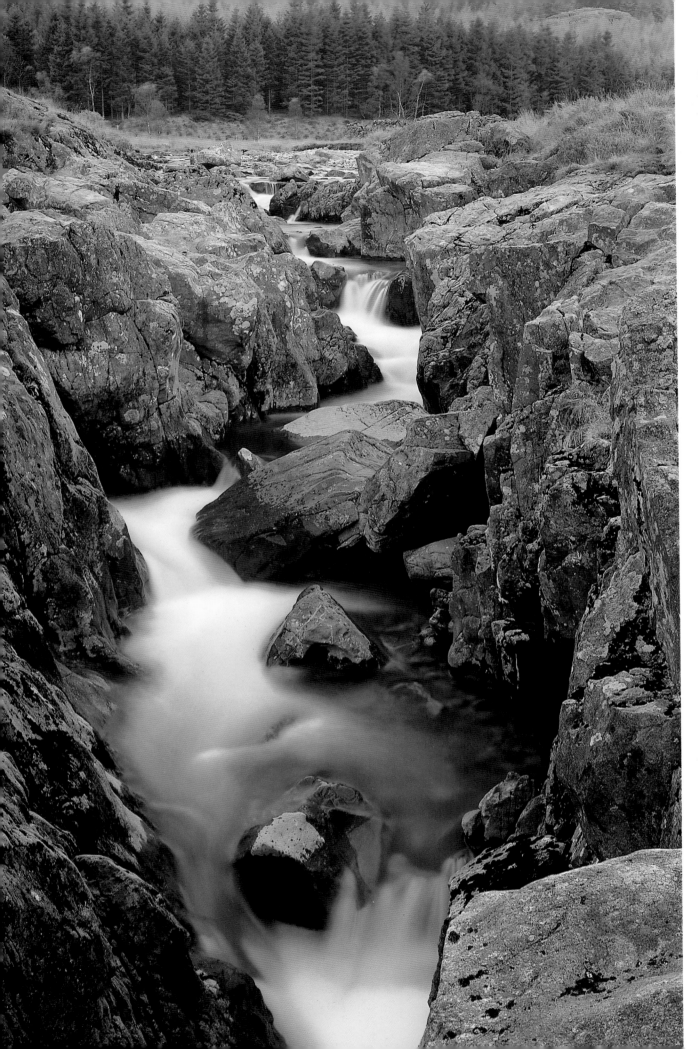

Birks Rapids, Duddon Valley

Once forming the boundary between the old counties of Cumberland and Lancashire, the River Duddon rises at the head of Wrynose Pass and, after a twelve-mile journey through a rich variety of scenery, debouches into the sea beyond Millom and the Duddon Sands. It was one of Wordsworth's favourite rivers and in *The River Duddon* he composed no less than thirty-five sonnets about it. In the area around Birks Rapids and Birks Bridge – where the river narrows to be squeezed between walls of rock – the craggy fellsides have been planted with conifers. After heavy and continuous rain the river level rises very rapidly. During severe floods, the water has been known to pass, not only under Birk's Bridge, but also over it – through small, purposely built holes in the parapet.

Troutal & The Hows, Dunnerdale

In the Notes to his series of sonnets on the River Duddon, Wordsworth wrote of Dunnerdale in the first half of the nineteenth century: 'Russet and craggy hills, of bold and varied outline, surround the level valley, which is besprinkled with grey rocks plumed with birch trees. A few homesteads are interspersed, in some places peeping out from among the rocks like hermitages, whose site has been chosen for the benefit of sunshine as well as shelter … Time, in most cases, and nature everywhere, have given a sanctity to the humble works of man, that are scattered over this peaceful retirement. Hence a harmony of tone and colour, a consummation and perfection of beauty, which would have been marred had aim and purpose interfered with the course of convenience, utility or necessity.'

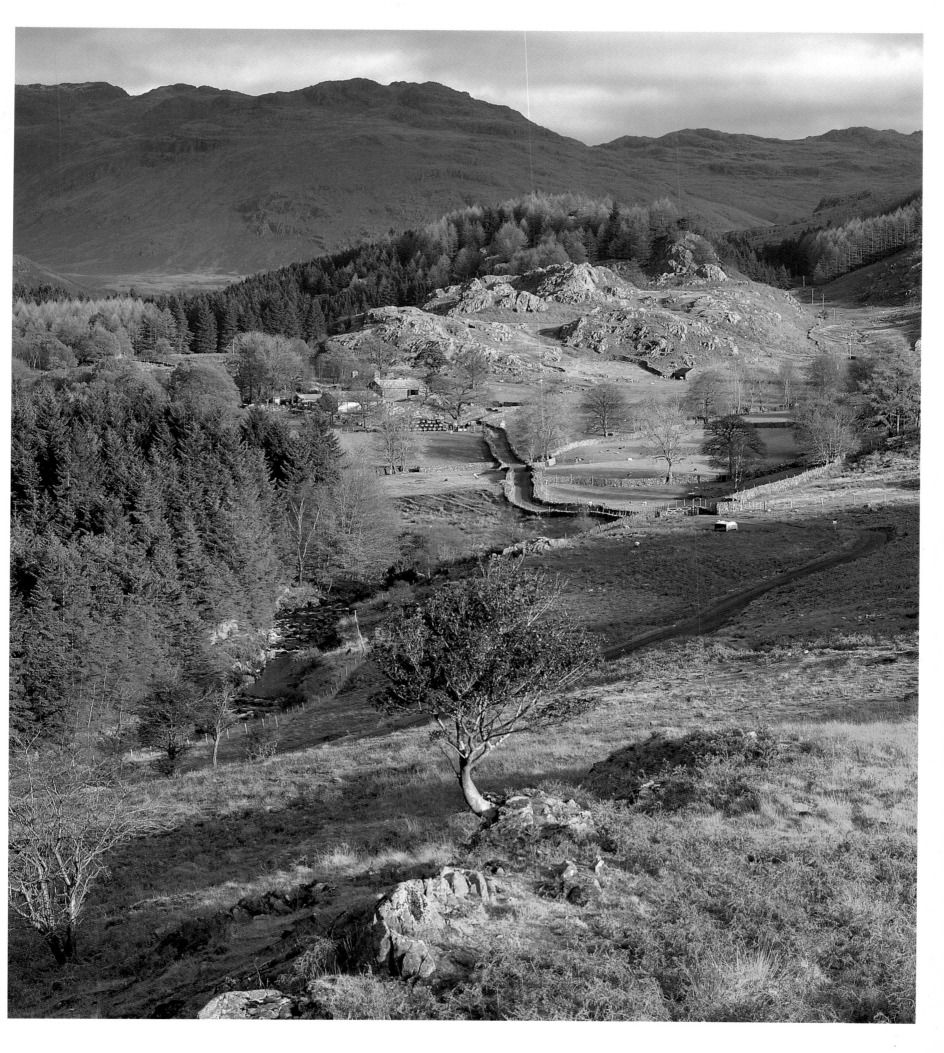

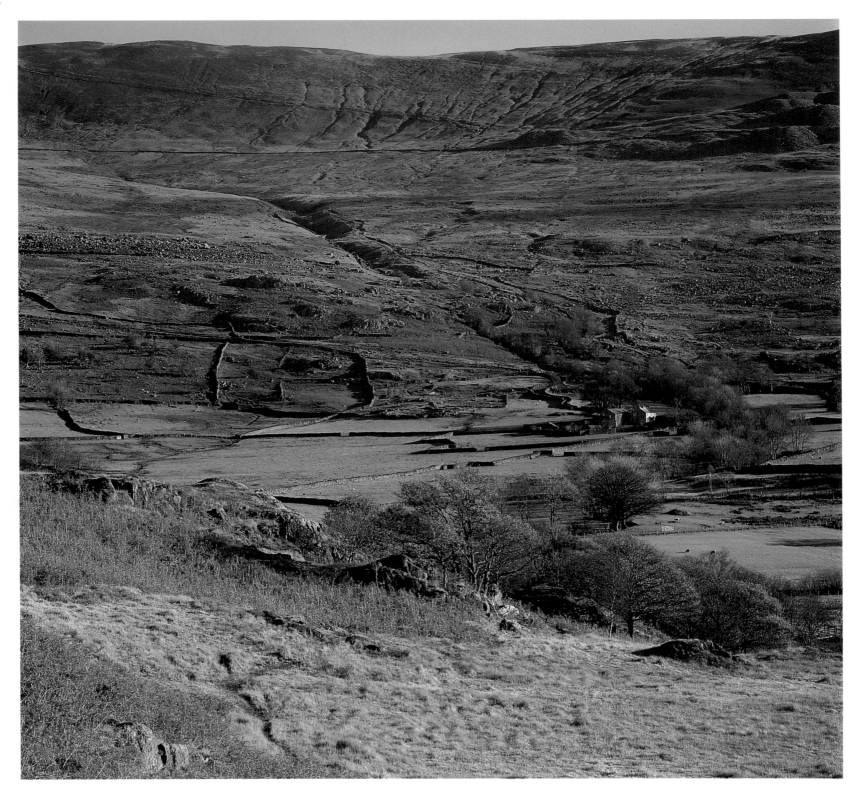

Long House & Dow Crag, Dunnerdale

One route of ascent from Dunnerdale to the summit of Dow Crag (2,555 feet) is by way of Long House farm and Walna Scar Pass. Although the pass was once used by wheeled traffic – transporting slate to Coniston from the nearby quarries – the route is now only suitable for walkers, cyclists and horses. Vehicles can, however, travel some distance along the Walna Scar road from both of its ends (Coniston and Seathwaite). The river which flows to the immediate west of Long House is Tarn Beck (a tributary of the River Duddon, which at this point is hidden in a deep wooded gorge). The beck is fed by Seathwaite Tarn, high up on the north-western slopes of Dow Crag. At the beginning of the twentieth century the tarn was dammed, creating a reservoir to supply water to the Barrow area.

Dale Head & River Duddon

At Cockley Beck – having accomplished the tortuous corkscrewing climb over Hardknott from Eskdale – the road forks east to Wrynose and Little Langdale and south to Seathwaite and Ulpha in Dunnerdale. Dale Head farm (shown in the photograph) stands less than a mile downstream of Cockley Beck farm. Wordsworth referred to the latter as a 'cottage rude and grey' in *The River Duddon* (Sonnet V). When James Thorne visited the farm in the autumn of 1842 he wrote: 'It is, indeed, worth a stranger's while to take some opportunity to observe the natives of Donnerdale ... Our dalesmen are reserved, and must be watched to have their real character caught: but the observer will not go unrewarded. They are a fine intelligent race of men, and worth observing ...'

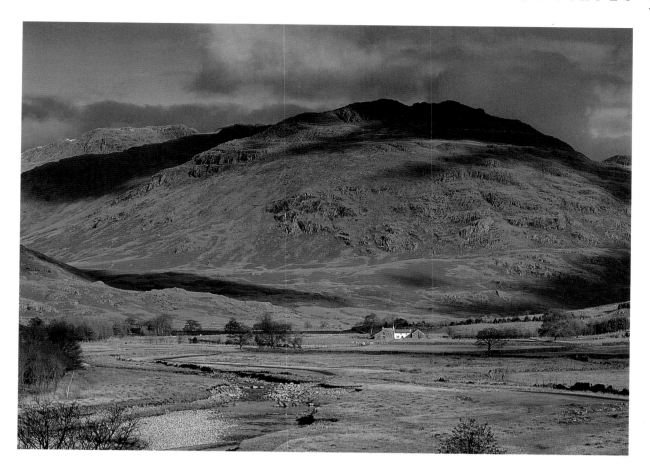

Dunnerdale & The Pike, near Ulpha

Despite a petition against the afforestation of Dunnerdale, signed by 13,000 persons in the summer of 1935, large tracts of the valley were subsequently planted with conifers by the Forestry Commission. Today the trees have become an integral, yet far from unattractive, part of the Lakeland landscape. Wordsworth, however, objected to the spread of larch and fir plantations in the region. Indeed, in his *Guide* he wrote: 'if ten thousand of this spiky tree, the larch, are stuck in at once upon the side of a hill, they can grow up to nothing but deformity'. The photograph was taken from Low Whineray Ground, looking north-west across the plantations of Ulpha Park, in Dunnerdale, to The Pike (1,214 feet), Rainsbarrow Wood and the tributary valley of Holehouse Gill.

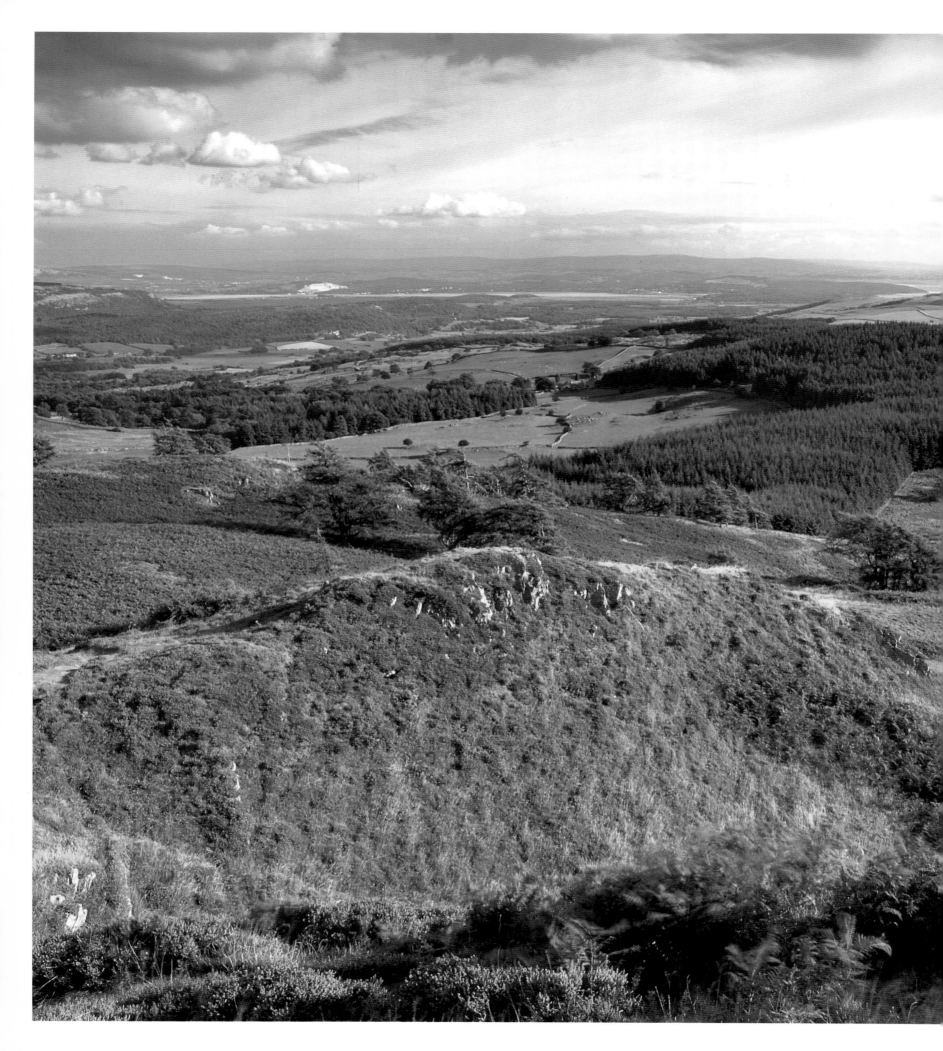

Cartmel Priory

Lying in the valley of the River Eea, two miles west of Grange-Over-Sands, Cartmel Priory was founded for Augustinian canons in about 1188 to 1190 by William Marshall, Earl of Pembroke. Although most of the buildings were demolished after the monastery's dissolution in 1537, the fourteenth-century gatehouse and the priory church still remain. The latter was saved because the founder had ordained that an altar, with a priest, should be provided for the people. In the churchyard is the grave of the Reverend William Taylor, headmaster of Hawkshead Grammar School, who died in 1786. Wordsworth recalled the 'honoured teacher of my youth'

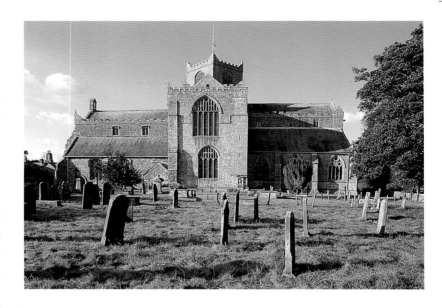

in *The Prelude: Book X*: 'He loved the Poets, and, if now alive, / Would have loved me, as one not destitute / Of Promise.'

Kent Estuary, from Gummer's How

Gummer's How (1,054 feet), on the eastern side of Windermere, was considered by Wainwright to be 'an old man's mountain. And when ancient legs can no longer climb it know ye that the sad day has come to hang up the boots for ever and take to slippers'. From its summit, the view south-east (shown in the photograph) looks across Astley's Plantation and the valley of the River Winster to Milnthorpe Sands, Grange-Over-Sands and the Kent Estuary, beyond which is Morecambe Bay. Many of the early travellers from the south entered Lakeland by crossing the perilous sands of Morecambe Bay at low tide. Guides were (and still are) essential. During medieval times they were maintained and endowed by the monks of Cartmel and Conishead Priories.

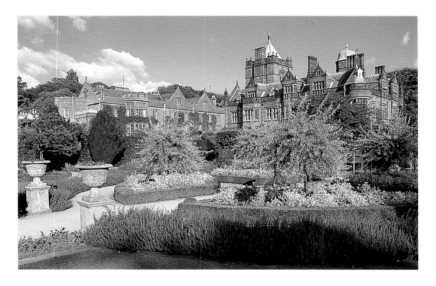

Holker Hall

After the Dissolution, part of the Cartmel Priory estates were acquired by the Preston family, including the land on which Holker Hall now stands. The first house to occupy the present site is thought to have been built in 1604 by George Preston (who was also largely responsible for the restoration of Cartmel Priory church). In 1756, having been in the ownership of the Lowthers for fifty-nine years, the property was left to Lord George Augustus Cavendish, the second son of the 3rd Duke of Devonshire, whose descendants still own it today. Much of the house was rebuilt in the Elizabethan style after a disastrous fire in 1871. Designed by Paley and Austin of Lancaster, Pevsner considered the Victorian building to be 'the grandest of its date in Lancashire'.

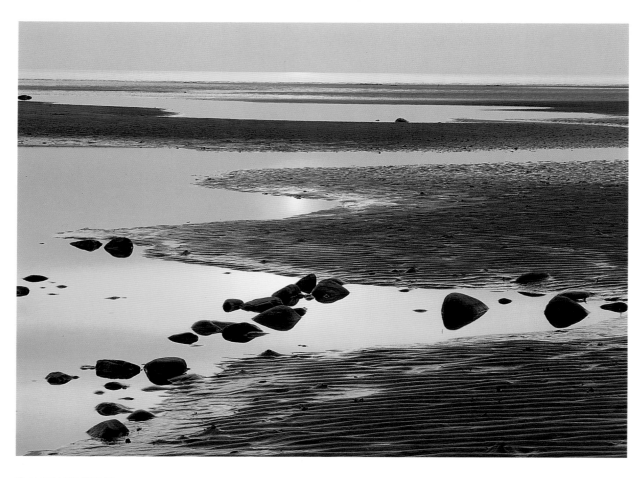

Cartmel Sands, Morecambe Bay

In *Over Sands to the Lakes* Edwin Waugh (1817–90) wrote about the danger of crossing the sands of Morecambe Bay: 'The channels are constantly shifting, particularly after heavy rains, when they are perilously uncertain. For many centuries past, two guides have conducted travellers over them. Their duty is to observe the changes, and find fordable points … The office of guide has long been so held by a family of the name of Carter, that the country people have given that name to the office itself. A gentleman, crossing from Lancaster, once asked the guide if "Carters" were never lost on the sands. "I never knew any lost," said the guide; "there's one or two drowned now and then, but they're generally found somewhere i'th bed when th'tide goes out".'

Bluebell Woods, near Cartmel

As plants like the bluebell and daffodil cease to grow above a certain temperature, it is predicted that they could be destroyed by a rise in the climate, possibly brought about by global warming. The threat to the survival of these flowering harbingers of spring was highlighted in a 1991 Plantlife report by Professor Philip Grime of Sheffield University and Dr John Rodwell of Lancaster University. In response to the report Jane Smart, director of Plantlife said: 'The findings show that everyone's local woodland could be transformed if we don't act soon. The sheet of bluebells covering a British woodland is one of the natural wonders of the world. It would be a tragedy if we let our rich plant heritage disappear.' (*The Observer*, 1 September 1991.)

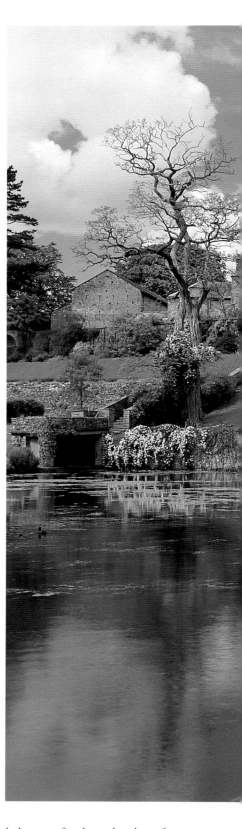

Kendal Castle

Standing on a mound overlooking the valley of the River Kent at Kendal are the ruins of a stone castle, with a deep ditch, built in the twelfth century. It is famous for being the birthplace of Catherine Parr, the sixth and last wife of Henry VIII. The remains of a second and more ancient motte-and-bailey castle can be found on the opposite (western) side of the river. The site, known as Castle Howe or The Mount, is surmounted by an obelisk commemorating the Glorious Revolution of 1688, when James II was deposed and William of Orange and his wife Mary jointly assumed the throne. Sited within a loop of the river at Watercrook, at the southern end of the former wool-market town, the Romans also built a fortress, first of wood and earth, and later of stone.

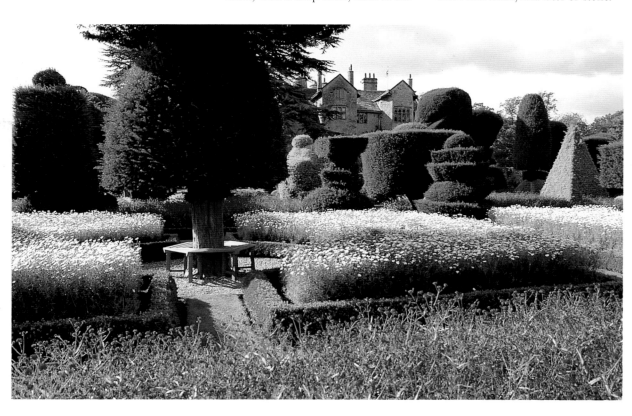

Levens Hall

Situated amid parkland on the banks of the River Kent, five miles south of Kendal, Levens Hall is an attractive Elizabethan house, incorporating a pele tower and hall dating from the latter half of the thirteenth century. Its unique topiary garden was designed for Colonel James Grahme by a Frenchman, Guillaume Beaumont. Laid out in 1694, the topiary is still maintained in its original plan. After visiting Levens, West wrote in his *Guide* of 1778: 'Here is one of the sweetest spots that fancy can imagine. The woods, the rocks, the river, the grounds, are rivals in beauty of style, and variety of contrast.' As a footnote he added: 'The gardens … are rather curious in the old style.' Now owned by the Bagot family, the house, park and gardens are open to the public.

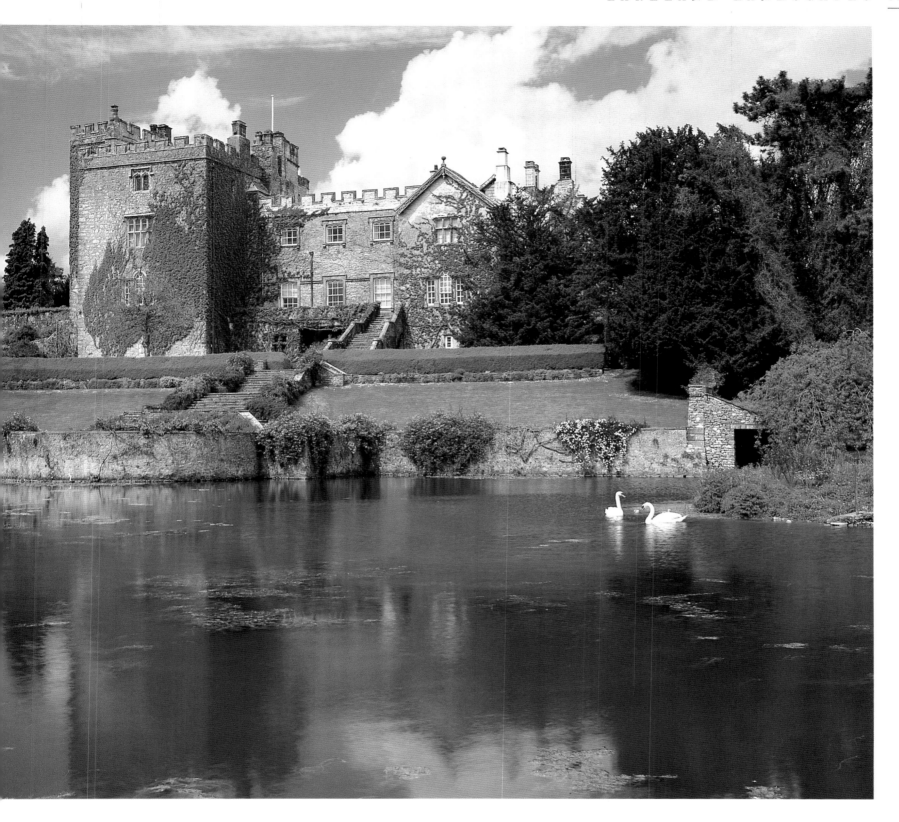

Sizergh Castle

The main residence of the Strickland family since 1239, Sizergh Castle – set in attractively landscaped gardens – is one of the finest fortified houses in Cumbria. The oldest part of the present building is the massive, fourteenth-century pele tower, almost sixty feet high. The projecting turret, rising a further ten feet above the battlements, is known as the Deincourt Tower. Alterations and extensions over succeeding centuries included: the Great Hall, built in about 1450; and the two long wings, added during the Elizabethan period. The lake (probably formed from the pele tower moat) was enlarged in 1926. Although the property was granted to the National Trust in 1950, it still remains the home of the Stricklands, and is regularly open to he public.

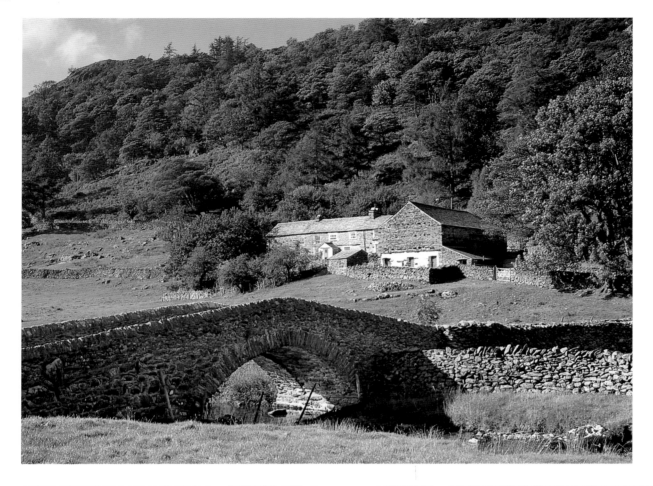

Low Sadgill Farm, Longsleddale

The long, narrow farming valley of the River Sprint, known as Longsleddale, lies to the north of Kendal. It was called 'Long Whindale' in *Robert Elsmere* (1888), the most famous novel of Mary Augustus Ward (better known as Mrs Humphry Ward). The 'gray-roofed and gray-walled' Low Sadgill farmhouse was 'Burwood Farm', home of the fictional Leyburn family. 'In these bare green valleys,' she wrote of Longsleddale, 'there is a sort of delicate austerity even in summer; the memory of winter seems to be still lingering about these wind-swept fells, about the farmhouses, with their rough serviceable walls, of the same stone as the crags behind them, and the ravines, in which the shrunken becks trickle musically down through the debris of innumerable Decembers.'

Shap Abbey

Standing in a remote and sheltered site beside the River Lowther, at the eastern extremity of the National Park, are the ruins of the abbey of St Mary Magdalene, founded for Premonstratensian canons at the end of the twelfth century. Although relatively well-endowed with lands in several parts of old Westmorland, the monastery only supported a small community of about a dozen monks, ruled by an abbot. The Order, founded by St Norbert (d. 1134), was intended for those monks who wished to combine the life of prayer and discipline with parish work as priests, serving local communities. After the Dissolution some of the buildings were converted into a farmhouse. The rest were partially demolished. The abbey ruins are now in the guardianship of English Heritage.

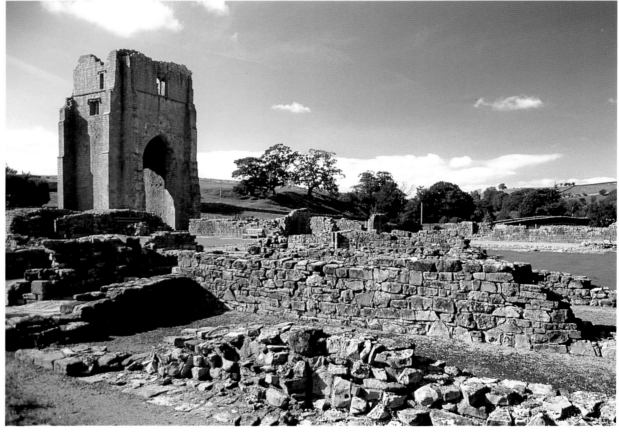

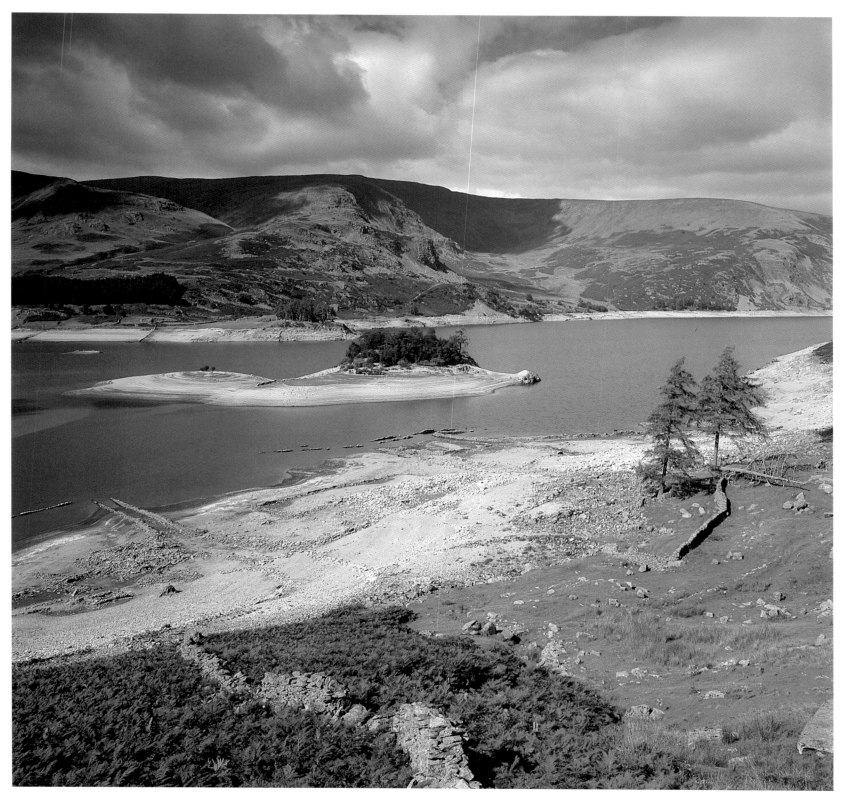

Wood Howe & Haweswater

Submerged beneath the waters of Haweswater Reservoir lies the old farming settlement of Mardale Green, drowned in 1940 when the valley was dammed, flooded and the water-level raised by ninety-six feet. In times of severe drought, the water-level can drop so dramatically that the remains of the abandoned village are revealed, including the ruins of the church. Like Thirlmere, the water from Haweswater is piped underground to the urban areas around Manchester, some 100 miles distant. The reservoir – four miles long and 198 feet deep when full – is also linked by an underground aqueduct to a pumping-station at Ullswater. In 1989 the water authority planned to establish a salmon farm at Haweswater. But, after vigorous opposition, the scheme was dropped.

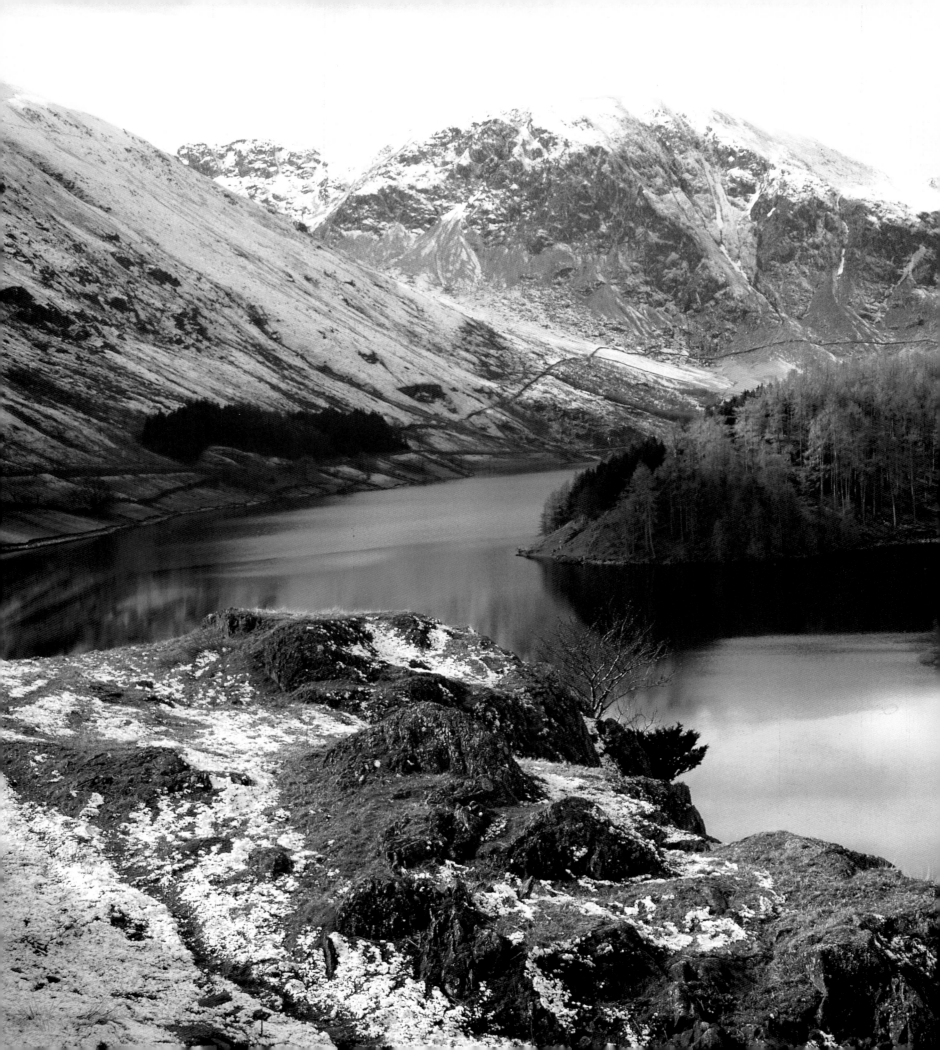

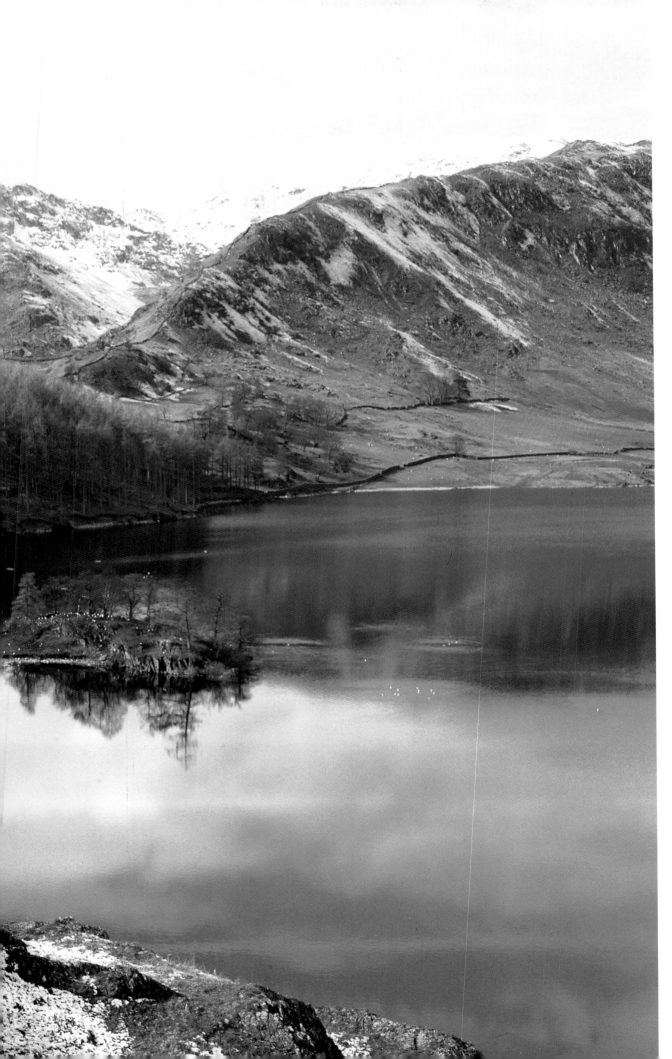

Haweswater

The photograph looks south-west across Haweswater and Mardale to the afforested peninsula of the Rigg. The island is Wood Howe. Harter Fell (2,539 feet) can be seen in the centre; with the long, bony ridge of Rough Crag on the right; and Branstree (2,333 feet) on the left. One route up to High Street from Mardale is by way of Small Water (on the northern side of Harter Fell), Nan Pass (2,100 feet), and the summit of Mardale Ill Bell (2,496). Another more dramatic ascent is by way of Rough Crag and its culminating 'stairway' Long Stile. Blea Water, on the southern side of Rough Crag, is the deepest tarn in Lakeland at 207 feet. In fact, only two of the sixteen lakes, Windermere and Wastwater, are deeper. Mardale is linked to Kentmere by the Nan Bield Pass.

High Street, from Racecourse Hill

Running along the crest of High Street (2,718 feet) is the highest Roman road in Britain – linking the forts of Galava (Ambleside) with Brocavum (Brougham). Its medieval name Brettestrete (or 'the Britons' road') reflects the probability that it was in use long before the arrival of the Romans. Until the early nineteenth century, the farmers of Mardale (the valley to the east) used the grassy summit as the venue for their annual meets. Horse racing was among the festivities, hence the summit being called Racecourse Hill. In about 1762, while fox hunting, a man named Dixon fell hundreds of feet over the cliffs on the Blea Water side of High Street. One version of the story says that he survived without a broken bone! The distant lake in the photograph is Windermere.

Ill Bell Ridge, from Wansfell

Drystone walls, like those on Wansfell, can be found all over Lakeland – seemingly growing out of the landscape for mile after mile, snaking across fells, circling round woods and rocky crags, climbing straight up the sides of mountains or simply following the roads. Although some are ancient, most were built in the eighteenth and nineteenth centuries, particularly after the Enclosure Acts of 1801, when the majority of the open fells and commons became private property. These, sometimes massive, structures not only delineated the boundaries of parishes, estates and manors, they also provided (and still provide) shelter and protection for sheep. They were often built, not by the farmers, but by gangs of professional wallers, who travelled the area seeking work.

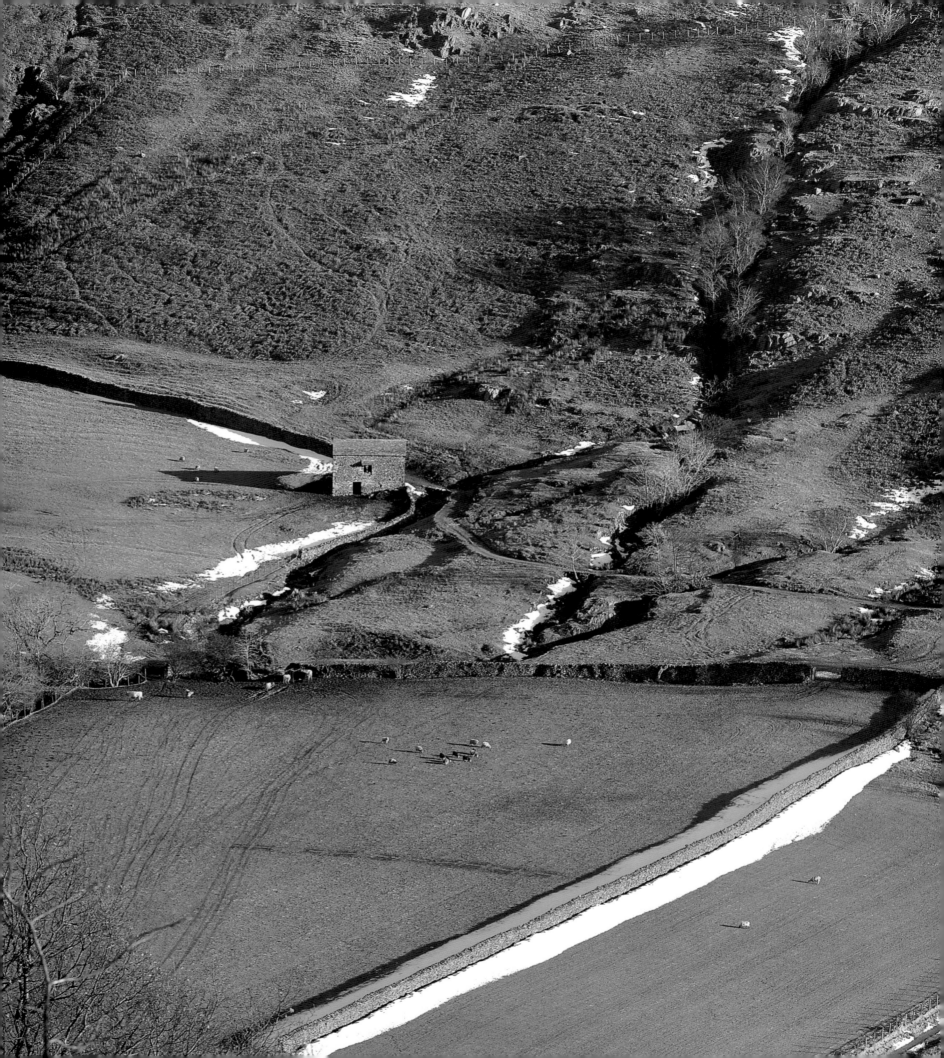

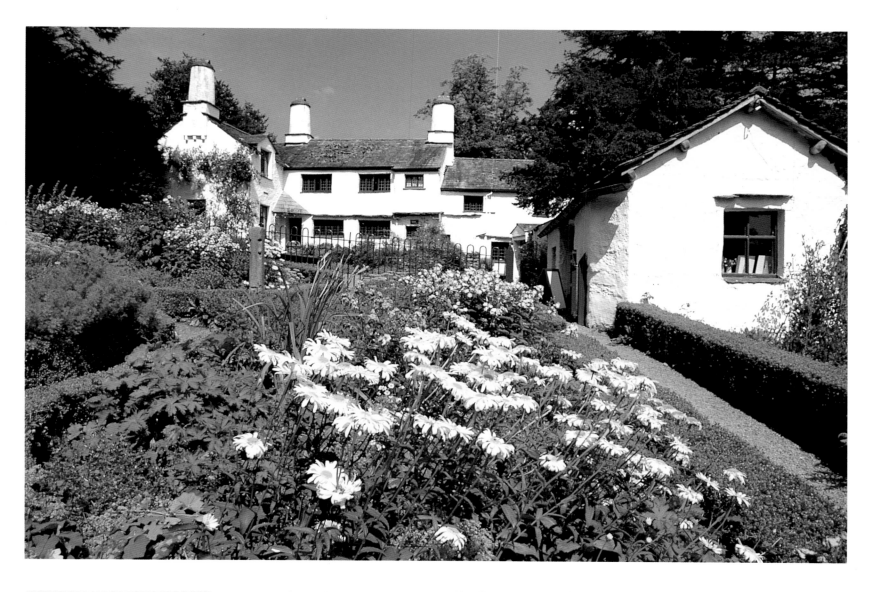

Troutbeck Valley, near Ing Bridge

The main road north from Windermere climbs steadily up the farming valley of the Trout Beck before ascending steeply to the summit of Kirkstone Pass. Harriet Martineau wrote in her *Guide to Windermere* (1854): 'Troutbeck is the most primitive of the frequented valleys of the district. To find another so antique and characteristic, it is necessary to leave the high road, and explore the secluded dales of which the summer tourist sees and hears nothing. The dale looks from the uplands as if it had been scooped out between the ridges with a gigantic scoop. Its levels are parcelled out into small fields, of all manner of shapes; and the stream, – the beck abounding in trout, – winds along the bottom, from the foot of High Street, to fall into the lake just by Calgarth.'

Townend, Troutbeck

Owned by the National Trust, Townend is an excellent example of a Lakeland yeoman farmer's house, with tall cylindrical chimneys, slate roof, oak-mullioned windows and lime-rendered stonework. The oldest part of the present building is thought to be the central main living room (or 'fire house'), built in the late sixteenth or early seventeenth century. To the east side of this room, in about 1626, was added a long passage (or 'hallan'), and, beyond, a kitchen (or 'down house'). Further improvements and additions were made to the farmhouse in the eighteenth century. The property belonged to the Browne family from at least the mid-fifteenth century until 1943. Much of the panelling and furniture in the house has been carved, initialled and dated by them.

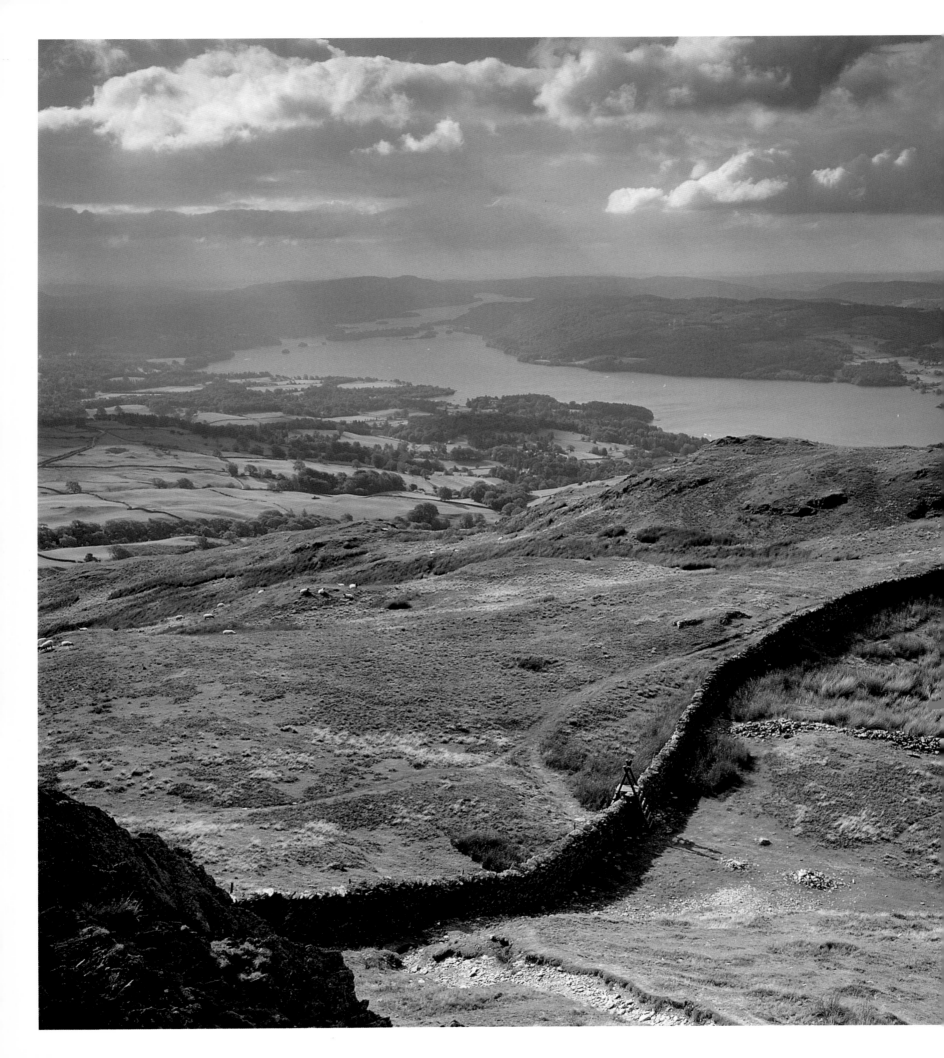

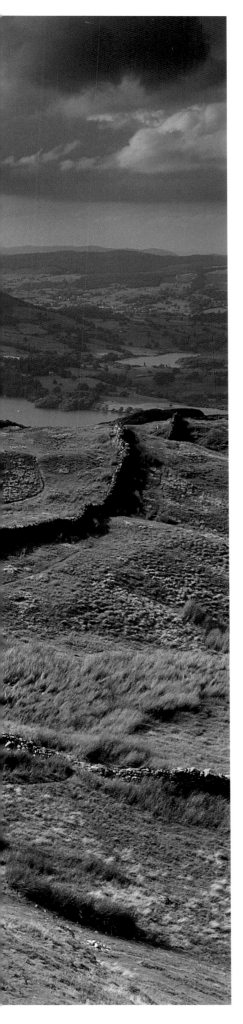

Windermere, from Wansfell

Windermere (named after a Norseman, Winland or Vinandr) is almost divided in the middle by Belle Isle, the largest of the lake's fourteen islands. Wordsworth described the isle's domed round house, built in 1774, as a 'pepper pot'. The lake itself is a popular recreational centre for all sorts of boating activities and water sports. The town of Windermere, once the village of Birthwaite, developed into a popular tourist centre after the arrival of the railway in 1847. Wansfell lies between Ambleside and the Troutbeck valley.

Reaching a height of 1,597 feet above sea-level, its south-western side drops steeply to the shores of the lake. On the extreme right in the photograph is Blelham Tarn – its name derived from the Old Norse for the 'black' or 'blue pool'.

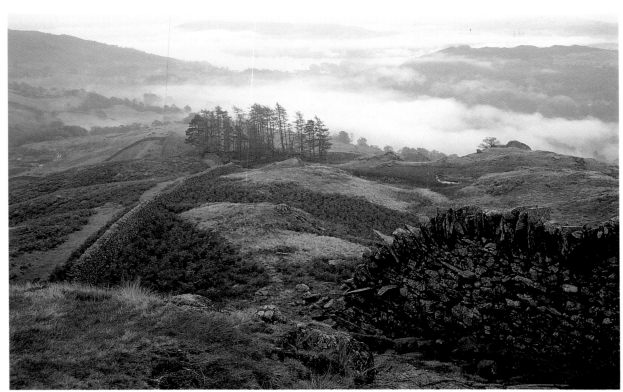

Windermere, from High Pike

Ten-and-a-half miles long, one mile wide and 219 feet deep, Windermere is the largest natural lake in England, and is fed by numerous rivers and streams, including the Brathay, Rothay, Trout Beck, and the Cunsey Beck from Esthwaite Water. At its southern end the waters emerge as the River Leven to enter the sea in Morecambe Bay. Since at least the second century when the Romans built the fort of Galava, at its northern end, Windermere has been an important waterway, particularly with regard to the transportation of heavy, bulky materials like stone, iron ore and timber. High Pike – rising from Ambleside to a flat, grassy summit, 2,155 feet above sea-level – forms the long southern spur of Dove Crag (2,603 feet). Running along the ridge is a massive drystone wall.

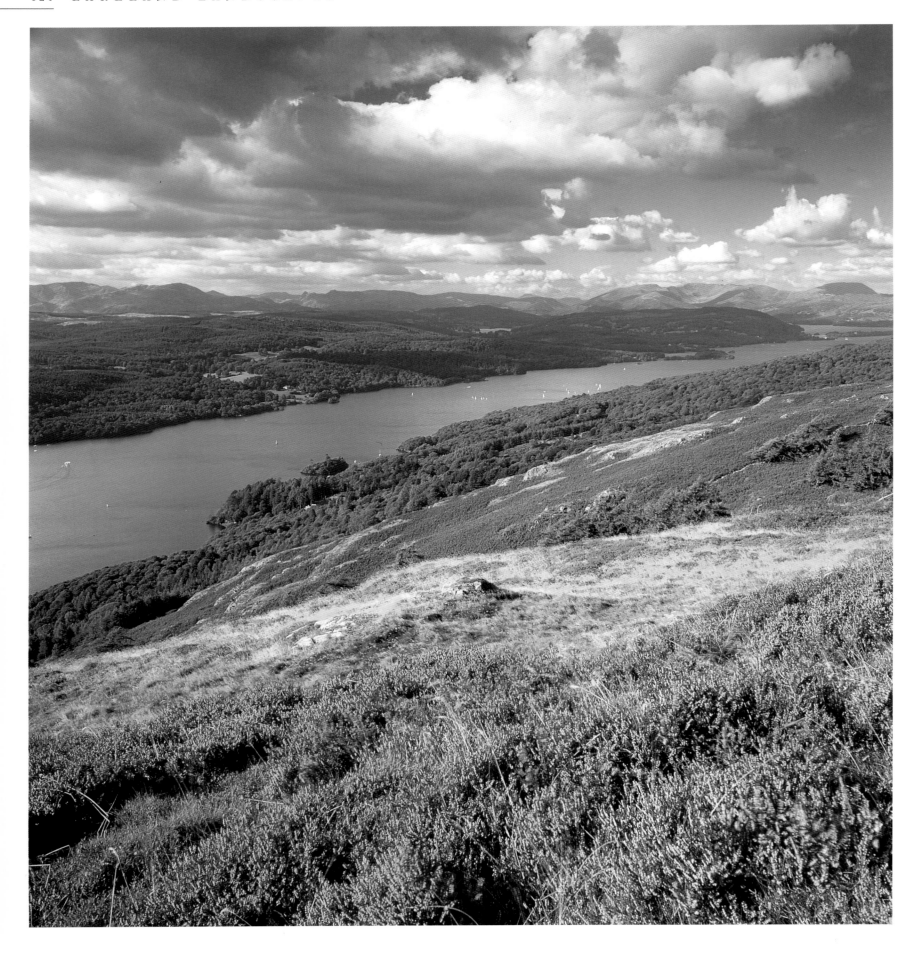

Windermere, from Gummer's How

In his *Northern Tour of 1771* Arthur Young wrote, viewing Windermere from the 'side of a large ridge of hills that form the eastern boundaries of the lake': 'The valley is floated by the lake, which spreads forth … in one great but irregular expanse of transparent water. A more noble object can hardly be imagined. Its immediate shore is traced in every variety of line that fancy can conceive, sometimes contracting the lake into the appearance of a winding river; at others retiring from it, and opening large swelling bays, as if for navies to anchor in; promontories spread with woods, or scattered with trees and inclosures, projecting into the water; rocky points breaking the shore, and rearing their bold heads above it. In a word, a variety that amazes the beholder.'

Hawkshead

Surrounding the old market square at Hawkshead are a series of partly cobbled lanes, courtyards and narrow alleys, often overhung by the upper floors of houses. Once an important centre of the home-spun wool and cloth industry, the town is particularly noted for being the place where Wordsworth spent his schooldays; attending the Old Grammar School between 1779 and 1787, and lodging for a short while at Anne Tyson's Cottage. When the Tysons moved to the nearby hamlet of Colthouse, Wordsworth went with them. The 'snow-white' exterior of the parish church of St Michael (mentioned by the poet in *The Prelude: Book IV* (1805), was rendered with mortar and gravel in 1875. 'Hawkshead', derived from the name of a Norse settler, means 'the summer pastures of Haukr'.

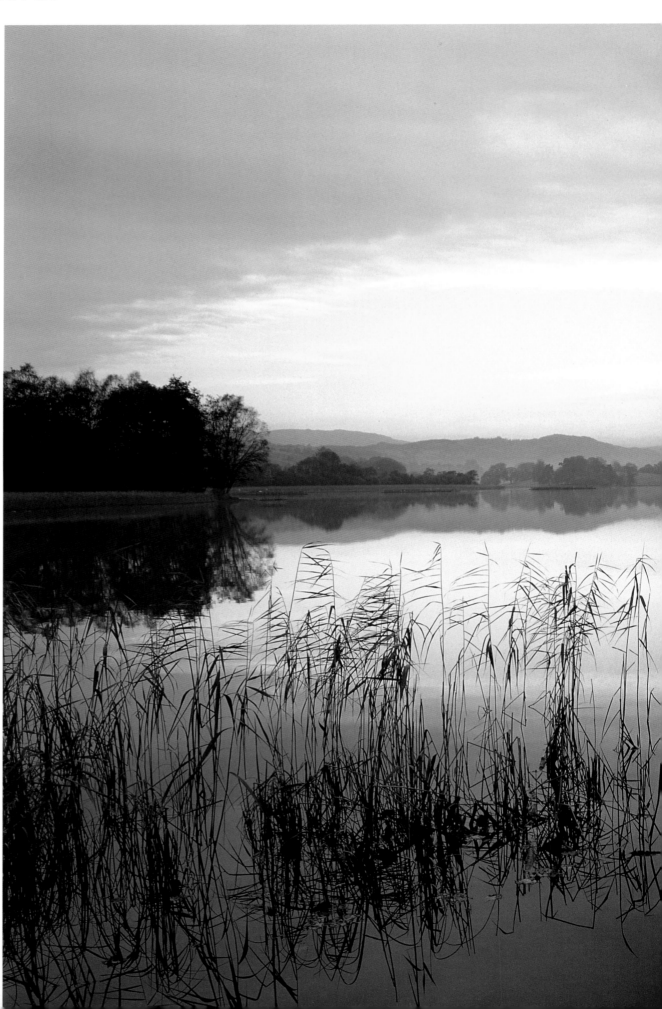

Esthwaite Water

One-and-a-half miles long and nearly half-a-mile wide, Esthwaite Water lies a short distance south-east of Hawkshead – the small market town where, as a boy, Wordsworth lived and went to school. In 1779, on one of his many walks around the shores of the lake, the future poet noticed a pile of discarded clothes on the promontory of Strickland Ees. In *The Prelude: Book V*, he described the recovery 'with grappling irons and long poles' of the body of the schoolmaster to whom the garments belonged: 'At last, the dead man, 'mid that beauteous scene / Of trees and hills and water, bolt upright / Rose, with his ghastly face, a spectre shape / Of terror.' The name 'Esthwaite Water' means 'the lake by the eastern clearing'. Its outlet, the Cunsey Beck, feeds Windermere.

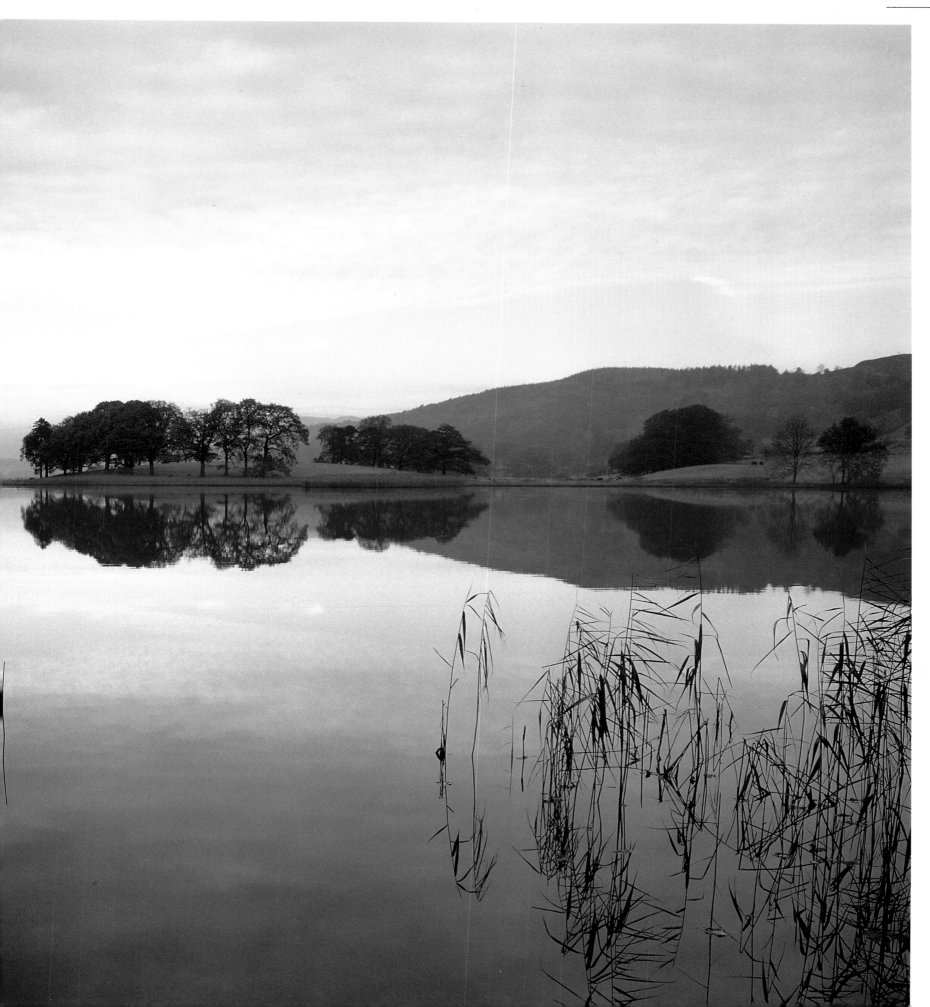

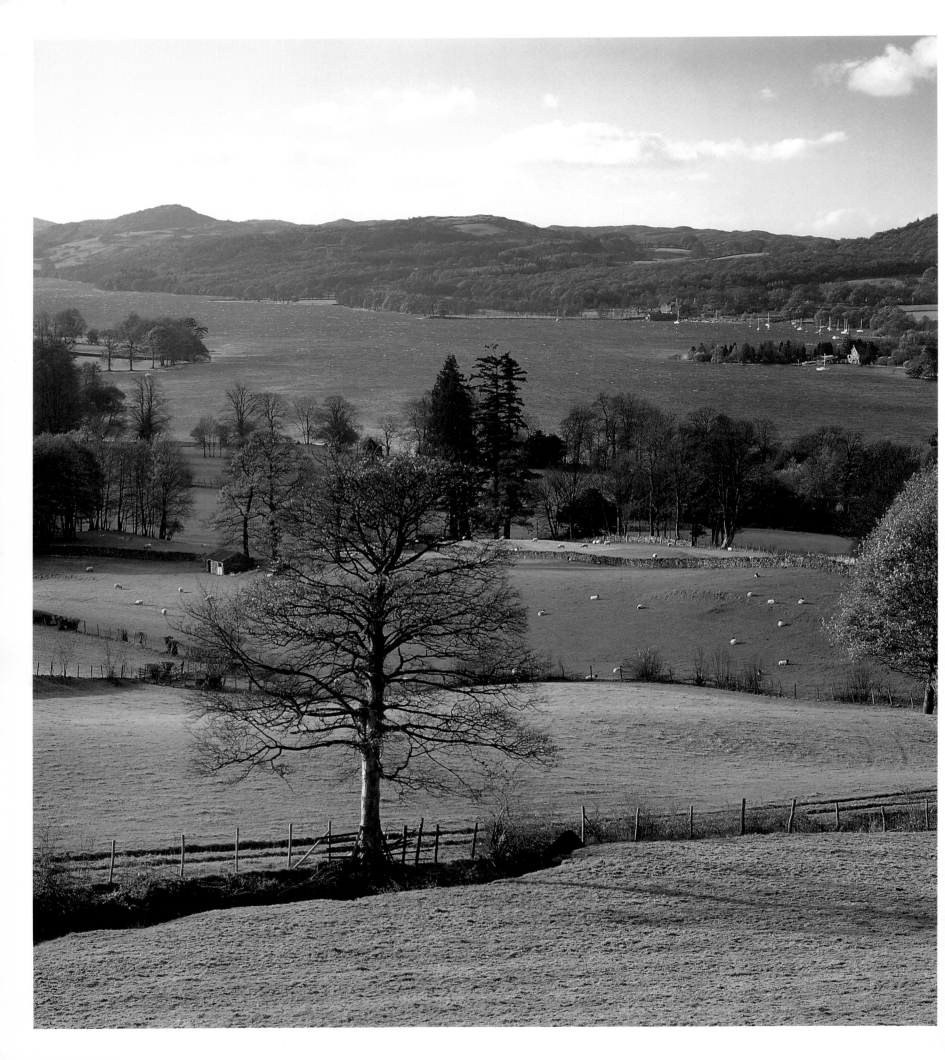

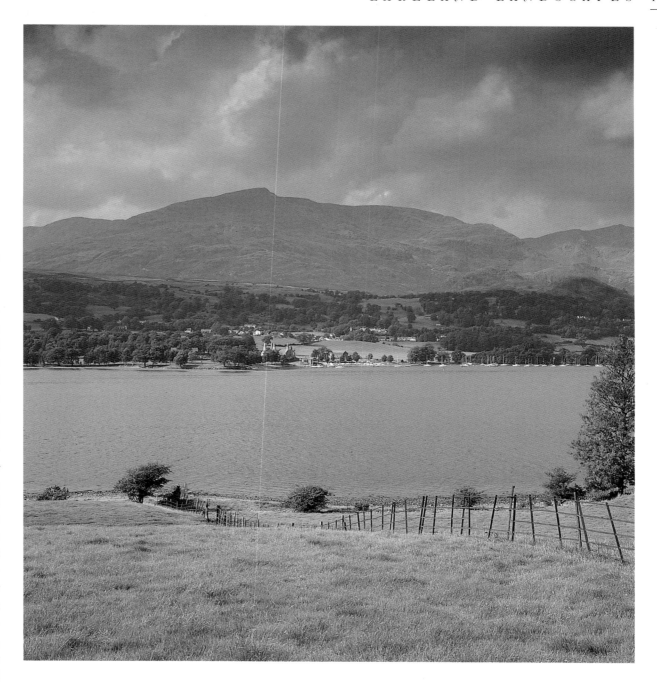

*Coniston Water,
from High Hollin Bank*

The two main islands on Coniston Water, both owned by the National Trust, are Fir Island (named after the Scots pines which grow on its half-acre of ground) and Peel Island (so-called because it once supported a pele tower). The latter, incidentally, was 'Wild Cat Island' in Arthur Ransome's *Swallows and Amazons*, first published in 1930. In *The Lake Country* (1864), Eliza Lynn Linton – who lived at Brantwood before Ruskin purchased the house in 1871 – claimed that the lake once had a floating island, but it 'got stranded among the reeds at Nibthwaite during a high wind and heavy flood, and has never been able to get off again'. Eliza's guide book contained engravings by her husband, W. J. Linton, the political reformer and editor of the journal *The English Republic*, printed at Brantwood.

*Coniston & the Old Man,
from Brantwood*

Dominating the western side of Coniston Water is the Old Man of Coniston (2,633 feet), scarred and mutilated by the workings of stone quarries and abandoned copper mines. Although Coniston, lying at its foot, was once an important mining centre, the village's prosperity is now mainly dependent on tourism. The railway line, constructed along the west bank of the lake and terminating at Coniston, was opened in 1859 and closed in 1957. One Victorian attraction still operating on the lake is the restored steam-yacht *Gondola*, owned by the National Trust. The tall-chimneyed house on the lake shore in the photograph is Coniston Hall, once the seat of the le Flemings. John Ruskin lived at Brantwood from 1872 until his death in 1900. He lies buried in Coniston churchyard.

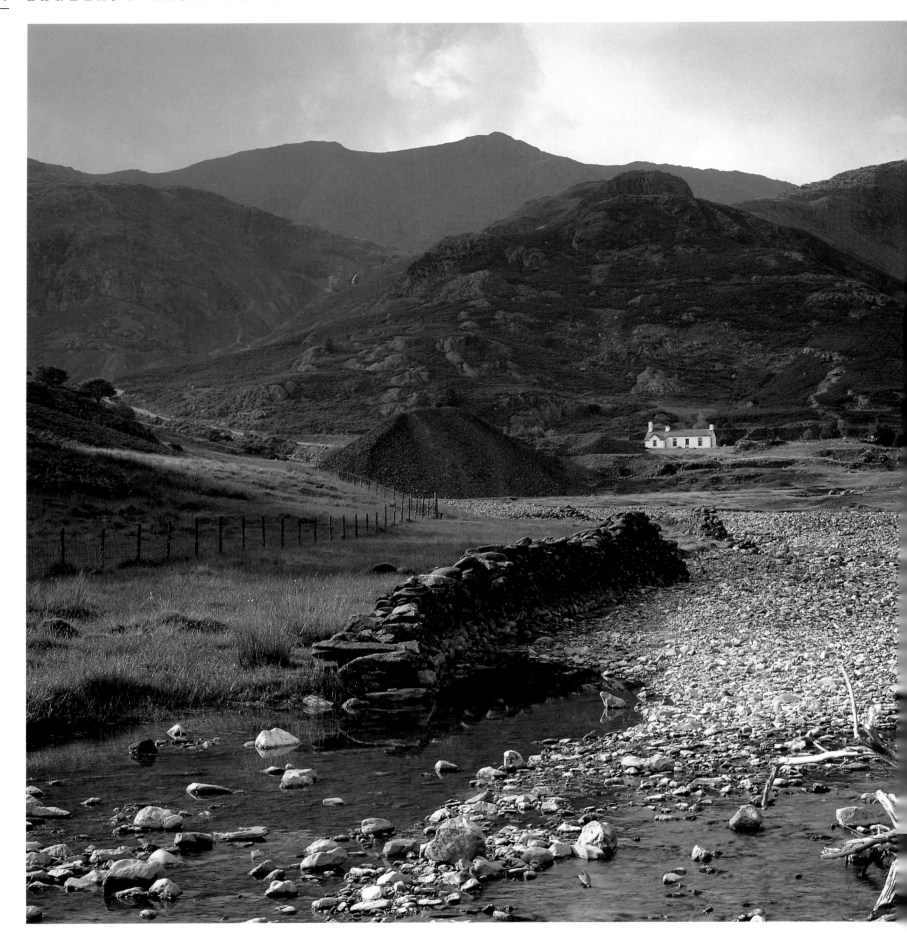

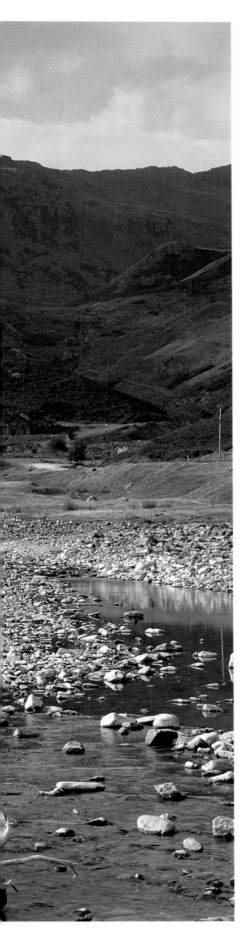

Coppermines Valley

Some two miles north-west of Coniston village, on the disfigured lower slopes of the Old Man, is Coppermines Valley, scarred with the debris of long-abandoned mining activity. Although the rich veins of copper may have been exploited from at least Roman times, mining of the ore on a large scale did not begin until Elizabethan times, when mining experts were imported from Germany. The mined ore was transported by packhorse to Keswick for smelting. Most of the crumbling remains, however, date from the nineteenth century. The reason for the decline and eventual closure of the Coniston mines was not because the veins were exhausted, but because cheap imported ore brought about an irreversible slump in copper prices. The white building in the photograph is a Youth Hostel.

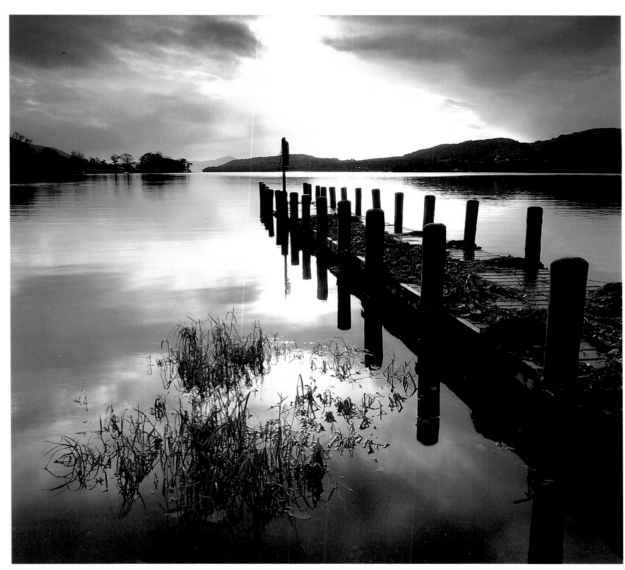

Coniston Water

Anciently called 'Thurston Mere', Coniston Water is five-and-a-quarter miles long, half-a-mile wide and 184 feet deep. Because it is long, straight and narrow the lake has been used for several attempts on the world water-speed record. In 1939 Sir Malcolm Campbell achieved a record-breaking speed of 141.74 mph. His son, Donald, subsequently raised the record to 202 mph on Ullswater and, four years later, reached over 260 mph on Coniston. It was while attempting to break the 300 mph barrier, on 4 January 1967, that Campbell's turbo-jet engined Bluebird K7 lifted up into the air, somersaulted, plunged into Coniston Water and disintegrated. Although Campbell's helmet, oxygen mask, shoes and teddy-bear mascot were found, his body was never recovered.

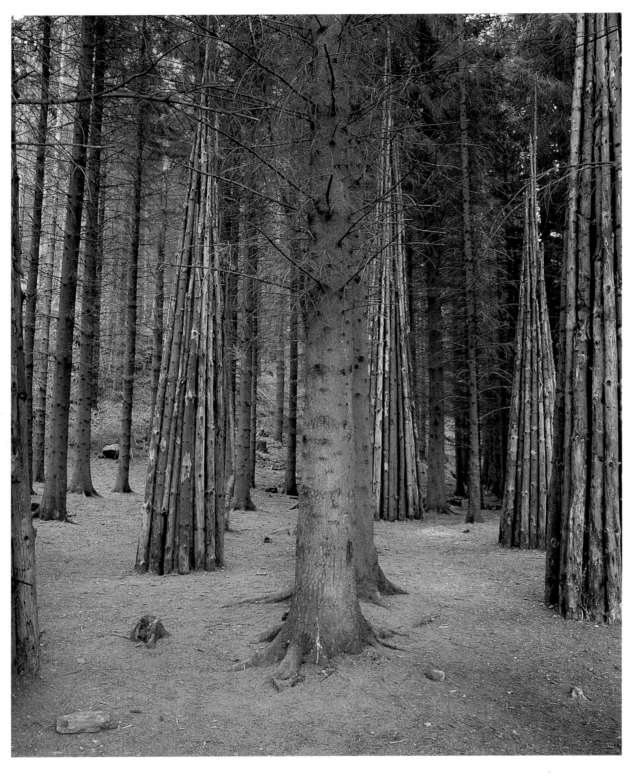

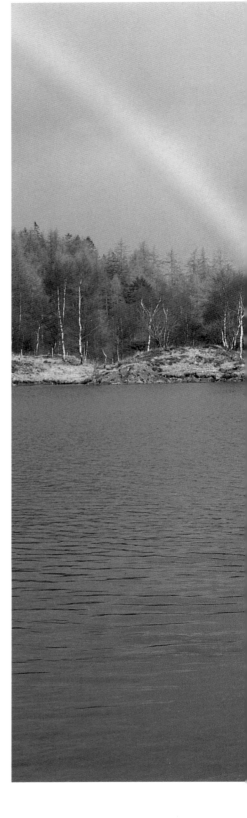

'Seven Spires', Grizedale Forest

Since 1977 many artists from Britain and abroad have been given the opportunity to work in the natural environment of Grizedale Forest. Andy Goldsworthy's 'Seven Spires' (1984), stands near Bogle Crag. In *The Grizedale Experience* (1991), edited by Bill Grant and Paul Harris, the artist wrote: 'In making the spires I wanted to concentrate the feelings I get from within a pine wood of an almost desperate growth and energy driving upward. The spire also seemed appropriate with its reference to churches and, in particular, the Cathedral with its architectural use of lines leading the eye skyward. I also felt a similarity in the subdued brown light and stillness found both in cathedrals and pine forests.'

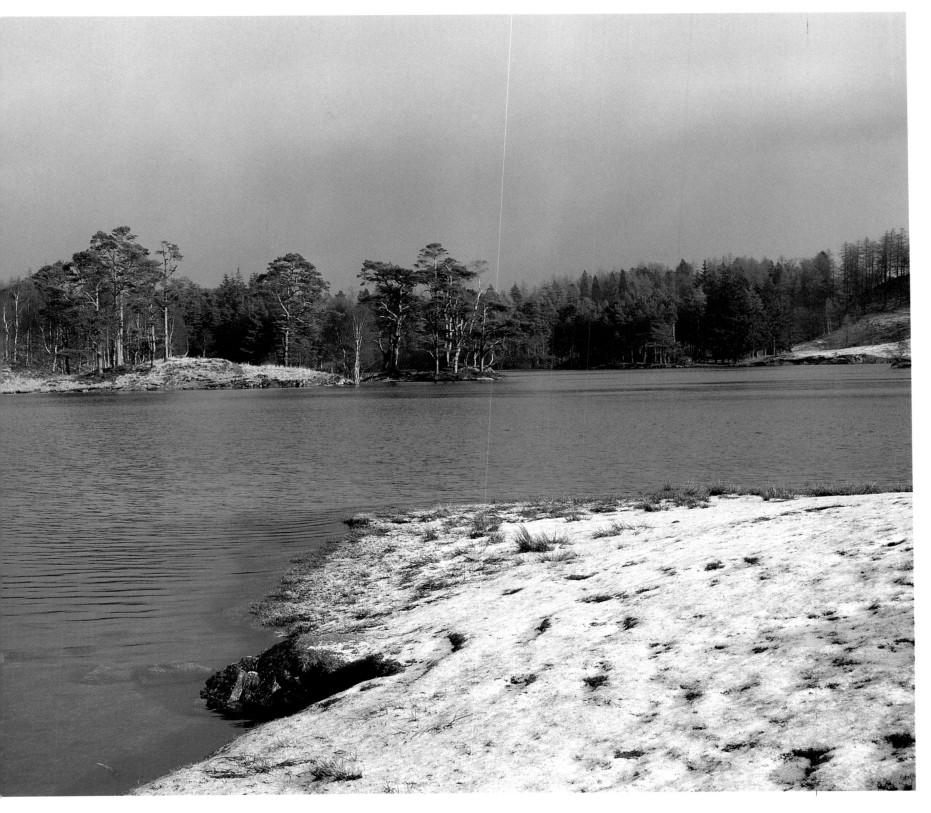

Tarn Hows, near Coniston

Surrounded by rocky promontories and wooded shores, Tarn Hows is one of the most popular and most beautiful places in Lakeland. The latter half of its name is derived from the Old Norse for a 'small hill' or 'mound'. 'Tarn Hows' is also the name of a nearby farm. The three original, natural tarns (known as Monk Coniston Tarns) were transformed into one large irregularly shaped tarn, with two small islands, at around the close of the nineteenth century, when the landowner built a small dam at the southern end. He also planted the spruce and larch. Medieval legend says that the place was the home of a giant, 'Gurt Will of the Tarns', who was slain after killing the beautiful Eva le Fleming of Coniston Hall, together with her fiancée, a handsome young falconer.

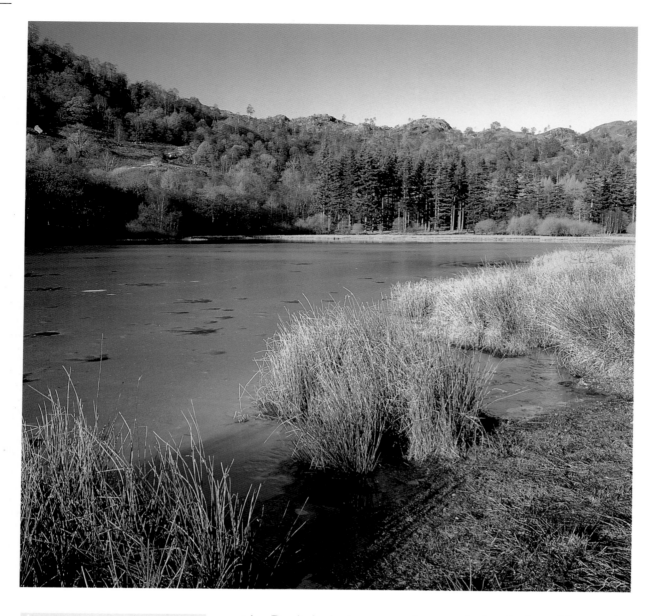

Yew Tree Tarn, near Coniston

Alongside the main Skelwith Bridge to Coniston road, on the eastern side of Holme Fell (1,040 feet), Yew Tree Tarn was created in the 1930s by damming its southern end. Like Yew Tree Farm and nearby Tarn Hows, the tarn is now owned by the National Trust. The old quarry road to the north, between Oxen Fell High Cross and Hodge Close, is reputed to be haunted by the 'Oxen Fell Dobby'. Apparently, Betty Briggs, the daughter of a Tilberthwaite farmer, was betrothed to Jack Slipe, a farm-worker. Despite having been escorted by Jack to a dance at Clappersgate, Betty spent most of the evening with a gardener at Rydal Hall. After escorting Betty home, the gardener mysteriously disappeared. The appearance of the dobby along the road is said to be accompanied by the sounds of a struggle.

Yew Tree Farm, near Coniston

One of over eighty working Lakeland farms in the care of the National Trust, Yew Tree Farm is a celebrated example of a farmhouse with an open 'spinning gallery' attached to the barn. More usually, however, the gallery was built as an extension of the house. In addition to being used for spinning, the gallery served as a storage area, a place where the wool was hung up to dry, and as a means of access to the upper floor of the building. The oldest part of Yew Tree farmhouse itself is of 'cruck' construction, to which a new wing was added in 1743 (the date appears on the front door handle, together with the initials 'CWA'). Apparently, the yew tree from which the farm took its name was some 700 years old before it was blown down in a storm towards the close of the nineteenth century.

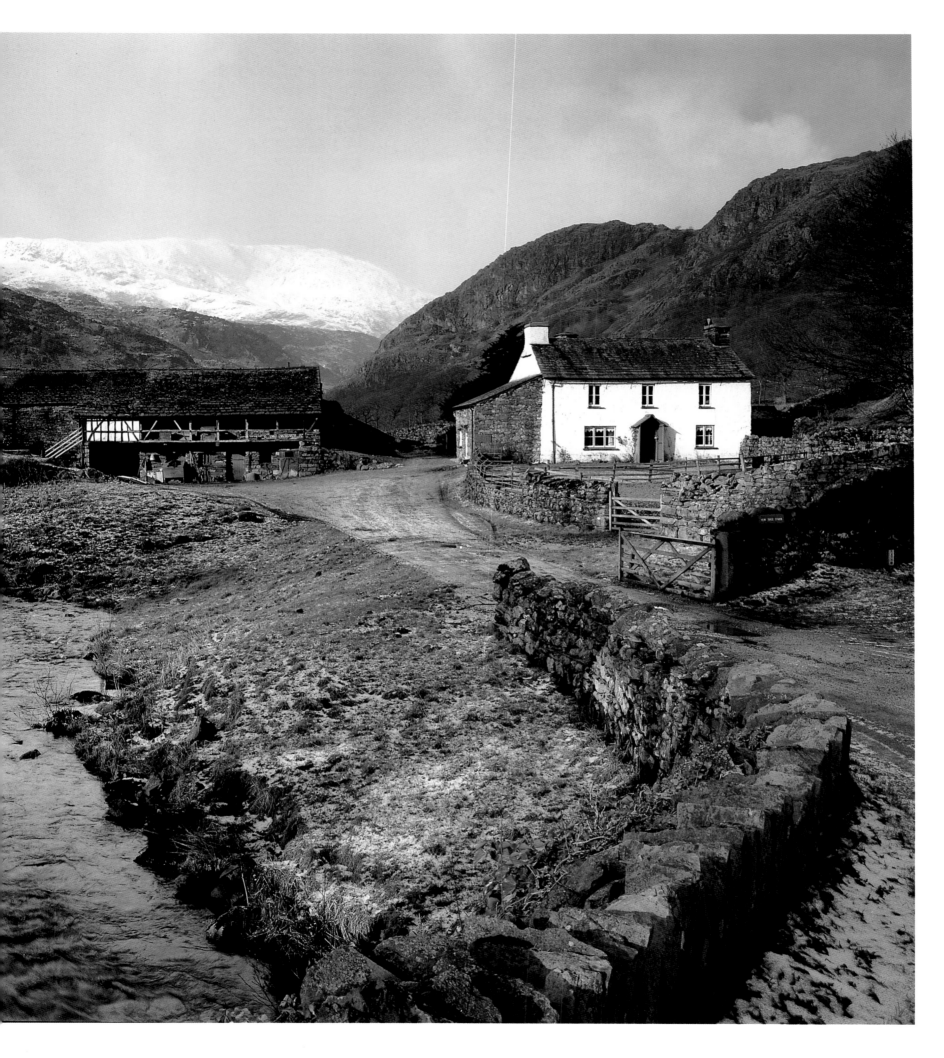

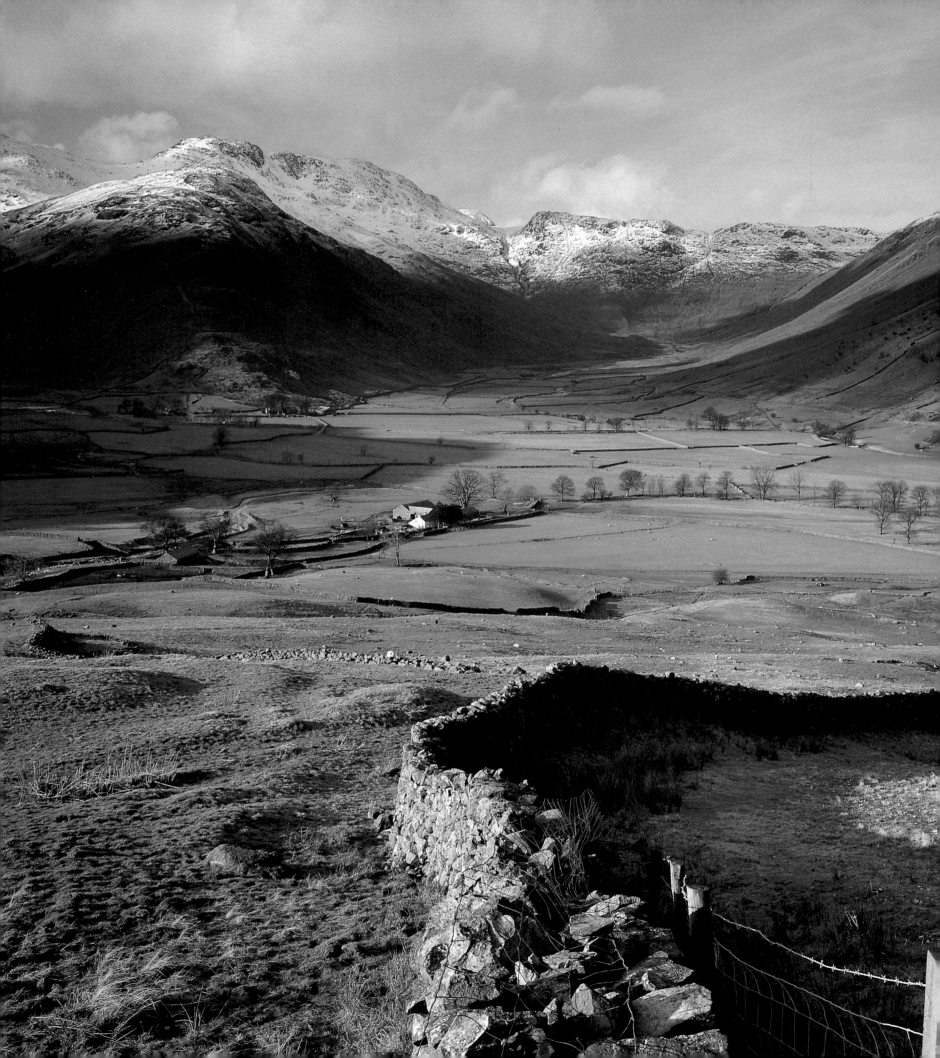

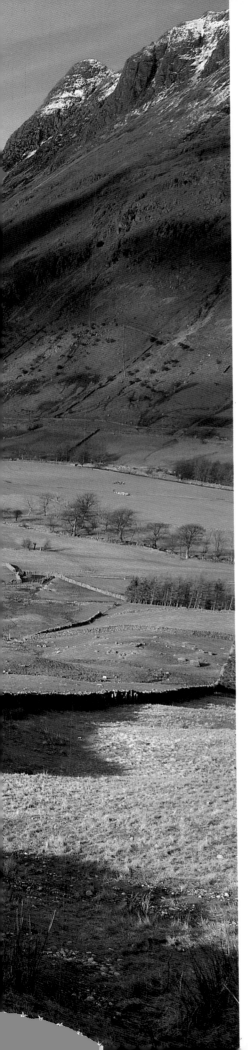

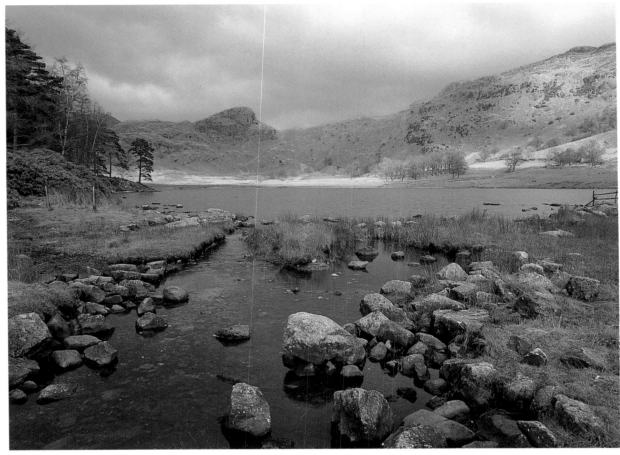

Mickleden, from near Side Pike

The head of Great Langdale divides into two lesser valleys, Mickleden and Oxendale, which are separated by the ridge known as the Band, rising to Bow Fell (2,960 feet). Mickleden, watered by the Mickleden Beck, forms a deep trench between the steep slopes of the Langdale Pikes (on the right of the photograph) and the Band (on the left). South of the Band, the valley of the Oxendale Beck contains a small reservoir (extreme left). One old packhorse route up Mickleden links Great Langdale with Borrowdale by way of Stake Pass (1,576 feet) and the Langstrath valley. Another, following Rossett Gill up to Angle Tarn, leads to Esk Hause (2,490 feet), from where there are alternative routes to Wasdale Head, – via Sty Head Pass (1,600 feet) – Eskdale and Borrowdale.

Blea Tarn, Little Langdale

The valley of the Bleamoss Beck, linking the two Langdales, provided the setting for Wordsworth's 'The Solitary' (*The Excursion: Book II*): 'A lowly vale, and yet uplifted high / Among the mountains; even as if the spot / Had been from eldest time by wish of theirs / So placed to be shut out from all the world!' Blea Tarn and nearby Bleatarn House, the home of the Solitary, are both mentioned in the poem: 'A liquid pool that glittered in the sun, / And one bare dwelling; one abode, no more!' Forming almost a circle some 600 to 700 feet in diameter, the tarn reaches a maximum depth of just over twenty feet. It is the most accessible of several Blea Tarns in Lakeland. The prominent peak in the photograph (centre-left) is Side Pike (1,187 feet).

Tilberthwaite Fells & Wetherlam, from Wrynose

'Among the beautiful appearances of fogs, and mists,' wrote William Gilpin in *Observations ... [on] the Mountains, and Lakes of Cumberland, and Westmorland*, 'their gradually going off may be observed. A landscape takes a variety of pleasing hues, as it passes, in a retiring fog, through the different modes of obscurity into full splendour. There is great beauty also in a fog's partially clearing up at once, as it often does; and presenting some distant piece of landscape under great radiance; when all the surrounding parts are still in obscurity. The curtain is not entirely drawn up; it is only just raised, to let in some beautiful, transient view; and perhaps falling again, while we admire, leaves us that ardent relish, which we have for pleasing objects suddenly removed.'

Cathedral Cave, Wetherlam

From Slater's Bridge, Little Langdale, one ascent to the 2,502-foot-high summit of Wetherlam passes near to the entrance of an underground tunnel that opens unexpectedly into a huge and spectacular green cavern, known as Cathedral Cave. Unusually, it is lit by an opening at the side. To remove the slate the quarrymen had to hang by chains from the roof – which, incidentally, is itself supported by a massive fifty-foot pillar of slate. The wooded fellside in this area is gashed and disfigured by centuries of slate quarrying. Indeed, Wetherlam – scarred not only by quarrying but also by copper mining – is one of the most industrially exploited mountains in Lakeland. Many of the underground workings are extremely dangerous and should not be entered.

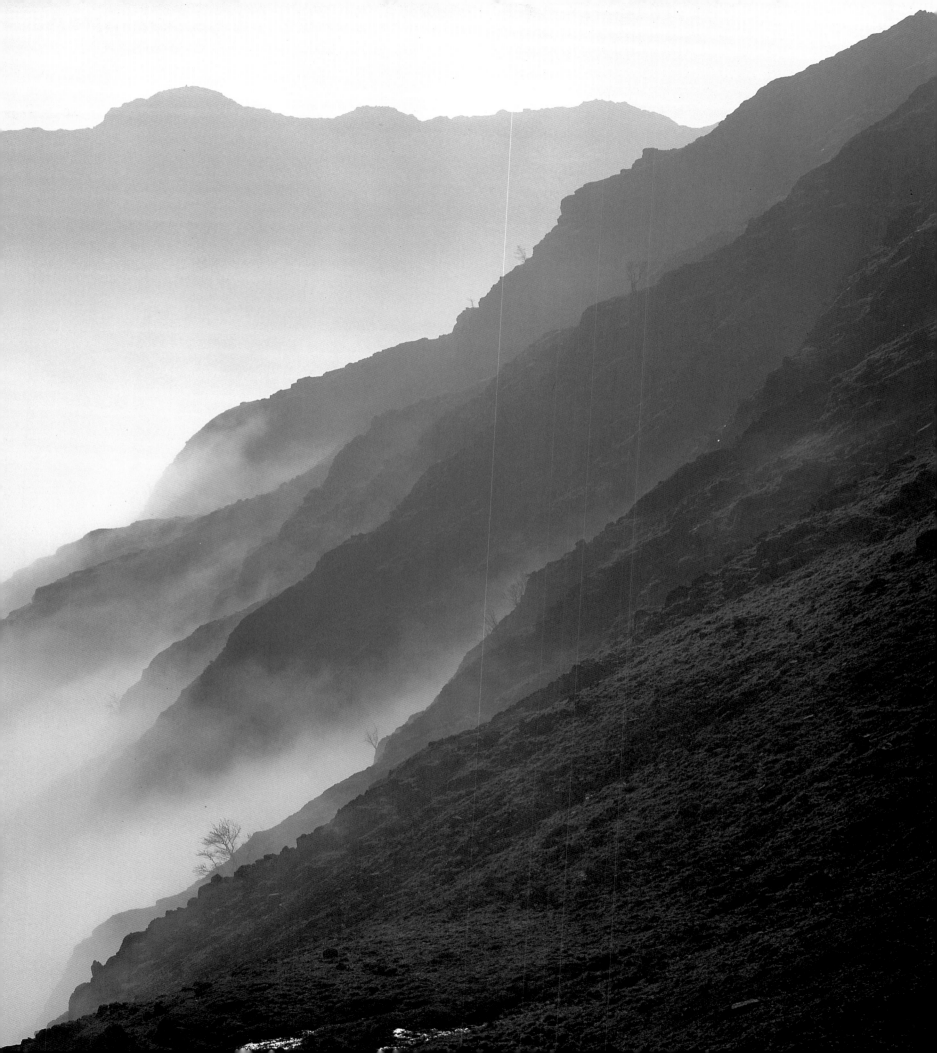

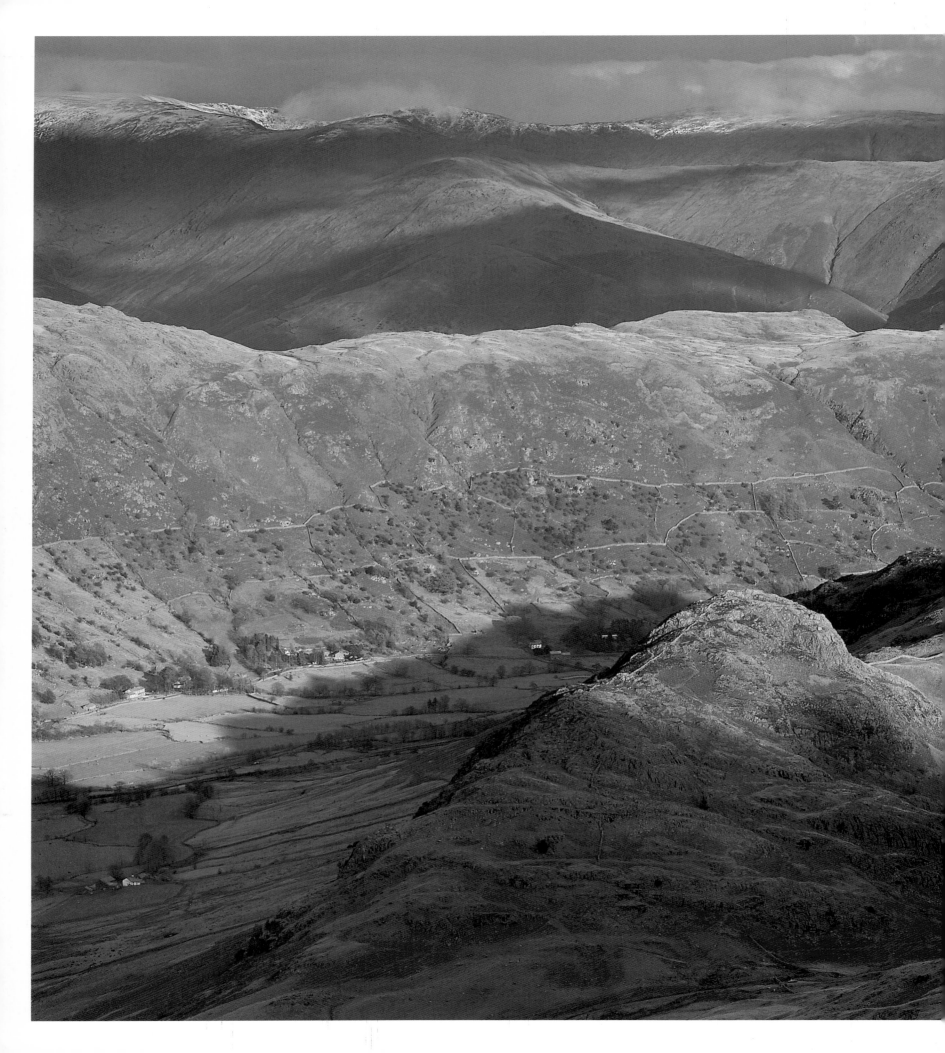

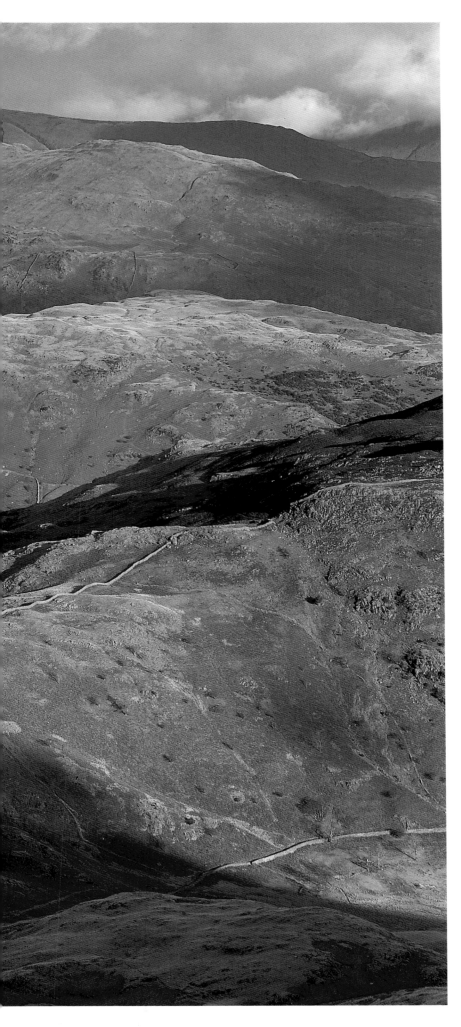

Side Pike & Great Langdale, from Pike o' Blisco

Side Pike is part of the crescent-shaped ridge of Lingmoor Fell (1,530 feet), separating Little Langdale from Great Langdale. Linking both valleys is a narrow, winding road which heads northward from near Fell Foot Farm to follow the course of Bleamoss Beck to Blea Tarn and Bleatarn House, before dropping steeply (from the western end of Side Pike) to Wall End and the Old Dungeon Ghyll Hotel. The high ground in the middle of the photograph forms part of the long, undulating ridge that runs south-eastward from High Raise (2,500 feet) to terminate near Ambleside. The section dropping into Great Langdale rises to Blea Rigg (1,776 feet). The easiest ascent to the summit of Pike o' Blisco (2,304 feet) is from the Three Shire Stone on Wrynose Pass.

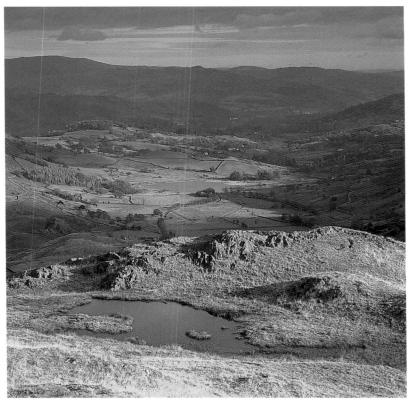

Little Langdale, from Wrynose

From the late seventeenth century, when heavy taxes were levied on the import of goods like tea, wine and spirits, many Lakeland inhabitants, from all levels of society, were involved in the smuggling trade. One of the most notorious smugglers and moonshiners was Lanty Slee, who was born in Borrowdale in 1802 and died at Greenbank Farm, Little Langdale, seventy-six years later. For much of his life he operated several illicit liquor distilleries in hideouts high up in the fells around Little Langdale and Wrynose. In *Inside the Real Lakeland*, A. H. Griffin described finding the remains of Lanty's apparatus in a cave in the deserted Betsy Crag quarry on Wetherlam. Although some of Lanty's whisky was sold locally, most of it went over the old smugglers' road to Ravenglass.

Terraced Cottages, Elterwater

Once a busy industrial centre for slate quarrying and gunpowder manufacture, this village stands at the north-western end of Elterwater. Many of the stone terraces were built to house the workers. Although quarrying for high-quality green slate is still carried out in the locality, the gunpowder works – established alongside the fast-flowing Great Langdale Beck in 1824 – ceased production in 1928–29. A time-share development now occupies the site. The Britannia Inn, originally built as a farmhouse, dates from the seventeenth century, while the single-arched stone bridge crossing the beck dates from 1702. The riverside walk from the village, past Elterwater lake and Skelwith Force, leads to Skelwith Bridge, where the Kirkstone Green Slate Quarries have a showroom.

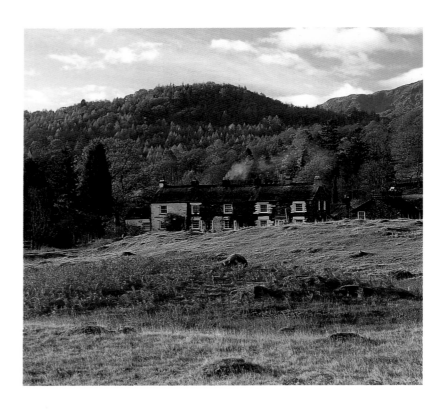

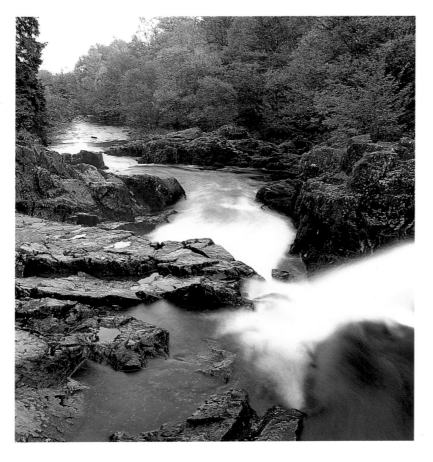

Skelwith Force, Skelwith Bridge

From its source on Pike o' Blisco, near Wrynose Pass, the River Brathay flows eastward through Little Langdale Tarn and Elterwater to merge with the River Rothay near the Roman fort of Galava (Ambleside). Within a short distance, the combined waters enter the northern end of Windermere. At Skelwith Force – near the hamlet of Skelwith Bridge, below Elterwater – the Brathay is squeezed through a narrow cleft of rock, to create a single fifteen- to twenty-foot fall of immense power. After heavy rain the valley between Skelwith and Clappersgate often floods, transforming the river into a vast and shallow lake. Reference to the river's fairly wide lower reaches may be found in the name 'Brathay', derived from the Old Norse for 'the broad river'.

Elterwater & Langdale Pikes

Lying at the junction of the Great and Little Langdale valleys, Elterwater is only half-a-mile long and, therefore, the smallest of the sixteen lakes. Indeed, as silt and other river-borne material builds up around its irregular reed-fringed shoreline, the lake is steadily growing smaller. This infilling process, which has been going on steadily since the last glaciation, will inevitably lead to its complete disappearance (as has already happened with the lake that was once higher up in Great Langdale). The name 'Elterwater' is derived from the Old Norse for 'lake of swans', and even today it is often visited in winter by the whooper swan. Among other water birds to frequent the lake are herons, coots, moorhens, mallards, tufted ducks, grebes, mergansers and mute swans.

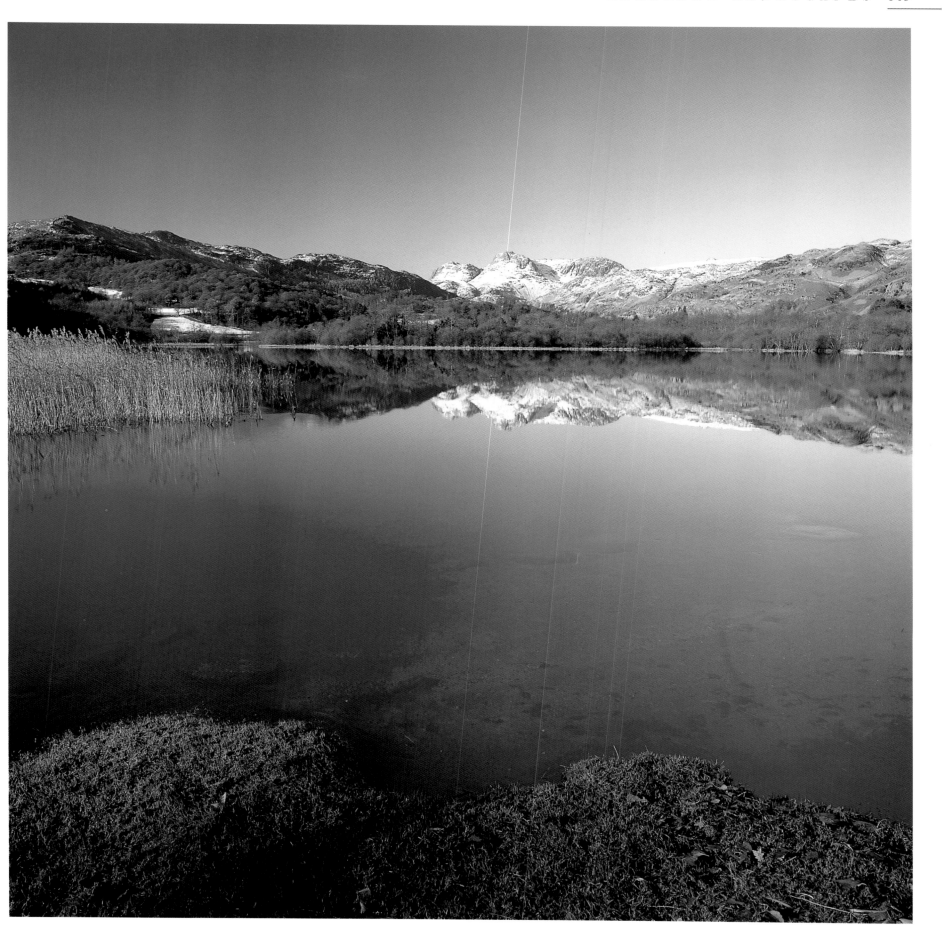

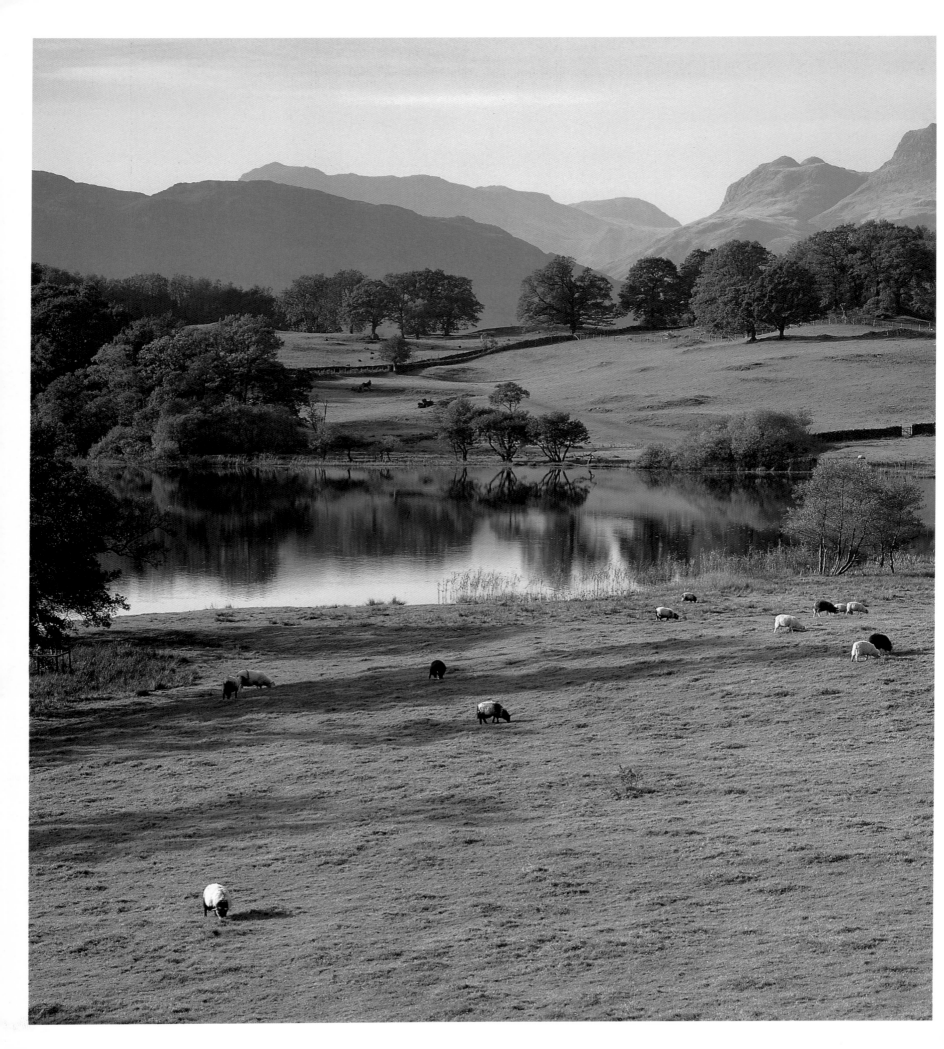

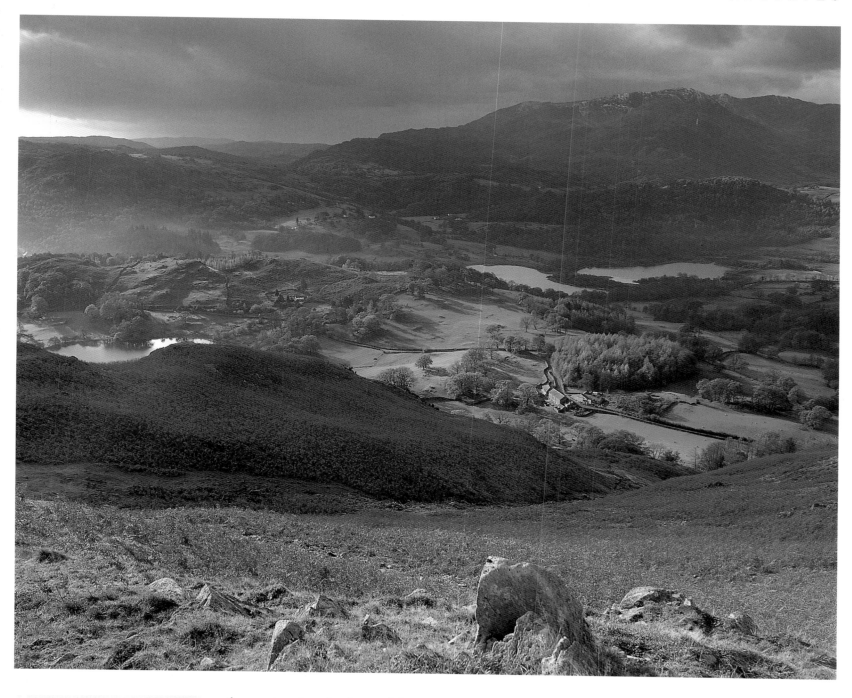

Loughrigg Tarn

Wordsworth wrote in his *Guide*: 'A Tarn, in a Vale, implies, for the most part, that the bed of the vale is not happily formed; that the water of the brooks can neither wholly escape, nor diffuse itself over a large area. Accordingly, in such situations, Tarns are often surrounded by an unsightly tract of boggy ground; but this is not always the case, and in the cultivated parts of the country, when the shores of the Tarn are determined, it differs only from the Lake in being smaller, and in belonging mostly to a smaller valley, or circular recess. Of this class of miniature lakes, Loughrigg Tarn, near Grasmere, is the most beautiful example. It has a margin of green firm meadows, of rocks, and rocky woods, a few reeds here, a little company of water-lilies there ...'

Loughrigg Tarn, Elterwater & Little Langdale

Despite reaching a height of only 1,101 feet, Loughrigg Fell offers magnificent views over four lakes (Elterwater, Grasmere, Rydal Water and Windermere) and one tarn, Loughrigg, nestling on the lower slopes of its south-western side. In *A Pictorial Guide to the Lakeland Fells: Book Three*, Wainwright wrote of Loughrigg: 'for many people who now find pleasure in walking over the greater mountains it served as an introduction and an inspiration'. Unhappily, the peace hereabouts is often shattered by low-flying military aircraft. Despite complaints, the RAF maintains that low flying is the only way pilots can acquire the skills essential to avoid detection by enemy radars. Tragically, several planes have crashed, not only into the fell-sides but into each other.

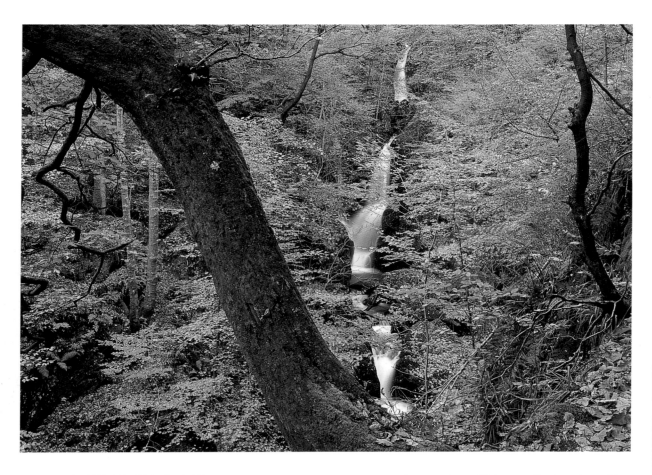

Stock Ghyll Force, Ambleside

John Keats wrote of this fall in 1818: 'First we stood a little below the head about half way down the first fall, buried deep in trees, and saw it streaming down two more descents to the depth of near fifty feet – then we went on a jut of rock nearly level with the second fall-head, where the first fall was above us, and the third below our feet still – at the same time we saw that the water was divided by a sort of cataract island on whose other side burst out a glorious stream – then the thunder and the freshness. At the same time the different falls have as different characters; the first darting down the slate-rock like an arrow; the second spreading out like a fan – the third dashed into a mist – and the one on the other side of the rock a sort of mixture of all these.'

Stock Beck, Ambleside

Stock Beck, a tributary of the River Rothay, rises on the prominent whale-back mass of Red Screes (the 2,541-foot-high fell that towers above Kirkstone Pass) and tumbles south-westward down the valley and over Stock Ghyll Force to the market town of Ambleside (where it passes under the tiny 'Bridge House'). Stock Ghyll is thought to derive from the Old Norse words *stokkr*, meaning 'a tree stump', and *gil*, 'a narrow ravine'. 'Stock', alternatively, may refer to one of several watermills that were known to have existed in the valley. Within a quarter-mile stretch of the Stock Beck at Ambleside, for instance, there was a corn-mill, a woollen-mill, a bobbin-mill and a bark-crushing mill – all powered by the fast-flowing stream.

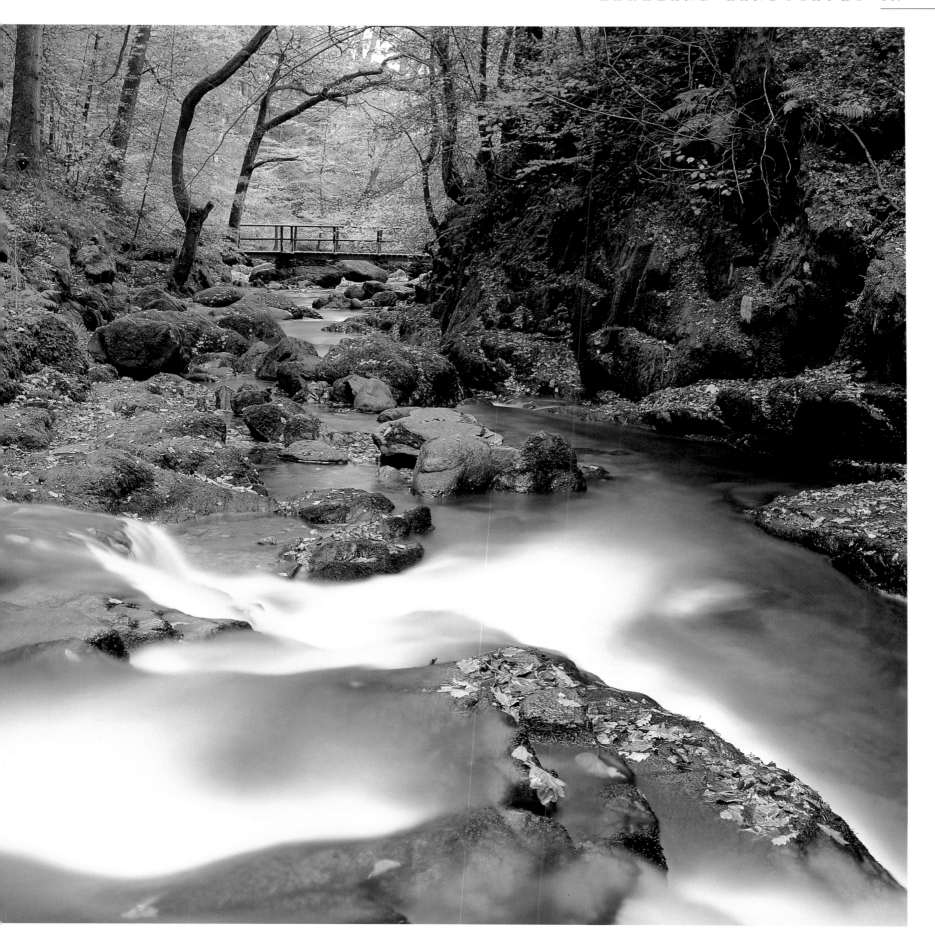

Rydal Water, from White Moss Common

Before the level highway was built in about 1831 the road from Grasmere to Rydal climbed over White Moss Common (so named because the eminence supports cottongrass, a type of sedge whose fruiting head resembles white balls of cottonwool). While she was living at Dove Cottage, Dorothy Wordsworth often wrote in her *Journal* of the walks she and William took to Rydal to collect their mail. The route took them over White Moss. In early June 1802 she wrote: 'We saw the lake [Rydal Water] from a new and most beautiful point of view, between two little rocks, and behind a small ridge that had concealed it from us. This White Moss, a place made for all kinds of beautiful works of art and nature, woods and valleys, fairy valleys and fairy tarns, miniature mountains, alps above alps.'

Rydal Mount, Rydal

In May 1813, after living at Grasmere for some thirteen years, the Wordsworths moved to Rydal Mount, a large house on the wooded hillside above St Mary's Church, Rydal. Originally a small farm cottage, dating from the mid-sixteenth century, the house was extended and improved in the mid-eighteenth century. It was purchased by Lady Diana le Fleming of Rydal Hall in 1812, and rented to Wordsworth the following year. All three Wordsworths – William, his sister and his wife – resided at Rydal Mount until their deaths in 1850, 1855 and 1859, respectively. The garden, covering some four-and-a-half acres, was designed by the poet himself. The mound in front of the house (from which it takes its name) is thought to have been used as an ancient 'look out post'.

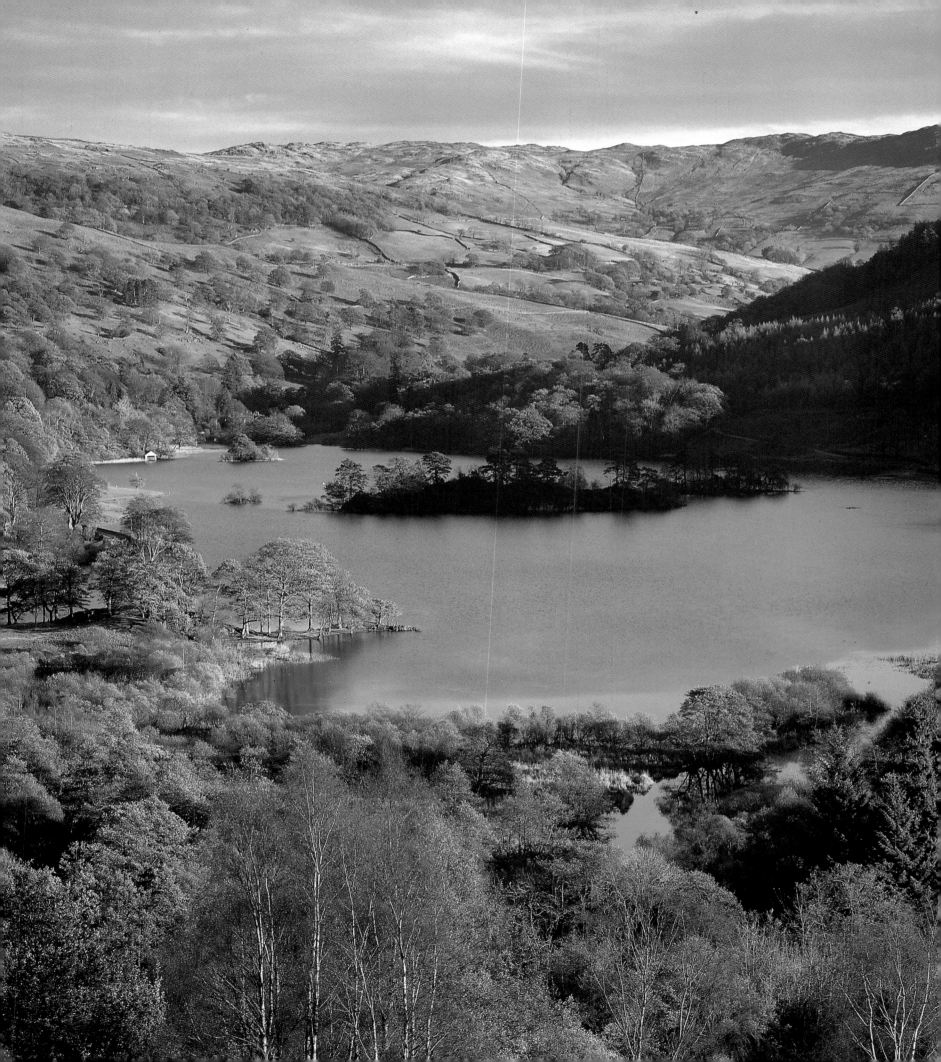

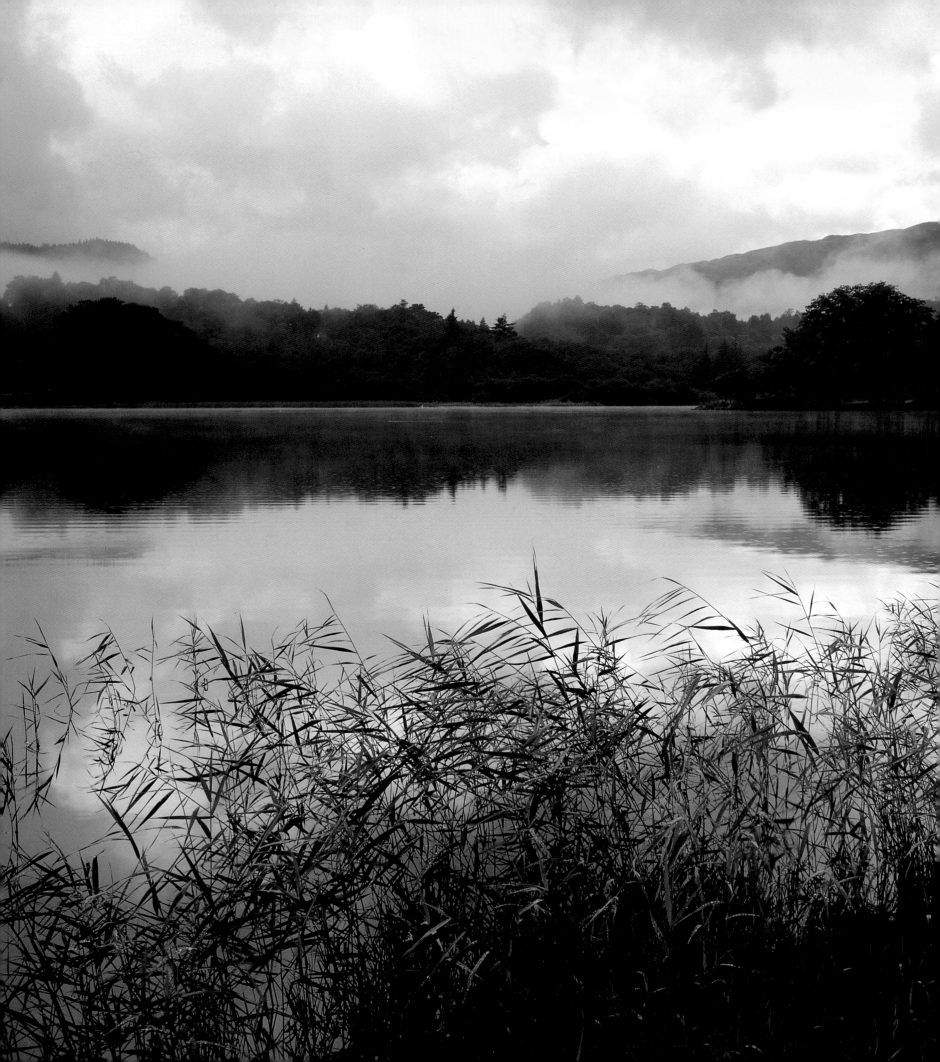

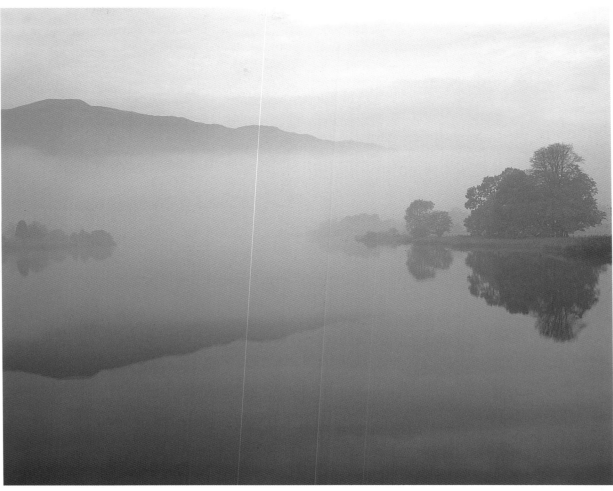

Rydal Water

Regarding the Lakeland climate and ' "skiey influences," in which the region, as far as the character of its landscapes is affected by them, may upon the whole, be considered fortunate' – Wordsworth wrote in his *Guide*: 'Vapours exhaling from the lakes and meadows after sun-rise, in a hot season, or, in moist weather, brooding upon the heights, or descending towards the valleys with inaudible motion, give a visionary character to everything around them; and are in themselves so beautiful, as to dispose us to enter into the feelings of those simple nations (such as the Laplanders of this day) by whom they are taken for guardian deities of the mountains; or to sympathise with others who have fancied these delicate apparitions to be the spirits of departed ancestors.'

Rydal Water

On Sunday 19 October 1800, Dorothy Wordsworth wrote in her *Journal*: 'Rydal very beautiful. The surface of the water quite still, like a dim mirror. The colours of the large island exquisitely beautiful, and the trees, still fresh and green, were magnified by the mists.' The largest island in Rydal Water – the second smallest of the sixteen lakes – was the setting for Wordsworth's 'The Wild Duck's Nest' and 'Written with a Slate Pencil upon a Stone, the largest of a Heap lying near a Deserted Quarry, upon one of the Islands at Rydal'. The latter was inspired by a plan to build a 'pleasure-house' on the island. Although work started, the project was abandoned when the landowner, Sir William le Fleming, found out that a 'full-grown man might wade' to the island from the shore.

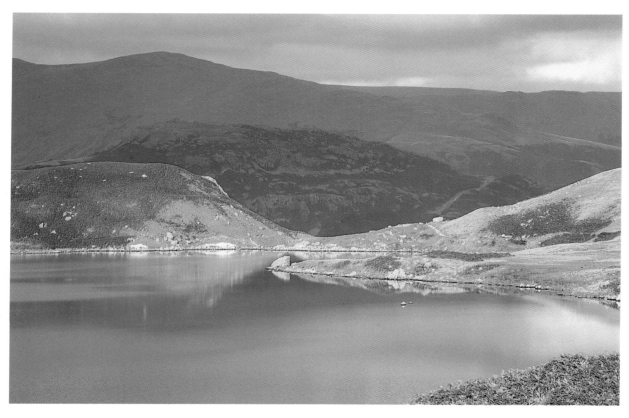

Easedale Tarn, Grasmere Common

Lying in a glacial valley, below the steep and rugged slopes of Tarn Crag (1,801 feet), Easedale Tarn has long been a popular destination for visitors. Wordsworth often walked to the tarn from Grasmere, following the Easedale Beck upstream, and past the 'single mountain-cottage' of Goody Bridge Farm. In old age, the poet reckoned that he had composed thousands of lines while walking beside the stream. The natural dam that retains the waters of the tarn is formed of debris deposited by melting glacial ice. A similar glacial moraine holds the smaller Codale Tarn, occupying a shelf higher up the fell. Its waters feed Easedale Tarn, to eventually emerge as Sour Milk Gill, a tributary of the Easedale Beck. Dorothy Wordsworth called the Sour Milk Gill waterfall 'Churn Milk Force'.

Grasmere, from Red Bank Woods

In 1801, while living at Dove Cottage, Grasmere, Dorothy Wordsworth wrote in her *Journal*: 'Grasmere Lake a beautiful image of stillness, clear as glass, reflecting all things.' Like William, she was born at Cockermouth and, like him, spent most of her long life in Lakeland. Her brother had been mysteriously drawn to Grasmere while he was a pupil at Hawkshead Grammar School. Later he wrote of the experience in his unfinished poem 'The Recluse'. In it the 'roving schoolboy' forgot his 'boyish pursuits' and 'sighing said': 'What happy fortune were it here to live! / And, if a thought of dying, if a thought / Of mortal separation could intrude / With paradise before him, here to die!' The Wordsworths lie buried in the cemetery of St Oswald's Church, Grasmere, beside the River Rothay.

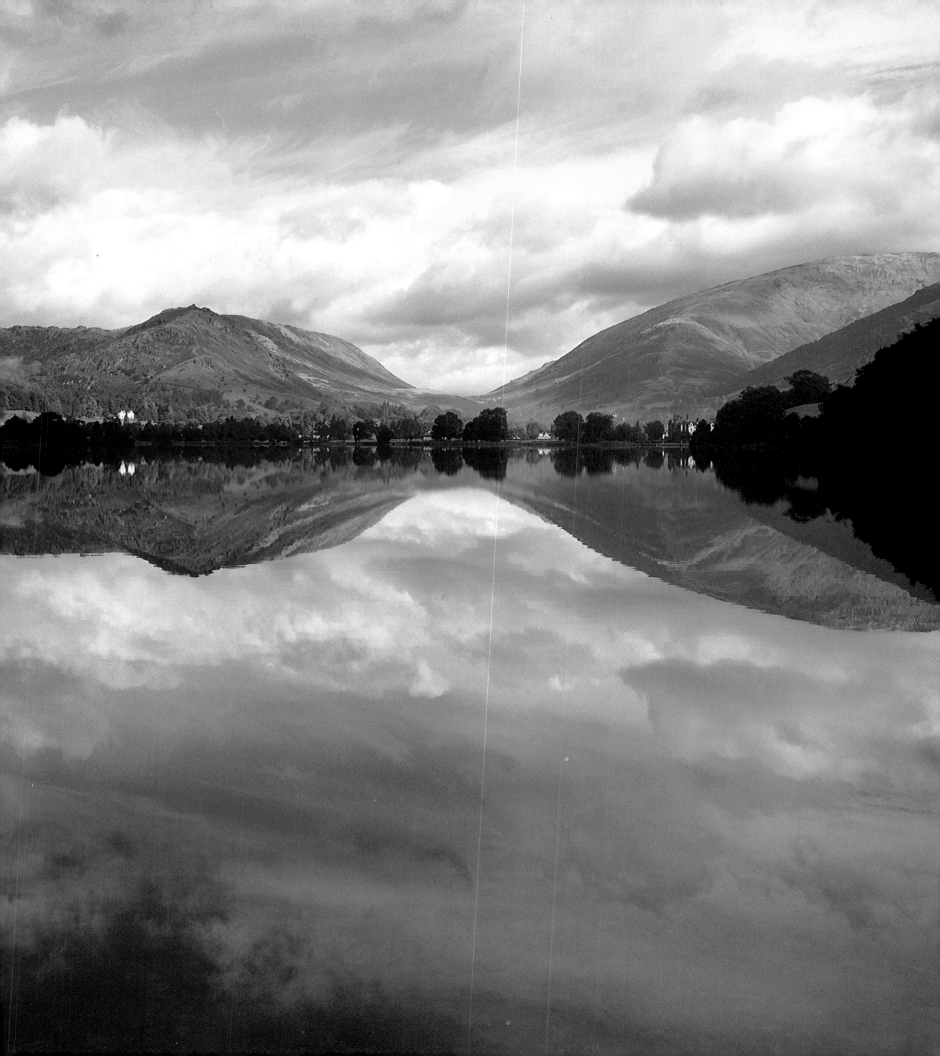

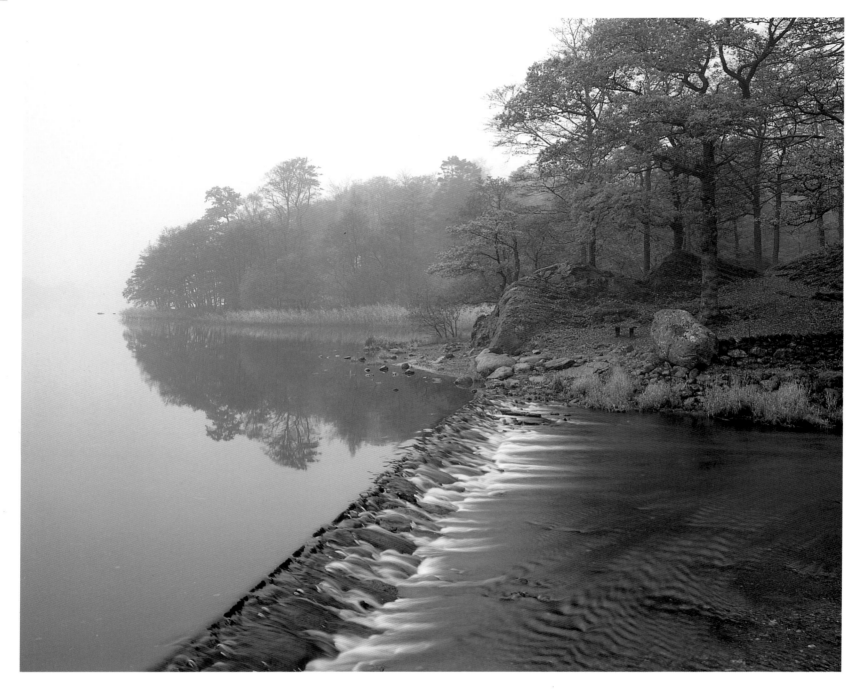

Grasmere

Lakeland's major sporting event is held annually in a field at Grasmere, not far from the northern shores of the lake. 'The Grasmere Sports', wrote Canon Rawnsley in 1899, 'are to the dalesmen of Westmorland and Cumberland what the gathering for the Highland games is to men across the Border.' The three main traditional events are: Cumberland and Westmorland wrestling, hound trailing, and the guides' fell race. Recent attempts to 'woo back the big crowds' with new 'attractions' like inflatable 'Cumberland Giants' have provoked criticism. The *Westmorland Gazette* (30 August 1996) urged: 'Greater efforts should be made to promote the key sports and encourage others of a more traditional nature, rather then have them wrestle for attention with circus acts which can be seen anywhere.'

Grasmere Island, Grasmere

When Wordsworth wanted solitude he often rowed out to the single island on the lake of Grasmere, sometimes sharing the stone barn with the sheep and cattle for which it provided shelter. It was here in 1800 that he composed the poem 'Written with a pencil upon a stone in the wall of the house (an outhouse), on the island at Grasmere'. In the same year the Wordsworths invited Coleridge to a picnic on the island. In one of his letters he wrote: 'Afterwards, we made a glorious Bonfire on the Margin, by some alder bushes, whose twigs heaved & sobbed in the uprushing column of smoke – & the Image of the Bonfire, & of us that danced round it – ruddy laughing faces in the twilight – the Image of this in a lake smooth as that sea, to whom the Son of God has said, PEACE!'

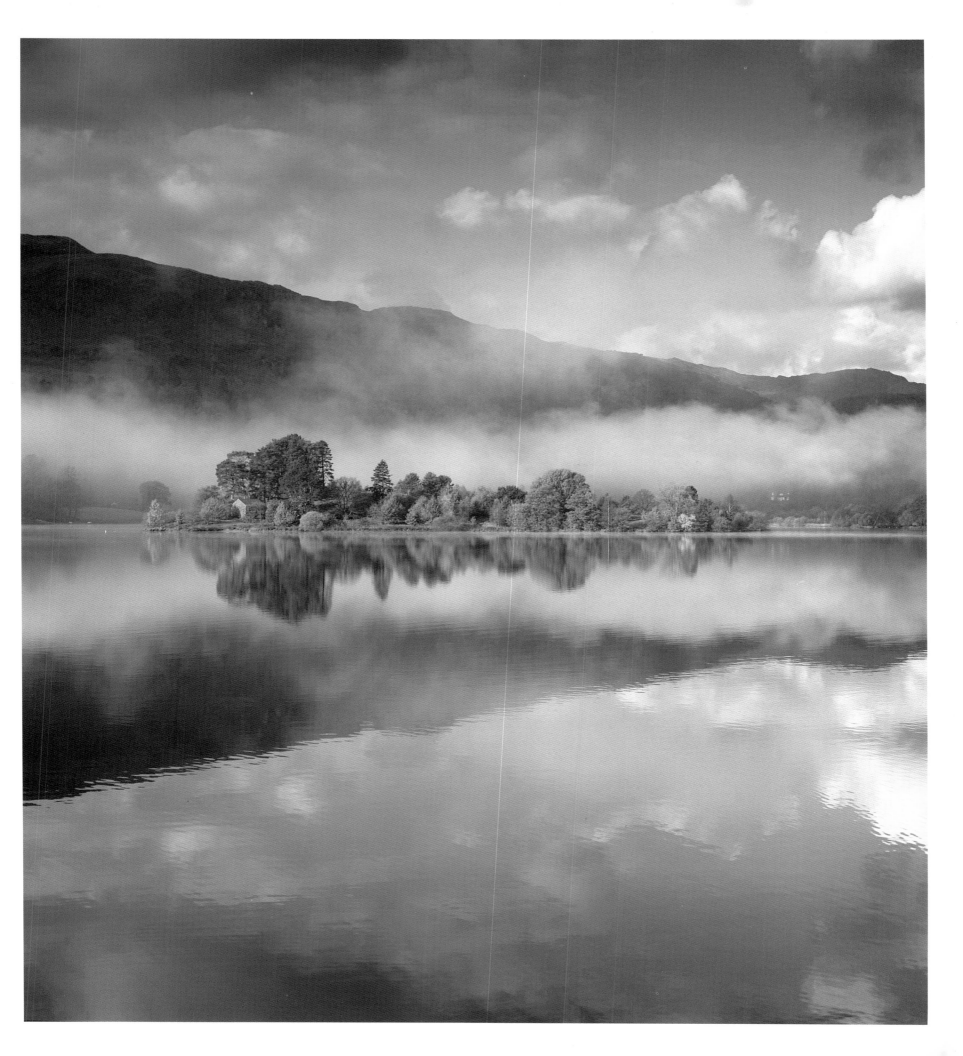

THE LAKE DISTRICT NATIONAL PARK

Although this book embraces the area covered by the Lake District National Park, it also explores lesser-known Cumbrian sites outside its boundaries. However, given that the Park is one of the most famous tourist centres in the world, the following information may be of interest. Situated in the north-west corner of England, the Lake District is the largest of the eleven National Parks in England and Wales. Yet it is only thirty miles from west to east, thirty-five from north to south, and covers an area of only 885 square miles. Before the county boundary reforms of 1974, it straddled parts of Cumberland, Westmorland and Lancashire (which met at the Three Shire Stone on Wrynose Pass). It is now entirely in Cumbria (a new county formed from all of Cumberland and Westmorland and parts of Lancashire and the West Riding of Yorkshire). Established in 1951, the Park contains England's highest mountain (Scafell Pike at 3,210 feet), sixteen lakes (the largest being Windermere) and countless tarns. Around one quarter of the Park is owned by the National Trust, an independent charity dedicated to the preservation of the beauty and character of the landscape. As the largest landowner in the district, the Trust looks after over eighty working farms, including some 30,000 sheep, and over 250 houses and cottages. It has to be stressed that, unlike other countries, most of the land in Britain's National Parks is not owned by the nation, but belongs primarily to private landowners. The National Park Authority, however, has managed to acquire about four per cent of the Park, including Bassenthwaite Lake. Among other landowners are: the North West Water Authority (privatized in November 1989), whose assets include Haweswater and Thirlmere; and the Forestry Commission, which manages, among its woodlands, the forests of Ennerdale, Grizedale and Thornthwaite. Within the Park there are over 1,800 miles of public rights of way (ranging from gentle strolls to strenuous ascents), all of which have to be regularly maintained and sometimes improved. The district is rich in history and tradition, and out of the working life of the dalesmen has grown a number of distinctly Cumbrian sports for which great strength and stamina is essential: fell running, wrestling, hound trailing and fox hunting (not on horseback but on foot). The landscape is particularly celebrated for its inspiring influence on nineteenth-century writers, poets and artists, including: William Wordsworth (1770–1850); Samuel Taylor Coleridge (1772–1834); and Robert Southey (1774–1843), the so-called 'Lake Poets'. The emblem adopted by the Lake District National Park is a view of Great Gable from Wastwater.

SELECTED PROPERTIES & REGIONAL OFFICES

LAKE DISTRICT NATIONAL PARK

BROCKHOLE VISITOR CENTRE
Brockhole
Windermere
Cumbria LA23 1LJ
Tel: (015394) 46601
Open: daily from end March to November.

ENGLISH HERITAGE

HISTORIC PROPERTIES NORTH
Bessie Surtees House
41–44 Sandhill
Newcastle Upon Tyne
NE1 3JF
Tel: (0191) 261 1585

BROUGHAM CASTLE
Brougham
Penrith
Cumbria CA10 2AA
Tel: (01768) 862488
Open: daily April to end October.

FURNESS ABBEY
Barrow-in-Furness
Cumbria LA13 0TJ
Tel: (01229) 823420
Open: daily April to end October;
November to end March,
Wednesdays to Sundays; closed
24–26 December and 1 January.

PENRITH CASTLE
Penrith
Cumbria
Tel: (0191) 261 1585
Open: daily at any reasonable time.

SHAP ABBEY
Shap
Cumbria
Tel: (0191) 261 1585
Open: daily at any reasonable time.

NATIONAL TRUST

NORTH-WEST REGIONAL OFFICE
The Hollens
Grasmere
Ambleside
Cumbria LA22 9QZ
Tel: (015394) 35599

HILL TOP
near Sawrey
Ambleside
Cumbria LA22 0LF
Tel: (015394) 36269
Open: April to end October,
Saturdays to Wednesdays and
Good Fridays.

SIZERGH CASTLE
near Kendal
Cumbria LA8 8AE
Tel: (015395) 60070
Open: April to end October,
Sundays to Thursdays.

TOWNEND
Troutbeck
Windermere
Cumbria LA23 1LB
Tel: (015394) 32628
Open: April to end October,
Tuesdays to Fridays, Sundays and
Bank Holiday Mondays.

WORDSWORTH HOUSE
Main Street
Cockermouth
Cumbria CA13 9RX
Tel: (01900) 824805
Open: April to end October,
Mondays to Fridays, and
certain Saturdays.

MISCELLANEOUS

BRANTWOOD
Coniston
Cumbria LA21 8AD
Tel: (015394) 41396
Open: daily March to November;
mid-November to mid-March,
Wednesdays to Sundays.

DALEMAIN
Stainton
Penrith
Cumbria CA11 0HB
Tel: (017684) 86450
Open: April to early October,
Sundays to Thursdays.

DOVE COTTAGE & THE WORDSWORTH MUSEUM
The Wordsworth Trust
Grasmere
Cumbria LA22 9SH
Tel: (015394) 35544
Open: February to December, except
24–26 December.

ESKDALE MILL
Boot
Eskdale
Cumbria CA19 1TG
Tel: (019467) 23335
Open: daily April to end September.

HOLKER HALL
Cark-in-Cartmel
near Grange-Over-Sands
Cumbria LA11 7PL
Tel: (015395) 58328
Open: April to end October,
Sundays to Fridays.

HUTTON-IN-THE-FOREST
Penrith
Cumbria CA11 9TH
Tel: (017684) 84449
Open: House, May to end
September, Thursdays to Saturdays;
also Easter week, Wednesdays in
August, and Bank Holiday
Mondays; gardens and grounds,
daily, except Saturdays.

LEVENS HALL
Kendal
Cumbria LA8 0PD
Tel: (015395) 60321
Open: April to end September,
except Fridays and
Saturdays.

MIREHOUSE
Keswick
Cumbria CA12 4QE
Tel: (017687) 72287
Open: House, April to end October,
Sundays, Wednesdays and
Bank Holiday Monday afternoons,
Fridays in August, and
other times by appointment;
Lakeside Walk open daily April
to end October.

MUNCASTER CASTLE
Ravenglass
Cumbria CA18 1RQ
Tel: (01229) 717614
Open: Castle, mid-March to end
October, Sundays to
Fridays; gardens open daily all year.

RYDAL MOUNT
Ambleside
Cumbria LA22 9LU
Tel: (015394) 33002
Open: daily all year, except Tuesdays
in winter.

BIBLIOGRAPHY

Baddeley, M. J. B., *The Lake District* (Ward Lock, n.d.)

Barringer, Chris, *National Trust Histories: The Lake District* (Willow Books, 1984)

Battrick, Elizabeth, *Guardian of the Lakes: A History of the National Trust in the Lake District from 1946*, (Westmorland Gazette, 1987)

Bennett, John and Jan, (ed.), *A Guide to the Industrial Archaeology of Cumbria* (Association for Industrial Archaeology, 1993)

Berry, Geoffrey, and Beard, Geoffrey, *The Lake District A Century of Conservation* (Bartholomew, 1980)

Bicknell, Peter, and Woof, Robert, (comm.), *The Lake District Discovered 1810–1850* (Trustees of Dove Cottage, 1983)

Bingham, Heather, *Learning to Live with Tourism* (Lake District National Park Authority, 1988)

Bodman, Janet, *Lake District Stone Walls* (Dalesman, 1984)

Bradley, A. G., *Highways and Byways in the Lake District* (Macmillan, 1903)

Brearley, Denis, *Lake District Place-Names* (Frank Graham, 1974)

Brewer, J. Norris, *The Beauties of England & Wales, Vol. XV: Westmorland*, (Harris, 1814)

Brunskill, R. W., *Vernacular Architecture of the Lake Counties* (Faber & Faber, 1974)

Bulmer, T., *History, Topography & Directory of Westmorland* (Bulmer, 1906)

Burkett, Mary E., and Sloss, David, *Read's Point of View* (Skiddaw Press, 1995)

Camden, William, *Britannia* (Gibson, 1695; first pub. 1586)

Clare, T., *Archaeological Sites of the Lake District* (Moorland Publishing, 1981)

Collingwood, W. G., *The Lake Counties* (Dent's County Guides) (Dent, 1902)

Cooper, W. Heaton, *The Tarns of Lakeland* (Warne, 1960)

Darlington, Beth, *Home at Grasmere: Part First, Book First of the Recluse by William Wordsworth* (Cornell University Press, 1977)

Defoe, Daniel, *A Tour Thro' the Whole Island of Great Britain* (2 Vols) (Peter Davies, 1927)

Denyer, Susan, and Martin, Janet, *A Century in the Lake District* (National Trust, 1995)

Denyer, Susan, *Traditional Building & Life in the Lake District* (Gollancz, 1991)

De Quincey, Thomas, (Wright, David, ed.) *Recollections of the Lakes and the Lake Poets* (Penguin Books, 1970)

Dickinson, William, *Cumbriana* (Whittaker, 1875; revised 1876)

Dunn, Michael, *The Lake District* (David & Charles, 1988)

Eversley, Ruth, *Wasdale: A Celebration in Words & Pictures* (Michael Moon, 1981)

Fausset, Hugh I'Anson, (sel.), *Letters of John Keats* (Nelson, 1938)

Gilpin, William, *Observations on the River Wye, and several parts of South Wales, &c., relative chiefly to Picturesque Beauty, made in the Summer of the Year 1770* (Blamire, 1782)

Gilpin, William, *Observations, relative chiefly to Picturesque Beauty, made in the year 1772, on several parts of England: particularly the Mountains, and Lakes of Cumberland and Westmorland* (2 Vols) (Blamire, 1786)

Gilpin, William, *Three Essays on Picturesque Beauty, on Picturesque Travel and on Sketching Landscape* (Blamire, 1794)

Grant, Bill, and Harris, Paul, *The Grizedale Experience* (Canongate Press, 1991)

Griggs, Earl Leslie, (ed.), *Collected Letters of Samuel Taylor Coleridge (Vol II 1801–1806)* (Clarendon Press, 1956)

Hankinson, Alan, *Camera on the Crags* (Silent Books, 1990; first pub. 1975)

Hankinson, Alan, *A Century on the Crags* (Dent, 1988)

Hodge, Edmund W., *Enjoying the Lakes: From Post-Chaise to National Park* (Oliver & Boyd, 1957)

Jackson, Herbert and Mary, *Lakeland's Pioneer Rock-Climbers* (Dalesman, 1980)

Kelly, Stephen F., *Victorian Lakeland Photographers* (Swan Hill Press, 1991)

Knight, William, (ed.), *Journals of Dorothy Wordsworth* (Macmillan, 1924)

The Lake District National Park (H.M.S.O., 1969)

Lefebure, Molly, *Cumberland Heritage* (Gollancz, 1970)

Lefebure, Molly, *The English Lake District* (Batsford, 1964)

Lindop, Grevel, *A Literary Guide to the Lake District* (Chatto & Windus, 1993)

Martineau, Harriet, *Guide to Windermere* (John Garnett, 1854)

McCracken, David, *Wordsworth & the Lake District: A Guide to the Poems & their Places* (Oxford University Press, 1984)

Mee, Arthur, *The Lake Counties* (Hodder & Stoughton, 1937)

Millward, Roy, and Robinson, Adrian, *The Lake District* (Eyre Methuen,1970; revised 1974)

Mitchell, W. R., *Changing Lakeland: Forty Years of 'Progress'* (Dalesman, 1989)

Morris, Christopher (ed.), *The Journeys of Celia Fiennes* (Cresset Press, 1947)

Nicholson, Norman, *Greater Lakeland* (Hale, 1969)

Nicholson, Norman, (comp.), *The Lake District: An Anthology* (Hale, 1977)

Nicholson, Norman, (comp.), *The Lakers: The Adventures of the First Tourists* (Hale, 1955)

Nicholson, Norman, *Portrait of the Lakes* (Hale, 1963; republished as *The Lakes*, 1972)

Palmer, William T., *The English Lakes* (Black, 1908)

Pearsall, W. H., and Pennington, W., *Collins New Naturalist Series: The Lake District* (Collins, 1973)

Pevsner, Nikolaus, *Buildings of England: Cumberland and Westmorland* (Penguin Books, 1967)

Pevsner, Nikolaus, *Buildings of England: North Lancashire* (Penguin Books, 1969)

Plumptre, James, *The Lakers: A Comic Opera in Three Acts* (Clarke, 1798)

Poucher, W. A., *Lakeland Holiday* (Chapman & Hall, 1942)

Poucher, W. A., *The Lakeland Peaks* (Constable, 1960)

Poucher, W. A., *Lakeland Through the Lens* (Chapman & Hall, 1940)

Raistrick, Arthur, *Faces of Lakeland* (Frank Peters Publishing, 1987)

Rawnsley, H. D., *Life and Nature at the English Lakes* (MacLehose, 1899)

Rollinson, William, *A History of Cumberland and Westmorland* (Phillimore, 1978)

Rollinson, William (ed.), *The Lake District: Landscape Heritage* (David & Charles, 1988)

Rollinson, William, *Lakeland Walls*, (Dalesman, 1978)

Rollinson, William, *Life and Traditions in the Lake District* (Dent, 1974)

Rowling, Marjorie, *The Folklore of the Lake District* (Batsford, 1976)

Sandilands, G. S., *The Lakes: An Anthology of Lakeland Life and Landscape* (Muller, 1947)

Scott, Daniel, *Cumberland and Westmorland* (The Little Guides series) (Methuen, 1920)

Scott, Sir Walter, *The Works of Sir Walter Scott* (Wordsworth Poetry Library, 1995)

Sedgwick, Adam, *A Memorial by the Trustees of Cowgill Chapel* (Cambridge University Press, 1868)

Size, Nicholas, *The Secret Valley: The Real Romance of Lakeland* (Warne, 1930)

Slack, Margaret, *Lakeland Discovered: From No Man's Land to National Park* (Hale, 1982)

Smith, Lucy Toulmin, (ed.), *The Itinerary of John Leland* (Vols 4 & 5) (Southern Illinois University Press, 1964)

Symonds, John, and Grant, Kenneth (ed.), *The Confessions of Aleister Crowley* (Hill & Wang, 1970)

Symonds, H. H., *Afforestation in the Lake District* (Dent, 1936)

Taylor, John, *A Dream of England: Landscape, Photography and the Tourist's Imagination* (Manchester University Press, 1994)

Thompson, B. L., *The Lake District & The National Trust* (Titus Wilson, 1946)

Thorne, James, *Rambles by Rivers: The Duddon* (Knight, 1844)

Victoria & Albert Museum, *The Discovery of the Lake District* (V & A Museum, 1984)

Wainwright, A., *A Coast to Coast Walk* (Westmorland Gazette, 1973)

Wainwright, A., *Ex-Fellwanderer* (Westmorland Gazette, 1987)

Wainwright, A., *Fellwanderer: the Story Behind the Guidebooks* (Westmorland Gazette, 1966)

Wainwright, A., *The Outlying Fells of Lakeland* (Westmorland Gazette, 1974)

Wainwright, A., *A Pictorial Guide to the Lakeland Fells: Books One to Seven* (Westmorland Gazette, 1955–66)

Weaver, John, *Exploring England's Heritage: Cumbria to Northumberland* (H.M.S.O., 1992)

West, Thomas, *The Antiquities of Furness* (West, 1774)

West, Thomas, *A Guide to the Lakes in Cumberland, Westmorland & Lancashire* (3rd edition, 1784)

White, John Pagen, *Lays and Legends of the English Lake Country* (Smith, 1873)

Wordsworth, William, *A Guide Through the District of the Lakes in the North of England* (Fifth edition, 1835)

Wyatt, John, *The Lake District National Park* (Webb & Bower, 1987)

Young, Arthur, *A Six Months Tour Through the North of England* (4 Vols) (Strahan & Nicoll, 1771 edition; London, 1784)

INDEX

PHOTOGRAPHIC INFORMATION
The cameras used to take the
photographs for this book were:
Hasselblad 503CX, with 50mm,
80mm and 150mm lenses;
and Nikon F3, with 28mm PC,
35mm and 85mm lenses.
The film was Fuji Provia 120
or Fuji Velvia 35mm.

All lenses had a filter attached
primarily to protect the front
element, but chosen to have a
slight warming quality. The
tripod was an amazingly light,
but very strong, carbon-fibre
Gitzo, and the light meter a
handheld Seconic. All equipment
was carried in standard
rucksacks.

Drystone Walls
The photographs of drystone
walls which appear throughout
this book were taken in the
following areas of Lakeland:
Contents 5, Coniston (above),
Stonethwaite (below);
Introduction 6, Hartsop;
9, Whinlatter; 14, Newlands
Valley; 18, Wythburn; 23, Shap;
24, Wasdale. The Lake District
National Park 156, Coniston.
Photographic Information 160,
Wasdale. Endpapers, Little
Langdale.